ARTS OF AFRICA, OCEANIA, AND THE AMERICAS

Selected Readings

Edited with critical introductory essays by

JANET CATHERINE BERLO
University of Missouri–St. Louis

LEE ANNE WILSON
Smithsonian Institution

PRENTICE HALL, Englewood Cliffs, New Jersey 07632

Library of Congress Cataloging-in-Publication Data

Arts of Africa, Oceania, and the Americas : selected readings / edited
with critical introductory essays by Janet Catherine Berlo, Lee Anne
Wilson

 p. cm.

 ISBN 0-13-756230-6

 1. Art, Primitive. 2. Ethnic art. 3. I. Berlo, Janet Catherine.
II. Wilson, Lee Anne.

 N5311.A78 1993

 709'.01'1—dc20 91-45137

Acquisitions Editor: *Norwell F. Therien*
Editorial/production supervision and interior design: *Edie Riker*
Cover design: *Ray Lundgren Graphics, Ltd.*
Prepress buyer: *Herb Klein*
Manufacturing buyer: *Patrice Fraccio*

To our teachers,
George Kubler and Douglas Fraser,
and
to our students

 © 1993 by Prentice-Hall, Inc.
A Simon & Schuster Company
Englewood Cliffs, New Jersey 07632

Printed in the United States of America

10 9 8 7 6 5 4

ISBN 0-13-756230-6

Prentice-Hall International (UK) Limited, *London*
Prentice-Hall of Australia Pty. Limited, *Sydney*
Prentice-Hall Canada Inc., *Toronto*
Prentice-Hall Hispanoamericana, S.A., *Mexico*
Prentice-Hall of India Private Limited, *New Delhi*
Prentice-Hall of Japan, Inc., *Tokyo*
Simon & Schuster Asia Pte. Ltd., *Singapore*
Editora Prentice-Hall do Brasil, Ltda., *Rio de Janeiro*

CONTENTS

PREFACE

This book presents some notable essays on the wide-ranging arts of Africa, Oceania, and the Americas that the editors have found useful for teaching an undergraduate course on this subject. There are few textbooks for such a course, and even fewer that incorporate some of the newest research and methods. It is our opinion that the best approach to take in formulating a book of readings such as this is a thematic one. Few scholars of our generation teach according to the simple African style-area approach or the North American Indian culture-area method that was the legacy of our teachers. Recent studies place increasing emphasis on concepts and theories that cross-cut geographic boundaries and historical periods to provide ideological frameworks for better understanding art in its dynamic social context.

Both editors experimented with reading lists and duplicated materials for their students, who seemed fascinated by this approach and quite capable of leaping from one continent and ethnic group to another without confusion. The only confusion arose from library reserve materials that were missing and duplicated articles with blurry photos. We began to think about compiling a text of interesting, current readings that could be used in an introductory course on the arts of native peoples of Africa, Oceania, and the Americas—those peoples who have come to be called "the fourth world,"—autonomous societies within the framework of third world and first world countries, yet predating such modern geo-political formations.

We quickly decided on certain basic guidelines for this book—only one article per author, a representative balance from the regions of Africa, Oceania, and the Americas, and publication within the last 20 years. We quickly realized that it would be impossible to include all the articles we thought important, and we made some hard choices. Other choices were forced upon us by simple expediency, inability to locate authors, or availability of materials.

In some instances, we have included more than one article on an ethnic group while omitting other groups that might well have been represented. Our intention was to provide in-depth coverage in particular areas. For example, such duplication of coverage encourages discussion of men's (Warren d'Azevedo, *Mask Makers and Myth in Western Liberia*) and women's (Ruth B. Phillips, *Masking in Mende Sande Society Initiation Rituals*) art forms as complementary systems. For the Northwest Coast, it suggests ways in which the work of the individual artist (Bill Holm, *Will the Real Charles Edensaw Please Stand Up?: The Problem of Attribution in Northwest Coast Indian Art*) fits into the social system in which the art was circulated (Stanley Walens, *The Weight of My Name Is a Mountain of Blankets: Potlatch Ceremonies*). In order to keep the text to one volume, we decided to focus

principally on the historic and modern traditions of Africa, Oceania, and the Americas; a number of other anthologies cover the ancient cultures of Mesoamerica and the Andes. We believe that the final choices appearing in this reader contribute new information, address critical approaches, and discuss theories important to the study of ethnographic arts.

The book is divided into six sections, each with its own introduction and bibliography. Each of these sections focuses on one major theme (with numerous subthemes) that can be amplified through discussion and further reading. The section introductions present issues of significance for the readings in that section while also indicating the broader implications of these topics through a brief discussion of related books and articles (included in the bibliography at the end of each introduction). Both the introductions and reading lists are designed to spark further exploration of the issues presented in the essays. Some of the readings may challenge traditional Euro-American concepts of art and its purposes; others may suggest new ways to view art, or provide new definitions for it. We believe students from a variety of fields will find the exploration of these themes and theories exciting and will respond with their own questions and ideas.

This anthology will aid in the initial exploration of the art of traditional African, Oceanic, and Amerindian cultures; yet it is by no means the only word on the topic. While many different approaches by art historians and anthropologists from both Europe and North America have been included, other editors would certainly select alternative titles or cluster them according to different themes. Any volume such as this is simply a sampler, to give students a taste for the richness of ethnographic art and the incredible complexity of a few of its traditions. Indeed, if the volume elicits questions, encourages discussion, and stimulates further reading, we will have achieved our goals as editors. This volume can stand alone as a textbook for an introductory course on "the Art of Africa, Oceania, and the Americas," "Tribal Arts," "Anthropology and Art," "Primitive Art," or whatever it may be titled in anthropology and art history departments across North America. Yet it is also designed to function as an in-depth supplement to other texts, both general and specific. While we have no preconceived plan of how this book should function within the classroom, we do hope that it will be a fruitful tool to explore the many ways that tribal arts touch our own world.

No preface is complete without a long list of acknowledgments, and we could certainly provide such a list. Instead, we would like simply to express our appreciation and thanks to our husbands, Bradley Gale and Bill Harlow, for their patience and support over the years that this project has taken shape; to our contributors for their generosity and assistance with their articles and photographs; to Edie Riker and her staff for superb editorial and production supervision; and to our editors—especially Wayne Spohr, Prentice Hall college field editor—for helping bring this book to fruition.

Janet Catherine Berlo
Lee Anne Wilson

PART ONE

AESTHETIC SYSTEMS
KNOWLEDGE, BEAUTY, AND POWER

Janet Catherine Berlo

In no modern, western society does the concept of aesthetics have implications that are as far-reaching as those discussed in this section. Often in Africa, Oceania, and native North America, aesthetics do not simply concern the artistically beautiful. They reach into moral and spiritual realms as well. When Yoruba people of Nigeria consider aesthetics, they say *"iwal'ewa"—"essential nature is beauty"; in other words, only when a work of art captures the essential nature of its subject will the art work be evaluated as beautiful (Drewal and Pemberton 1989:42). Inuit artists of the Canadian arctic would agree with this assessment; for the Inuit stone carver, the essence of art is translating truth into tactile form (Swinton 1978:85). When carving a stone seal, walrus, or polar bear, the sculptor strives to "tell the truth well" (Trott 1986:346). This does not necessarily result in graphic realism, for the truth (or to borrow the Yoruba phrasing, the "essential nature") may reside in small details: the curve of a walrus' tusk, the distinctive cut of a woman's parka. If the small details are true, the larger sculpture may be exaggerated or fanciful in form yet still be aesthetically successful.*

For the Yoruba artist to create beautiful forms, he or she must have numerous attributes of good character:

> these include *ifarabalé* (calmness); *iluti* (teachability); *imoju-mora* (sensitivity, good perception, appropriate innovation); *tito* (lastingness, endurance, genuineness); *oju-inu* (insight); and *oju-ona* (design consciousness, originality). In addition, there is admiration for the visual (photographic) memory, which is expressed in the judgment that the artist is "one who sees well and remembers," and the ability to concentrate that requires the attribute of patience. (Drewal and Pemberton 1989:42)

For the Navajo artist in the American southwest, too, aesthetic concepts have far-reaching implications for morality as well as art. The concept of *hozho* illuminates Navajo notions of aesthetics:

> the Navajo does not look for beauty; he generates it within himself and projects it onto the universe. The Navajo say *shilhozho,* "with me there is beauty"; *shiihozho,* "in me there is beauty"; and *shaahozho,* "from me beauty radiates." Beauty is not "out there" in things to be perceived by the perceptive and appreciative viewer; it is a creation of thought. The Navajo experience beauty primarily through expression and creation, not through perception and preservation. (Witherspoon 1977:151)

In modern Euro-American societies, we tend to think of aesthetic categories as applying to the finished product—the art work itself. But to the Navajo, and to a number of other ethnic groups as well, it is the *process* of making art that is aesthetically significant. For the Navajo weaver to creatively combine the world of plants (vegetal dyes), animals (sheep's wool), and humans (her own artistic skill) is to effect a profoundly beautiful aesthetic transformation (Witherspoon 1977). Virtuoso technique is important in all Navajo arts: weaving, ritual sandpainting, and chanting. In contrast, the finished product is less important. The rug may be sold, the sandpainting destroyed at the end of the ceremony, and the song last for only a moment in the ears of the listeners.

The ephemeral nature of some art works in the Fourth World is central to their meaning. Among the New Irelanders of Melanesia, sculptural assemblages called *Malangan* are made for public display at funerals. The sculptures are replacements for the body of the deceased, allowing his life force to be redirected to the world of the living. *Malangan* are allowed to rot, or even to be sold to foreigners, after the sculptures have fulfilled their job. What is important is the constant rechanneling of the life force, not the objects themselves (Kuechler 1987; see also Lincoln 1987).

Arnold Rubin (*Accumulation: Power and Display in African Sculpture*, page 4) considers aesthetics to be central to the understanding of content of a work of art. Content or meaning lies not simply in the realm of iconography and symbolism but, as Rubin says, "originates in the orchestration of materials and techniques." He points out that the numerous materials that make up African sculpture—wood, mineral pigments, skulls, fur, feathers, horns, nails, beads, blood, oils, and the like—form an aesthetic of accumulation. Sometimes these items are used for reasons of power, linking the object and its user to diverse spiritual, material, and political realms of power. In other instances, the sheer visual display evoked by such an assemblage affirm the status and cosmopolitanism of the wearer or owner of the work.

In a different vein, Barbara Tedlock (*The Beautiful and the Dangerous: Zuni Ritual and Cosmology as an Aesthetic System*, page 48) discusses display and accumulation among the Zuni Indians of New Mexico. *Tso'ya,* meaning dynamic, multi-colored, varied, exciting and beautiful, is at the heart of what Tedlock calls the "multi-sensory aesthetic" of the Zuni. Her essay points out a fact which is crucial for discussions of aesthetics in non-Western societies: the realm of aesthetics often breaks down boundaries between different arenas of human experience. The decoration of a Zuni house, the ritual attire of the Kachina dancers, and even the

choice of food served to guests at the Shalako feast all point to the multi-vocality of the Zuni aesthetic system.

Robert Farris Thompson has explored the multiple aesthetic links among African sculpture, dance, music, literature, and other categories (1974). In this volume (*An Aesthetic of the Cool*, page 22) he deepens our understanding of one aesthetic category, the concept of "cool." Thompson illuminates its meaning for figural sculpture, dance, oral literature, paint applications, right living, and moral philosophy. He further shows us that this ancient African aesthetic mandate came to the New World in the African diaspora and informs our own slang and attitudes today. In the art of Tonga in Polynesia, too, aesthetic categories hold forth across different realms. According to Adrienne Kaeppler (*Melody, Drone, and Decoration*, page 36), Tongan society, music, dance, and fiber arts all are organized according to the aesthetic principles drawn from music.

Every essay in this section reinforces the idea that it is impossible to consider visual arts of the Fourth World apart from the social contexts in which they were made. Rich layers of meaning accrue to these arts through dance, song, ritual, and the many other strands of their complex social fabric.

BIBLIOGRAPHY

Dark, Philip. 1983. "Among the Kilenge 'Art is something which is well done,'" in *Art and Artists of Oceania*, edited by Sidney M. Mead and Bernie Kernot. The Dunmore Press, pp. 25-44.

Drewal, Henry John and John Pemberton III. 1989. *Yoruba: Nine Centuries of African Art and Thought*, New York: The Center for African Art and Abrams Co.

Hanson, Allan. 1983. "Art and the Maori Construction of Reality," in *Art and Artists of Oceania*, edited by Sidney M. Mead and Bernie Kernot. The Dunmore Press, pp. 210-225.

Kuechler, Suzanne. 1987. "Malangan: Art and Memory in a Melanesian Society," *Man*, vol. 22(2), pp. 238-255.

Lincoln, Louise. 1987. *Assemblage of Spirits: Idea and Image in New Ireland*. New York: George Braziller.

Swinton, George. 1978. "Touch and the real: contemporary Inuit aesthetics—theory, usage, relevance," in *Art and Society*, edited by M. Greenhalgh and V. Megaw. New York: St. Martin's Press, pp. 71-88.

Thompson, Robert Farris. 1974. *African Art in Motion*. Berkeley: University of California Press.

Trott, Christopher. 1986. "The Semiotics of Inuit Sculpture: Art and *Sananguat*," *Recherches Semi-otiques/Semiotic Inquiry*, vol. 2(4), pp. 337-359.

Waite, Deborah. 1979. "Aspects of Style and Symbolism in the Art of the Solomon Islands," in *Exploring the Visual Arts of Oceania*, edited by Sidney M. Meade. Honolulu: University of Hawaii Press, pp. 238-264.

Witherspoon, Gary. 1977. *Language and Art in the Navajo Universe*. Ann Arbor: University of Michigan Press.

1

Accumulation
Power and Display
In African Sculpture

Arnold Rubin

As an aspect of Western intellectual history, the systematic study of African art must be regarded as still in its infancy. A history of African art comparable in scope and depth to those achieved for the major Western and Oriental traditions lies in the future, although some promising beginnings have been made. There seems to be little question, however, that art-historical questions have received—and continue to receive—comparatively little scholarly attention. Students of the arts of Africa have also been reluctant to confront the aesthetic and artistic dimensions of their data; traditional art-historical and critical perspectives have been subordinated to the gathering and organization of masses of minutely particularized behavioral information. Some younger scholars have sought to approach African art as inseparable, for all practical purposes, from complexes of sound.

The predominance of these orientations in recent research—the "anthropological" on the one hand, and the "comprehensive/interdisciplinary" on the other—appears to be directly related to the circumstances surrounding the expansion of "area studies" curricula in American universities during the 1950s and 1960s. African area studies, in particular, were characterized by a strong interdisciplinary orientation, with especially heavy emphasis on the social sciences. Prior to the 1960s, information in any significant depth regarding the cultural and historical ramifications of particular African artistic traditions was meager where it was not altogether lacking. Discussions of African art or, indeed, of most aspects of traditional African culture depended heavily upon the usually biased reports of missionaries and colonial administrators, ethnocentric and

Reprinted in abridged form from *Artforum*, Vol. 13(9):35–47, 1975 with permission of the author's heirs and publisher.

racist culture-history theories and reconstructions, unwarranted extrapolations from the known to the unknown and other more-or-less imaginative inventions. Other writers, for the most part mainly interested in European art of the early 20th century, sought to make a virtue of ignorance. Cultural data associated with the objects were dismissed as irrelevant to their "understanding" or "appreciation" of what were acknowledged to be high artistic achievement.

A stereotyped image of Africa as culturally impoverished had been challenged only by a small group of skeptical—and dedicated—anthropologists. Their field researches showed the cultures of Africa to be rich, resonant and magnificently diverse, with deep and complex histories. Especially important for students of the arts, their findings indicated significant roles for the arts in the functioning of many African communities. In some areas, art was shown to impinge upon the exercise of political authority and other forms of social control. In other areas, or at other times, art served to organize rites of passage—birth, maturation, and death, for example—or to render visible and tangible key elements of subtle and highly articulated metaphysical systems of the sort usually described as religious.

The education of a number of Africanist art historians trained during the '50s and '60s culminated in an opportunity to investigate African art in Africa. This experience, previously rare, provided opportunities to verify firsthand the strength and vitality of African culture as reported by their anthropological predecessors. Since the methods and perspectives of anthropology had provided the only reliable guides to the realities of African culture which these students encountered in the field, it should not be surprising that their attempts to correct earlier distortions and misunderstandings regarding the nature and significance of African art should rely heavily upon these same methods and perspectives. I do not mean to deprecate the important results achieved in the study of African art within the frame of reference provided by these well-tested anthropological/ethnographical modes. Nevertheless, the fascination of exploring the interplay of art and other aspects of culture in Africa has tended to overshadow other dimensions of the material and other approaches to the subject.

In particular, what might be described as the *content* of African sculpture has clearly not received the attention it deserves. For present purposes, *content* is defined as one dimension of the affective power and complex of multiple meanings embodied in a work of art. It originates in the orchestration of materials and techniques, and transcends both purely formal qualities on the one hand and comparatively explicit iconographical or symbolic associations on the other. As one of several possible approaches to *content* in African sculpture, I propose to consider media—their nature, how they are used, and what they seem to mean. At the primary level, conceptions which seem to relate to principles of assemblage in recent Western art are frequently counted.[1] African assemblage, however, exhibits a number of distinctive features. One special subcategory—here designated accumulation—raises issues which transcend consideration of form, extending to the role of art in fostering social cohesion and cultural continuity.

The formal brilliance of much traditional African sculpture is by now generally acknowledged, and its impact on the history of 20th-century Western art well known. These facts have often provided an avenue of approach to the original African forms, emphasizing their often striking resemblances to comparatively familiar modern Western experiments in artistic structure, concept, and materials. The richness of African sculptural invention tends to obscure the limited range of formal categories in which the forms are realized. As one becomes familiar with the range of possible variations within each localized idiom, the latitude available to individual artists for "personal statements" is seen to be very restricted.

For traditional Africa, the accumulated wisdom of the past, represented by the "formulae" in all aspects of culture, provided an acculturative and cohesive mechanism of enormous potency, to be tampered with only at the risk of potentially grave consequences. Art, in particular, served to define and focus group identity and to reinforce the sense of community which provided the only context in which individual identity was meaningful or even conceivable. Far from stifling the artistic impulse, we must conclude that these fundamentally conservative systems of shared values, emphasizing continuity and stability rather than change and challenge, have imbued the forms of African sculpture with an uncompromising and unequivocal sense of conviction which is the source of their often extraordinary impact. This characterization of African sculpture as essentially conventional and conservative is not contravened by recent field research which has shown that African artists and critics also respond to formal qualities; or that in some communities, such specialists even possess a developed vocabulary for explicating their judgments as to aesthetic qualities—as if this should come as something of a surprise! The point, of course, is that social utility and aesthetic quality are not—and never have been—necessarily incompatible; for most cultures, the positive role of the artist in objectifying and reinforcing the values of his community has been resolved in terms of a delicate and complex balance of aesthetic and other priorities. Acceptance of and operation within conventional limits on "artistic freedom" usually carried compensation in the form of increased leverage in the social, political, and economic spheres.

At one level, practically all African sculpture could have entered into the discussion which follows, since a puristic "truth to materials" appears to have been infrequent in traditional African sculpture. Masks, for example, typically incorporate a variety of materials whose presence is primarily dictated by "engineering" problems connected with keeping them in place during the dance, or which serve to cover transitions from mask to body-covering or costume.

A partial inventory of the materials they employ include accumulations of dried blood, millet beer, palmwine, and other libations; fomentations of sheanut "butter" or any of several types of oil, sometimes mixed with powdered camwood or red ocher; the skulls of small animals or birds; fur, feathers, teeth, and claws; the skins of snakes and other reptiles; the horns of various antelopes; tortoise and other types of shells, especially cowries; strips, sheets, and bits of iron, brass, copper, and other metals; local and imported woven textiles and other types of

fiber constructions; glass beads, mirrors, bells, and oddments such as spent shotgun shells, all usually associated with a more-or-less elaborately carved wooden core element.

These substances and elements may provisionally be divided into two broad categories—POWER and DISPLAY—on the basis of their visual characteristics. (In particular instances, however, some types may belong to either category, or partake simultaneously of the qualities of both.) Often they are employed in what seems at first glance to be unorganized, overwhelming profusion.

Closer inspection of a reasonable number of examples of any particular African accumulative configuration invariably reveals that even those which seem most random and accidental in composition are actually developed in accordance with consistent principles wherein what is used, and how, varies within fairly narrow limits.

DISPLAY materials (beads, bells, fabrics, mirrors, etc.) are primarily oriented toward enhancement of the splendor of the objects to which they are attached. They usually carry associations of prosperity and cosmopolitan sophistication for the individual or group on whose behalf such sculpture is created. (Most DISPLAY materials had recognized exchange-values in traditional economies; cowries, in particular, were widely used as currency.) (Figure 1)

The second category of materials—horns, skulls, and sacrificial accumulations, for example—is connected with the organization and exploitation of POWER. (Figures 2–6)

Nowhere, in my opinion, have the special qualities of power materials been enunciated with more discernment than in Robert Goldwater's discussion of the Bambara *boli*:

> The *boli* constitute one of three types of altars current among the Bambara (the others being tree stumps and stones), and are also a kind of symbolic fetish. Composed of a variety of materials—wood, bark, roots, horns, feet, claws, honey, precious metals, etc.—which symbolically represent the portions of the universe, they are covered with a thick black crust, in part the dried blood of the sacrificially offered animals. The *boli* have many forms, or almost no form at all, but some are shaped as hippopotami, others as human beings. Employed in all the important religious societies, the *boli*, Dieterlen explains, "occupy a signal place in the religious and cosmogenic representations of the society centered upon them. On the one hand, their composition makes of them a summary of the universe. On the other, they are a summary of the society, for all its members are included within them since, as a matter of fact, each of them has provided one portion of the elements that compose them after having impregnated it with his being by covering it with his saliva while pronouncing his name." The different *boli* are preserved in sanctuaries either within or on the outskirts of the village, and may be approached only by the chief of the village, or other qualified religious persons.
>
> Opinions will differ as to whether the *boli* are "works of art." If conventional concepts of artisanal skill are the criteria of judgment, they would hardly seem to qualify, although it must be recognized these objects have a very definite "style," in the sense that the employment of traditional techniques produces controlled and expected results familiar to the Bambara and identifiable by a stranger as a Bambara artifact. Thus there is here at least a craft. But in a deeper sense too they are works of art, since they issue from an imagination that does more than

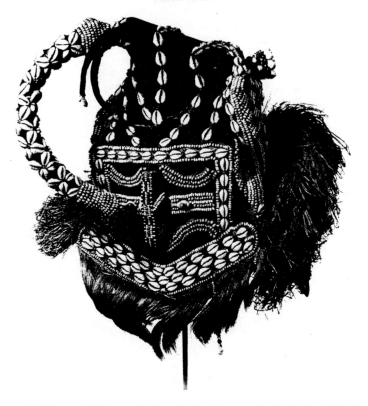

Figure 1 Kuba mask, Zaire. Cloth, raffia, leather, cowrie shells, beads, hair.
Fowler Museum of Cultural History, UCLA. X65-5400.

imitate appearance and so functions for the observer as an imaginative focus,
mysterious yet real. A little reflection will admit that it is not entirely the
materials of their manufacture that makes them "awful" objects and that their
effect—which combines fascination and repugnance—is related to having once
been objects of awe.[2]

SURFACE

According to conventional Western attitudes, a work of art should ordinarily be
the product of a single mind and its evolution should cease when it leaves the
artist's studio. Accordingly, the main work of curators and conservators becomes
that of returning the object as nearly as possible to this pristine condition (or
some other more or less arbitrarily chosen state) at which point it is then carefully
maintained. This enterprise may include repairing damage, restoring lost ele-
ments, and removing varnish, overpainting, or earlier repairs and restorations
judged unsatisfactory. In other words, the restorer and his client value the
appearance of an object at some early stage in its existence more highly than the
record of its changing circumstances over time, especially as this record incor-
porates the more-or-less drastic design decisions affecting the object made by the
succession of custodians through whose hands it had passed.

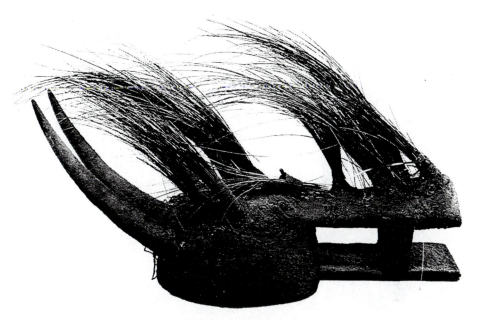

Figure 2 Bamana *Komo* mask, Mali. Wood, horns, porcupine quills, mud. Fowler Museum of Cultural History, UCLA. X77-392.

These attitudes may be contrasted with that exhibited by the collector who cuts down a painting to fit a particular space on his wall, or a government which countenances the melting-down of gold or silver ornaments for coinage or bronze statuary for cannon. The first body of attitudes and activities are praiseworthy antiquarianism, the second vandalism. Another perspective would treat of both as reflecting design-decisions deriving from different sets of priorities. These divergent points of view seem to reflect a deeper dichotomy: in Western culture, a sensitivity to art, music, poetry, and other "exalted manifestations of the human spirit" which are appreciated essentially for their own intrinsic qualities, is opposed to more pragmatic "engineering" attitudes primarily oriented toward coping efficiently with the exigencies of daily life. It is customary to stress that the relative weighting given to each of these inclinations is internally defined by each culture and, within societal parameters, by each individual. Cultures and individuals tend to be ranked higher on the scale of "civilization" according to the extent to which transcendental aspirations take precedence over mundane pursuits.

Available evidence suggests that Africans perceive no such dialectical opposition. As noted earlier, aesthetic decisions are definitely made, but they are comprehensible only in terms of a much wider set of values. In general, African peoples manifest an exquisite sensitivity to objects and experiences, structures and relationships, but primarily as means to ends rather than as ends in themselves. For most African communities, the over-riding objective of all beliefs and practices is the survival, orderly and effective functioning, and prosperity of the community and of the individuals who make it up; in such a context, "usefulness" tends to be extremely broad of definition. Moreover, each

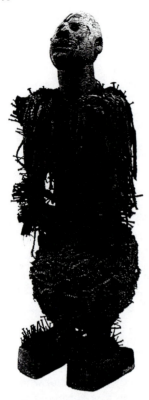

Figure 3
Kongo *Nkonde* figure, Zaire. Wood, cloth, rope, iron,
beads, bells, shells, and activating materials. Fowler Museum
of Cultural History, UCLA. X65-5837.

community typically relates to its natural, supernatural, and cultural environment
with rigorous pragmatism and a notable lack of sentimentality. Rarely is there
any compunction, for example, over melting down and recasting bronze orna-
ments or other configurations which have gone out of fashion or are otherwise
no longer relevant to any particular functional context. Nor does any serious
distress accompany acknowledgment of the fact that, despite reasonable care,
most masks and figures eventually have to be replaced owing to breakage,
weathering, insect damage, or fire. Many types of objects are made for one
period of use—often quite brief—and then discarded. Far from representing a
tragedy, the fairly high rate of attrition of monuments in most African com-
munities has had the effect of providing work for relatively large numbers of
artists in each generation, for whom the products of only the preceding two or
three generations are available as models and standards. In a broader sense, the
entire body of inherited cultural patterns, representing the accumulated
experiences, accomplishments, and wisdom of the past is typically evaluated
in each generation and reinterpreted or adjusted where deemed desirable in
the light of available options and altered circumstances.

Such a pattern of perceived and implemented distinctions between ends
and means, and of continuous cultural stock-taking, may help to clarify the
difficulty which many Africans living in traditional societies have in under-
standing the Western collector's motivation and rationale. In a traditional

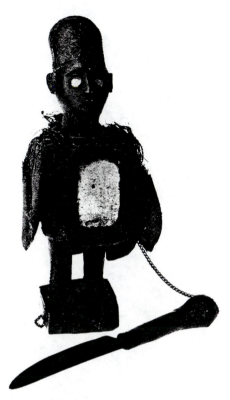

Figure 4
Kongo figure, Zaire. Wood, cloth, raffia,
metal, glass, activating materials. Fowler
Museum of Cultural History, UCLA. X67-879.

context, whatever else objects may be and do, they are first of all perceived as making statements about the self-identification of their makers and users. Conceptions of what we call style, form, iconography, use and function—the total configurations of houses, pots, weapons, thrones, and images of ancestors, for example—represent entities intimately bound up with particular cultural and social systems bounded in space and time. Peremptory removal of an object whose presence sanctions crucial political, religious, or social functions may render the exercise of those functions difficult if not impossible, representing a grave threat to the orderly life of the community. Only an enemy would undertake to remove such an object. On the other hand, if a new structural component in the areas of juridicial authority or enculturation of the young, for example, has supplanted an earlier one, objects associated with the supplanted system may be cast out.

More often, however, prudence will dictate that the earlier complex receive at least token maintenance for a period of time by virtue of its previous importance to the community (usually expressed in terms of the residue of power it will have accumulated through many sacrifices or other devotions), or as a reserve or "back-up" system in case the new system proves unsatisfactory. While the owners or custodians of such formerly important objects may agree to part with them, they often express puzzlement at what possible use members of another group could have for relics at the same time useless and intimately bound

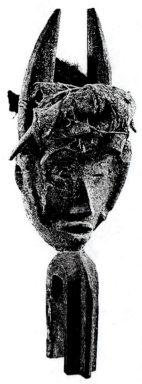

Figure 5
Touba *Maou* mask, Ivory Coast. Wood, horns, fur,
sacrificial materials. Fowler Museum of Cultural History,
UCLA. X73-632.

up with the identity and cumulative experience of an alien people; deprived of
their functional roots, the formal appeal as well as the effective power of the
objects wither away. As an even more important consideration, such objects will
also be regarded as almost certainly hazardous to an outsider who is, by definition,
ignorant of their proper use.

The French anthropologist Marcel Griaule reports traditions from the
Dogon of Mali which poignantly illustrate the hazards of casual contact with such
charged or contaminated objects and/or materials.[3] The traditions in question
are lengthy and complex and deal with the origins of many features of the Dogon
universe, including death. Initiated by an incident of cosmic incest, a chain of
antisocial and sacrilegious acts introduced death into the world of mankind. A
complex of red fiber costumes and associated carved wooden masks was
developed as a means of preventing the souls of the recently dead from interfer-
ing in harmful ways in the world of the living:

> Clothed in fibres, hoods and masks which they had woven and sculptured
> themselves, dancers in war-dress went to the terraces frequented by the souls.
> Against a background of funeral rhythms, they simulated, with their axes and
> lances, a battle against the invisible ones from which they emerged victorious;
> the souls fled and were guided by other rites to another place of repose where
> all tribulation ceased. From that time onwards, each death gave rise to this
> masked dance on the burial terrace which became the highlight of the
> ceremonies marking the close of the mourning period.

Figure 6
Ibo mask, Nigeria. Wood, seeds, bone,
cloth, horns, and mud. Fowler Museum of
Cultural History, UCLA. X73-631.

But very soon, the masks were not content with gesticulations in this limited theatre; they betook themselves to the public square to enhance aesthetically their religious actions.

This therapeutic action, even if it alleviated the lot of those who had died, helped to spread the evil among the men who pursued their immortal destiny. For these spectacular ceremonies excited their curiosity and their envy. Some of them took masks and fibre costumes for their own use. Others, thinking they were precious objects, hid them in holes in the rocks. Still others, seeing the object which had caused the rites, bought a body to have a reason for sculpturing, painting, and showing themselves in the public square.

But the masks and fibres, being funeral material, transmitted their impurity to those who wore them and death, winning over one region after another, spread throughout the Dogon world.

Other sections of the Dogon traditions reported by Griaule, and data from a number of other African societies, support the principle implied here: that certain forms and materials brought into conjunction and activated through appropriate procedures have the capacity to organize and concentrate what might be called "available capability." For the most part, power materials embody "signature elements" for the creature from which they have been taken, amounting to the distinctive survival equipment which characterizes each: for birds, their beaks, talons, or feathers; for the various types of antelopes, their horns; for snails or tortoises, their shells, and so on. Imitations in carved wood or other materials may, it seems, also serve. By virtue of the magnificently articulated survival system

he represents, the leopard is typically accorded special significance in such transfers or borrowings; claws, fangs, and pelt may be utilized, or pelt-markings emulated through spotting with paint.

Incantations, blood sacrifices, and libations of "spiritous" liquors may be used to introduce additional essences. A tendency to multiply media in POWER contexts should probably be seen as intentional design redundancy, calculated to organize a wide spectrum of systematic responses to particular types of problems—health, prosperity, or social advancement, for example—through the employment of configurations and procedures which experience has indicated will receive a desired result. Thus, activation of objects through this process of transfer and concentration of energies or capabilities is cumulative in intent as well as accumulative in aspect. The effectiveness of the principles involved is corroborated by the multiplication of elements and attributes unified by the residue of many sacrifices (Figures 2, 3, 4).

The investment of spirit principles in objects by invocation and convention, also frequently encountered in Africa, has been stressed in the literature. The conceptions involved seem fundamentally different from systematic exploitation of qualitative phenomena in POWER contexts, however. Procedures followed (sacrifices, adjurations, etc.) and observable signs of their effectiveness (e.g., possession of devotees) may be similar in both cases; the spirit-principles in question are usually personalized in the form of deities or ancestors, however, and their symbolic presence in their particular ceremonial context usually implies invitation and some measure of willingness or volition. In contrast, POWER sculpture may be said to draw directly upon essences, its effects conceived as resulting automatically from proper procedures properly carried out.

SUBSTANCE

William Fagg has argued that the principal of "increase" serves to organize life and art in African and other "tribal" societies.[4] He proposes that a special sensitivity to lifeforms characterizes such societies by virtue of their closeness to nature in connection with subsistence pursuits. This sensitivity, according to Fagg, is reflected in the frequency with which the exponential or "growth" curve appears in their arts—the helical spiral described by many types of germinating seeds, for example, or the tendrils of vines, or certain horns and shells.

There is certainly nothing to dispute in the proposition that enhanced security, reflected in the multiplication of children, food supplies, animals, or other types of wealth, represents a pervasive goal for members of the societies in question (and very likely a universal human goal as well). It seems to me, however, that the concepts of transfer and accumulation as outlined above may provide a more valid framework than "increase" for considering both the characteristics of design noted by Fagg and possibly other distinctive features of African (and other "tribal") societies.

"Increase" as used by Fagg, implies the possibility of creation or generation of matter or energy, of potentially unlimited expansion of the "good things" of

life, however defined. This premise may be said to have dominated Western approaches to nature at least since the beginnings of the Industrial Revolution, amounting to a fantasy popularly epitomized in recent times by the liberation of atomic energy. Strikingly different conceptions are indicated by evidence from a number of African societies, however. Available matter and energy—the resources upon which an individual or group may be able to draw—are perceived as manifestly finite and invariably entailed, therefore inevitably the subject of contention and competition. On the whole, one individual or group can prosper only at the expense (or through the largesse) of others.

Frank Willett has recently discussed the stone *nomoli* figures of Sierra Leone which are set up by Mende farmers in their rice-fields "to protect the crop and make it prosper. Indeed, it is reported that the *nomoli* are expected to steal rice plants from the neighboring fields to this end, and that they are beaten if they do not do this successfully."[5] A similar pattern of competition for resources seems to underlie the transfer of energy and vitality involved in headhunting, or in most reported instances of cannibalism, or conceptions of witchcraft. The most revealing data I have encountered in this regard are those reported by the anthropologists Laura and Paul Bohannan for the Tiv of north-central Nigeria.[6]

According to the Bohannans, the Tiv explain why some members of a community prosper more than others through reference to the exceedingly complex principle of *tsav*. Manifestations of *tsav* include charisma, skill or talent, and "capability" in general, and those who have it invariably prosper in all their undertakings.

> Above all, *tsav* is mystically dangerous . . . and this aspect is undoubtedly the most vivid one. *Tsav* is witchcraft substance, though possession of *tsav* does not necessarily indicate a witch . . . *Tsav* renders both good and evil effective. That *tsav* will be used for evil purposes—at least sometimes—is confirmed by Tiv beliefs in human nature and human relationships. In itself, *tsav* merely endows a man with great potentialities; but it is the man himself who directs and controls the potentialities. In Tiv belief any sane man chooses to benefit "his own"; a good man extends the connotation of "his own" through a wide range of kinsmen. Nevertheless every benefit to "his own" is matched by someone's loss and even "his own" are never sure that sometime it might not be theirs. A man of probity may never have taken anything from his kith and kin. Yet a man of ability has more wealth than his neighbors and more influence than his peers. One cannot make something out of nothing. . . .

The ramifications of these principles of Tiv belief are amplified and reinforced in an earlier passage from the same section:

> That aspect of personality which enables a man to dominate a situation, to turn events the way he wishes them to go, to command obedience and attract loyalty—be it through charm, persuasion, bullying or whatever means—is evidence of *tsav*. *Tsav* then gives power over people, and in a furiously egalitarian society like that of the Tiv, such power sets a man apart; it is distrusted, for Tiv believe firmly that no one can rise above his fellows except at their expense. Furthermore, *tsav* in this sense of power can be kept at bay only by greater *tsav*. Thus all old people, by definition, have *tsav*; if they did not, they would have succumbed to the *tsav* of someone else at an earlier age.

The gerontocratic organization of most African societies is well known. As is so clearly stated for the Tiv, the factor of longevity, the demonstrated survival-capability of the elders, is the main source of their social leverage within the community. It elicits the deference of family members or other dependents or adherents, conferring an elevated status often acknowledged and institutional-ized in the form of special political, religious, and social prerogatives. In the context of the redistributive economies which seem to predominate in traditional Africa, such prerogatives usually entail some measure of custodianship of the resources of the group, together with control of access to opportunities for individual advancement. All forms of wealth take on significance in terms of the networks of social relationships they may be used to forge.

For example, the priestly offices or high positions filled by elders in cults, "secret societies," and other associations usually entitle them to receive regular donations of various sorts, such as initiation dues or sacrificial offerings, which they consume or appropriate as a matter of course. Such sinecures amount to a kind of social security for elders who no longer hunt or farm, sanctioned by their control of access to the systems, procedures, and objects through which the deities, ancestors, and other spirit—and power—principles recognized by the group may be contacted. From the client's perspective, the premise seems to be that nothing significant ever comes free or even cheap, and that a desired improvement in one's circumstances will probably be proportionate to one's investment.

The anthropologist Daniel Biebuyck has described an instance of the operation of these principles in his report on the Bwami association of the Lega of eastern Zaire.[7] According to Biebuyck, the initiation process at each level of Bwami culminates in the revelation and explanation of examples of a wide range of natural and manufactured objects. Among many others, such objects may include carved ivory or wooden masks or figurative sculptures representing a variety of subjects, pangolin scales, warthog tusks, or the skulls of several types of monkeys or other small creatures. They serve simultaneously as didactic devices and as emblems of accomplishment, exemplifying through associated proverbs and aphorisms the Bwami ideals of intelligence, judgment, composure, moral virtue, and social responsibility. Access to progressively higher dimensions of knowledge—and the status such accomplishment carries within Lega society—depends upon the extent to which a member is judged to approach these expectations, along with his ability to furnish the increasingly heavy "dues" required for advancement. These dual requirements may seem mutually incon-gruous until it is realized that the novice is *not* expected to provide the necessary goods entirely on his own; rather, his ability to draw upon the network of social relationships he will have previously established to assemble the required dona-tions is itself a test of his credentials for advancement. A lower level, more general network of familial and other ties serves as a basis for elevation to another, more profound and specialized network—that composed of the Lega moral and philosophical elite. Not least important, such higher status carries the right to share in future initiatory dues and to adopt the distinctive elements of costume and associated attributes which serve simultaneously to reinforce the cultural

ideals of Bwami and to advertise personal accomplishment. Among the many Bwami images mentioned by Biebuyck is a carved wooden human figure with bent back. It is used

> . . . to represent the aphorism, "The Great-Old-One has seen many initiation objects; he goes bent under them," which refers to an old initiate who has helped many people go through the initiation and who, when some of them die, takes over the trusteeship and guardianship of their initiation objects. The display of the object in conjunction with other figurines tells the candidate that he should take good care of old, seemingly insignificant initiates because they are loaded with powerful things.

Among the Lega, then, high social standing is directly evident in the accumulation of important objects. Taking a broader frame of reference, my earlier observation that the appearance of powerful objects tends to reflect, at any given point in time, the record of their accumulating effectiveness and consequentiality is thus seen to be rooted in the real (or symbolic) aspect of powerful human beings. Complexes of regalia associated with important positions in African communities almost always incorporate POWER elements of some sort; in terms of visibility, however, materials described earlier as primarily oriented toward DISPLAY considerations are usually more prominent. Connotations of wealth and cosmopolitan sophistication ascribed to DISPLAY materials may thus plausibly be seen as references to accumulated POWER; rather than embodying trivial "dazzle" or shallow splendor, DISPLAY materials may be said to communicate information about *results* in contexts where POWER materials refer to *causes*. Finally, this special significance of DISPLAY materials is not usually confined to "self-design" complexes for high-status individuals; rather, such usages typically cut across social strata as declarations of individual and collective identity and as age-, sex-, role-, and status-markers within the group. On another level, arts of personal adornment serve to meter states of psychic vitality for the individual, projecting an external aspect which provides insights into internal realities. By extension, DISPLAY materials attached to objects thus enhance the status and prestige of their owners, custodians, or sponsoring groups. Moreover, the *ways* in which DISPLAY materials and techniques are used in African accumulative sculpture seem directly to parallel the ways in which comparable (or the same) materials and techniques are used in personal adornment. One of the compositional principles involved in both modes—that of profusion—has been touched upon earlier. Other shared characteristics may be elucidated through a brief discussion of the design implications of features as basic as the dark pigmentation and distinctive hair texture of African peoples.

Skin decoration among non-African peoples most commonly takes the form of tattoo—the injection of pigment to form designs in which line and/or color is emphasized; prominent scars are usually considered unattractive. In contrast, a wide range of types of what might be described as skin sculpture is known from Africa, characterized by patterns of relief decoration made up of raised keloids or depressed scars. The distinctive hair texture of most African peoples also lends itself to sculptural development through elaborate plaiting processes, impregna-

tion with various substances, and other techniques; the hair of most Europeans, on the other hand, usually requires complex appliances and chemical treatments for development of sculptural form. In Africa, most traditions of skin and hair sculpture emphasize aggregations of small, discrete units—plaits or keloids, for example—providing a richness of texture and complex detail which is often enhanced through the use of oil or other cosmetics. This tactile quality seems to be paralleled in the massing of large numbers of comparably small DISPLAY elements—beads, cowries, or bits of metal—on pieces of sculpture or people's bodies alike (Figure 1).

We may conclude this section with a final point which relates to the *qualities* of DISPLAY materials. Without question, the importation of large quantities of fluorescent plastic eardrops, cheap metal pendants, and other mass-produced ornaments into Africa has put many traditional craftsmen out of work, a loss which is unfortunate from many points of view. Yet, such goods are presently ubiquitous in Africa, and while the colors, textures, and materials involved might look garish and tawdry on a white skin, they usually "work" magnificently on a black one. This fact seems to have been responsible, indirectly, for great wailings and gnashings of teeth among Western connoisseurs of African art. I am unwilling to agree that present-day preferences among African peoples for intense analine dyes, liberal use of files and graving tools in metalworking, and replacement of traditional finishes for sculpture by enamel paints represents a "breakdown of taste." I suspect that connoisseurs who use such terms are primarily responding to the "subtle richness" and "dignity" of traditional materials—ivory, stone, wood, or patinated metal, for example—on the basis of their own criteria for self-design suitability. A consistent African preference for the most vivid and intense combinations of colors, textures, and patterns attainable, resolved in terms of the wider range of options made available by the conditions of modern life, seems a preferable explanation for present-day choices than does a decline in sensitivity or a "breakdown of taste." As with POWER materials, then DISPLAY materials and the ways in which they are used, far from being naive and random, appear to be rooted in consistent and coherent systems of aesthetic—and ultimately cultural—values.

ASSEMBLAGE AND ACCUMULATION

Some general points of resemblance may be discerned between this analysis and Margaret Trowell's proposal that the art of Africa may be divided into "Spirit-regarding Art," "Man-regarding Art," and "Art of Ritual display."[8] Among other differences, however, her categorizations seem to depend primarily upon stylistic judgments and interpretations of the sorts which are especially prone to ethnocentric distortions. In general, many of the words and concepts customarily used to deal with the phenomena discussed here are similarly compromised, or entail unfortunate associations. For example, the term *magic* figures prominently in the literature; despite attempts to qualify its meaning, *magic* seems to me to convey unavoidable implications of chicanery and triviality. Hence, the term does not appear in this discussion, since I consider that the beliefs and practices being

examined clearly do not partake of these qualities. POWER and DISPLAY have been proposed as core elements of what is intended as a more neutral frame of reference.

DISPLAY materials and techniques, as noted earlier, serve primarily to advertise the prosperity, vitality, and cosmopolitan sophistication of the sponsoring individual or group, representing the visible, tangible resolution of psychic vigor and strength. By virtue of their manifestly public function, masks and elements of costume comprise the majority of objects making up this category. Such objects usually participate in an ensemble which includes prescribed patterns of sound and movement; thus, they are usually difficult to appreciate in a museum context, stationary and stripped of their accouterments. Some DISPLAY configurations are realized almost entirely during the initial fabrication phase; others take shape through the accumulation of elements over time, a mode of development which is typical of POWER sculpture in general.

POWER sculpture is activated through the transfer and concentration of essential qualities in the form of a wide range of attributes derived from a variety of sources. The objective of these procedures is the organization and exploitation of the qualities inherent in such attributes for the benefit of an individual or group. Some of the larger, more awesome types of POWER sculpture are customarily maintained in shrines of limited access, with the intention of protecting the object from contamination (which would impair its capability), and of protecting the community from the effects of uncontrolled exposure to the power principles it embodies. Other POWER sculptures, usually smaller and somewhat less imposing, are the prerogatives of individuals or small groups (such as families), and are more closely bound up with the routine of daily life. They may be stationary—part of a domestic altar ensemble, for example—or portable, meant to be carried about or worn. While both stationary and portable POWER configurations are generally perceived as sharing functional qualities at some level, the relationships involved have been largely obscured by the abundance of terms traditionally applied to them: charm, amulet, talisman, "medicine," and *fetish*, among others.

Until recently, much European literature regarding Africa used *fetish* as an omnibus term to denote all aspects of African religion, including associated sculpture. Leon Kochnitzky was referring to this latter use of the term in the following etymological demolition:

> *Fetish* comes from the Portuguese *feitiço*, a fabricated object, a fake, equivalent to the Latin adjective *factitius*, the French *factice*, the Italian *fittizio*. It became popular after the publication of De Brosse's essay *Du Culte des Dieux Fétiches* (1750). It corresponds to nothing that exists in Africa. In his *Dictionnaire de la Langue Française*, Littré gives the following definition of a fetish: *idole grossiere qu'adorent les Nègres* (a coarse idol adored by the Negroes). Now, we know that an African statuette is not an idol, that it is seldom coarse, and that the Negroes do not adore it.[9]

Authors of some recent publications on African art have shown an unfortunate and regressive willingness to apply the term *fetish* to the body of material

which has here been designated POWER sculpture. Even leaving aside the
psychiatric connotations of *fetish,* singularly unfortunate in the present context,
the peculiar antecedents and associations of the term as sketched by Kochnitzky
must seriously compromise attempts at rehabilitation. (Periodic revivals of the
term *primitive* to refer to the arts of Africa, Oceania, and Native America must
fail for many of the same reasons.)

In contrast to DISPLAY elements, which in one form or another seem to
be represented in most traditions of African sculpture, applications of POWER
principles seem more circumscribed in geographical distribution. Immediately
apparent is the remarkable concentration of POWER configurations in the belt
of rolling grasslands and scrub forest on the southern fringes of the Congo River
Basin, extending from the mouth of the Congo to Lake Tanganyika. In this area,
POWER materials are used in the form of implants, attached capsules, massive
overmodelings (usually of the abdominal region), or additive elements (Figures
3, 4). Certain of these distinctive usages appear to be localized on a subregional
basis: the Lower Congo River Basin to the west, and the area more or less between
the upper reaches of the Sankuru and Lualaba Rivers in the east. More detailed
studies of the distributions of particular conventions may yield insights into
art-historical relationships.

Other concentrations of POWER sculpture are located in the Western
Sudan (particularly in the area where Mali, Upper Volta, and the Ivory Coast
share common borders), and in certain sections of the Guinea Coast, especially
the "Poro" area of Sierra Leone, Liberia, and the western Ivory Coast (Figures 2,
5). The traditions involved tend to exhibit a wide range of additive elements
associated with a thick, overall sacrificial patina. Isolated instances of POWER
traditions are also found elsewhere in West Africa—the "blackened" ancestral
stools and other heavily patinated objects of the Akan-speaking peoples of Ghana,
for example, and certain Nigerian traditions (Figure 6).

The principle of *accumulation* has been proposed here as a distinctively
African artistic convention, one which relates in significant ways to the phenomenon
of assemblage in modern Western art as discussed by Seitz.[10] Since his analysis is
extended to "folk" and "primitive" forms (pp. 72, 83), I conclude with a brief
evaluation of the validity of this proposition, emphasizing points of similarity and
difference between the two bodies of material. Seitz's definition of assemblage (p.
6) as referring to objects which are "assembled rather than painted, drawn, modelled,
or carved," whose "constituent elements are preformed natural or manufactured
objects or fragments not intended as art materials" seems broadly applicable—with
minor reservations—to the African data.

In a number of particular respects, however, important differences are
evident between African and modern Western forms, as in Seitz's emphasis (pp.
10, 38) on the artist's "ironic, perverse, anti-rational, even destructive" orienta-
tions and intentions, or the primacy (pp. 38-39, 83) of the artist's ego and unique
vision in making choices and structuring juxtapositions, or Seitz's charac-
terization (pp. 38, 73-76) of the materials of *assemblage* as predominantly the
detritus of industrialized, intensely urbanized civilization. None of these associa-
tions apply to the African data, which emphasize consensus and consolidation,

and the affirmation and reinforcement of social values and cultural continuity. As noted earlier, DISPLAY configurations may be realized by a single artist in a single period of work, and perhaps conform most closely to the definition of *assemblage* offered by Seitz and quoted above. The majority of POWER sculptures, on the other hand, involve the participation of many hands over a considerable period of time; the evolution of such objects may thus be said to begin rather than end when the basic forms have been defined, and to these the term *accumulative* seems most validly applied. In a fundamental sense, the bulk of the creative energy invested in a work of *accumulative* sculpture, and quite possibly the source of its special fascination, resides precisely in the unique succession of gestures of commitment and involvement each records and embodies.

NOTES

1. William C. Seitz, *The Art of Assemblage*, Garden City, The Museum of Modern Art, 1961.
2. Robert Goldwater, *Bambara Sculpture from the Western Sudan*, New York, The Museum of Primitive Art, 1960, p. 10.
3. Marcel Griaule, *Folk Art of Black Africa*, New York, 1950, pp. 71-75.
4. E.g., William Fagg, "The Study of African Art," in Simon & Phoebe Ottenberg, eds., *Cultures and Societies of Africa*, New York, 1960, pp. 471-72; William Fagg & Margaret Plass, *African Sculpture: An Anthology*, London, 1964, pp. 148-58.
5. Frank Willett, *African Art: An Introduction*, New York, 1971, p. 98.
6. Laura & Paul Bohannan, *The Tiv of Central Nigeria* (Ethnographical Survey of Africa: Western Africa, part VIII), London, 1953; later quotations from pp. 84-85.
7. Daniel Biebuyck, *Lega Culture: Art, Initiation, and Moral Philosophy among a Central African People*, Berkeley, 1973; later quotation from caption, pl. 64.
8. Margaret Trowell, *Classical African Sculpture*, London, 1954.
9. Leon Kochnitzky, *Negro Art in the Belgian Congo*, New York, 1958, p. 2.
10. See footnote 1.

2

An Aesthetic of the Cool

Robert Farris Thompson

The aim of this study is to deepen the understanding of a basic West African/Afro-American metaphor of moral aesthetic accomplishment, the concept *cool*. The primary metaphorical extension of this term in most of these cultures seems to be *control*, having the value of *composure* in the individual context, *social stability* in the context of the group.[1] These concepts are often linked to the sacred usage of water and chalk (and other substances drenched with associations of coolness and cleanliness) as powers which purify men and women by return to freshness, to immaculate concentration of mind, to the artistic shaping of matter and societal happening. Coolness in these senses is therefore the purifying means by which worlds are taken out of contingency and raised to the level of aspiration.

Put another way, coolness has to do with *transcendental balance*, as in Manding divination, where good outcomes are signaled by one kola half up, one down, and this is called "cool." But, before we move to the consideration of detailed instances of the concept in social context, let us review what is known about the linguistic and historical background of the notion.

THE LEXICON OF THE COOL

Language in Europe and in tropical Africa equally reveals, in the term, *cool*, a basic reference to moderation in coldness extended metaphorically to include composure under fire. Thus, in English:[2]

Reprinted in abridged form from *African Arts*, Vol. 7(1):40–43, 64–66, 89, 1973 with permission of the author and publisher.

Cool, composed, collected, unruffled, nonchalant, imperturbable, detached [are] adjectives [which] apply to persons to indicate calmness, especially in time of stress. *Cool* has the widest application. Usually it implies merely a high degree of self-control, though it may also indicate aloofness.

Now compare a West African definition, from the Gola of Liberia:[3]

Ability to be nonchalant at the right moment . . . to reveal no emotion in situations where excitement and sentimentality are acceptable—in other words, to act as though one's mind were in another world. It is particularly admirable to do difficult tasks with an air of ease and silent disdain. Women are admired for a surly detached expression, and somnambulistic movement and attitude during the dance or other performance is considered very attractive.

The telling point is that the "mask" of coolness is worn not only in time of stress but also of pleasure, in fields of expressive performance and the dance. Control, stability, and composure under the African rubric of the cool seem to constitute elements of an all-embracing aesthetic attitude. Struck by the re-occurrence of this vital notion elsewhere in tropical Africa and in the Black Americas I have come to term the attitude "an aesthetic of the cool" in the sense of a deeply and complexly motivated, consciously artistic, interweaving of elements serious and pleasurable, of responsibility and of play.

Manifest within this philosophy of the cool is the belief that the purer, the cooler a person becomes, the more ancestral he becomes. In other words, mastery of self enables a person to transcend time and elude preoccupation. He can concentrate or she can concentrate upon truly important matters of social balance and aesthetic substance, creative matters, full of motion and brilliance. Quite logically, such gifted men and women are, in some West and Central African cultures, compared in their coolness to the strong, moving, pure waters of the river. A number of languages in West and Central Africa provide a further basis for these remarks.

According to these sources, coolness is achieved where one person restores another to serenity ("cools his heart"), where group calms group, or where an entire nation has been set in order ("this land is cool"). The phrase, "this country is cool" (*di konde koto*)[4] is used with the same valence and the same suggestiveness by the descendants of runaway African slaves on the Piki Lio in the interior of Surinam, in northern South America.

Idioms of cool heart and cool territory do not, to my knowledge, communicate in Western languages the same sorts of meanings of composure and social stability unless the phrasing is used by or has been influenced by the presence of black people of African heritage. I think that the African definition of metaphorical or mystical coolness is more complicated, more variously expressed than Western notions of *sang-froid*, cooling off, or even icy determination. It is a special kind of cool. Perhaps the most convenient way of suggesting its specialness and complexity is to allude immediately to further nuances within African usages in addition to valences just discussed of composure, self-control, and social equilibrium. Comparison of the term "cool" in a variety of West, Central, and even

East African languages reveals further nuances of (1) *discretion* (2) *healing* (3) *rebirth* (4) *newness or purity*. Compare Yoruba nuances (raw, green, wet, silent)[5] with Kaonde, from Rhodesia (raw, green, wet, silent).[6] Wetness is an inevitable extension of coolness. But silence is not. "Cool mouth" (*enun tutu*, in Yoruba) or "cool tongue" (*kanua kahoro*,[7] in Kikuyu) reflect the intelligent withholding of speech for the purposes of higher deliberation in the metaphor of the cool. This is not the stony silence of anger. This is the mask of mind itself.

Remarkable pursed-lipped forms of African figural sculpture are sometimes formed in this mirror of discretion. Where the teeth are bared, the instance is exceptional and can take the form of a leader or a spirit or a leader-spirit who shows special power in order to confront negative powers of witchcraft and war. The idea of freshness in the cool intersects with visual art, too, in the sense that traditional artists sometimes (not always) impart a luminous quality of vital firm flesh to the representation of the elders and the ancient gods. Such images thus become ideally strong within their poise, suggesting, within depth of dignity and insight, commanding powers of mind and body.

The blending of muscular force and respectability leads to the appreciation of the fit human body in the cool, a right earned, however, by demonstration of character and right living. I once complimented the elders of Tinto-Mbu in the Banyang portion of the United Republic of Cameroon on the fine appearance of their chief. Whereupon they immediately corrected me: "We say people are not judged by physical beauty but by the quality of their heart and soul; the survival of our chief is a matter of his character, not his looks." However, no matter how ordinary his face, it is important for the chief to dress as beautifully as possible in order to attest his fineness of position in appropriate visual impact. He must consequently prove that he knows and controls the forces of beauty as much as the forces of polity and social pressure. Beauty, the full embodiment of manly power, or the power of women, in feminine contexts, is mandatory where it is necessary to clarify social relations. It would not make sense, in African terms of the aesthetic of the cool, to strike balances between opposing factions without aesthetic elaboration.

Coolness therefore imparts order not through ascetic subtraction of body from mind, or brightness of cloth from seriousness of endeavor, but, quite the contrary, by means of ecstatic unions of sensuous pleasure and moral responsibility. We are in a sense describing ordinary lives raised to the level of idealized chieftaincy. The harmony of the marriage or the lineage ideally reflects the expected first magnitude harmony imparted by the properly functioning ruler to the province or nation at large. Men and women have the responsibility to meet the special challenge of their lives with the reserve and beauty of mind characteristic of the finest chiefs or kings.

More than the benefit of the doubt is extended to mankind in his natural state by this philosophy. Man starts not from a premise of original sin but from the divine spark of equilibrium in the soul which enters the flesh at birth from the world of the gods. To act in foolish anger or petty selfishness is to depart from this original gift of interiorized nobility and conscience. This means a person has quite literally lost his soul. He has "departed from himself" and is in serious danger. The Gã of southern Ghana even say that a person out of harmony with

his ideal self can only win back his soul by means of extraordinary aesthetic persuasion: wearing brilliant cloth; eating cool, sumptuous food; keeping important company.[8]

If, therefore, in the cool, wild upsurges of animal vitality are tempered by metaphoric calm, such is the elegance of this symbolically phrased reconciliation that humor and ecstasy are not necessarily denied. Nor is physical beauty itself, a force which brings persons together via saturated expressions of sexual attractiveness and deliberately attractive behavior and charm, excluded from this moral vision. Being charming is also being cool, as suggested by the following interlude among black folk in Florida.[9] "I wouldn't let you fix me no breakfast. I get up and fix my own and then, what make it so *cool*, I'd fix *you* some and set it on the back of the cook-stove . . . " This man was flirting. But a whole ponderation lies concealed within his phrasing. He had cited the cool in an African sense, a diagram of continuity. He had promised to assume the role of another person in order to earn her love. He had promised to dissolve a difference which lay between them. The charm of what "made it so cool" in these senses suggests he knew, in Zen-like simplicity, the divine source of the power to heal, love. He had thereby identified the center from which all harmony comes.

This highly cultivated, yet deceptively simple, idiom of social symmetrization clearly seems ancestral. Philip Curtin shows that perhaps a fourth of the total 18th-century slave imports into the United States derived from the area of the Bantu language groups, principally in the region of Angola.[10] Now when we examine a number of Bantu roots (viz. *-talala, -zizira*) combining both the literal and the socially assuaging valences of the African usage of the term, cool, we seem to touch basic roots of black social wisdom. Part of the power of the cool is undoubtedly rooted in just this quality of referral to ancestral custom. The presence of structurally similar idioms of coolness in Central African languages separated by great distances implies their antiquity. As another demonstration of historical depth for the concept we have seen that descendants of 17th- and 18th-century slaves in Surinam use the expression to "cool his heart" (*koto di háti f'en*)[11] as an image of restored social tranquility. The precise idiom is used by Akan, Cross River, and some Bantu peoples. Indeed there are other suggestions of the ancientness of the concept.

THE ANTIQUITY OF THE COOL

Praise names for ancient African kings provide evidence for the presence of this intellectual principle at a time which might otherwise have seemed inaccessible. During the first half of the 15th century a certain leader was crowned king of the famous Nigerian empire, Benin. He took the title *Ewuare*, meaning literally "it is cool."[12] This referred perhaps to a conclusion of a period of disorder. In the same century a Yoruba ruler was crowned with the title, Cool-And-Peaceful-As-The-Native-Herb-Osun (*oba ti o tutu bi osun*) at Ilobi in what is today southern Egbado country.[13] The same title was awarded a 16th-century Ijebu Yoruba king. Undoubtedly a wider currency of the concept in ancient Yoruba ruling circles remains to be established.

Nigeria seems a fountainhead of the concept cool. Art historical evidence supports this. Superb sculptured heads of important personages at Igbo-Ukwu, Ile-Ife (Fig. 1), and Benin (Fig. 2), respectively dated to around the 9th century, around the 11th–15th centuries (for the so-called Lajuwa head illustrated), and the 1500's, suggest abiding interest in facial serenity as the sign, in the company of kings, by which certainty and calm from the past is transferred to the present and, as a phenomenon of mirrored order, from this world to the next. But it is surely more useful to pass from these speculations on origin to the concretely documented instances of the cool concept in certain modern traditional societies in West Africa.

THE CONTEXTS OF THE COOL

I am attempting identification of some main contexts of cool aesthetic happening in certain West African civilizations and their corresponding, historically related, African counterparts. When these strategies of aesthetic assuagement (what we might term the rites of the cool) are compared, point by point, certain elements of conceptual articulation seem clearly mirrored, suggesting, to this writer, the continuity in change of indelible cultural code.

Let us pursue this possibility with transoceanic pairs—Cross River, Lower Niger/Western Cuba; Dahomey/Haiti; Akan, neighbors/Surinam. The basis for

Figure 1
Head from a figure, Ife,
Nigeria, 11th–15th centuries AD.
National Museum, Lagos.

Figure 2
Head of an Oba. Benin, Nigeria.
Bronze. 15th–16th
centuries A.D.
St Louis Art Museum 12.1936.

this pairing is the proof of contact through the Atlantic slave trade.[14] Thus for a brief illustration, slaves from the region of Calabar on the west coast of Africa in southeastern modern Nigeria were brought in considerable numbers to the provinces of Havana and Matanzas in Cuba during the first half of the 19th century. Scraps of Efik and Ejagham, two languages of the Calabar area, are still spoken in these parts of Cuba to this day.

Cross River and Lower Niger Cool/Western Cuba

The civilizations of the Cross River, where the United Republic of Cameroon and the Republic of Nigeria come together, and the Igbo-speaking people farther west in the Niger Delta, both form an interesting province of the cool. There is, for example, a reference to the ceremony known as "cooling the village" (*lopon lawa*) in Daryll Forde's study of a lower Cross River society, the Yakö:[15] "Where questioning had elicited specific acts of hostility, obstruction, or other failures affecting rights and duties between patient and a spouse, relative, or neighbor, the loss of supernatural protection would be implicitly attributed to this and the prescriptions then included an explicit moralizing element. In such cases a 'cooling' rite was also enjoined at one or more shrines."

The offending person therefore restored social equilibrium by ritual gifts of money and sacrifice (material amends) or the performance of entire

ceremonies (behavioral amends). Diviners were crucial in such instances, for they were what might be phrased specialists in cool, whose own initiation had, significantly, combined prolonged staring at the sun with training in the lore of soothing herbs and cooling, sacred water. The concern with herbs (green) and the disk of the sun (orange) immediately suggests a vivid sense of contrast in nature harnessed for a higher order. (Yoruba diviners sometimes wear beads of alternating green and yellow color, symbolizing the mystic complementarity of heat and coolness, chaos and order, in the world of divination.)

Richard N. Henderson has written of coolness in traditional Onitsha Igbo culture. The classic example is homicide. The moment that a murder has been committed the land is said to become "hot" and is believed not to be properly assuaged until warriors from the immediate patrilineage of the victim attack the premises of the murderer's ancestral home, driving off all occupants (who take refuge with their mother's parents), burning or destroying the house, crops, and animals, and, quite symbolically, cutting down all the shade trees so that the land about the house becomes, in actuality, a "fiery surface."[16]

The heating up of the land illustrates how the lineage is caused to share responsibility for the transgression of a single member. The killer, if innocent, may later return with his lineage segment to recover the land. But first the lineage must provide compensatory transfer of one of the members of their own family segment to the family of the victim in order to "cover the abomination and cool the land." The "fiery surface" then cools down to habitable temperature, after the parties involved have bound their lives and reestablished social purity and coolness in reconciliation.

A person in traditional Onitsha society can acquire a sense of coolness through the learning of appropriate ancient lore. Thus a senior daughter of the patrilineage tests every pubescent child's knowledge of basic ancestral customs, to cleanse him of "strangeness" to lineage affairs.[17] Purification by conscious acquisition of ancestral lore relates to the purification of the self that pervades the whole notion of mystic coolness in the West African sense.

Personal purity cannot, however, be inherited. Personal purity is achieved. This is done through ceremonial rites in which the individual communes with his ancestors, becoming, in the process, more ancestral.[18] Other sources of ritual coolness, in the quest for purity, include learning to speak with words which bear evidence of diplomacy and high character, learning the "deep" uses of the fan, to enforce peace on disputing non-titled men by fanning them when they begin to argue, and ideally, to transcend arrogance and revenge in favor of situations in which men may move in whole concert with one another.

The essential Onitsha Igbo image of ritual coolness includes permanent lustre or luminosity, that state which, like the eagle feather, "does not tarnish."[19] People in this society take pains to maintain special neatness and brilliance in their personal appearance, and clay walls are carefully rubbed and polished. Purification of the self also elevates the individual beyond sorrow, close to the divine order of things, if only at the level of performance. Thus a chief confronted with news of death within the lineage indicates his status by absence of facial expression. He appoints others to mourn for him.

There are certain senior women in Onitsha Igbo society who are armed with extraordinary powers to restore coolness. When a person has committed an act which contaminates his compound, the senior priestess of the patrilineage must perform an oath to "quench the fire which makes his presence dangerous." She beats a fowl around the body of the malfeasor, in order that the bird absorb the "heat" of his morally dangerous condition, thus restoring equilibrium and social order.[20]

The quest of the cool in ritual purity reappears among the blacks of Western Cuba who are of Cross River and Igbo extraction. Here, too, a rooster is passed, fluttering and still alive, about the torso of an initiate into the famous all-male, Cross River-derived Abakuá Society (cf. the Abakpa Ejagham of the Calabar area). This act is said to absorb impurity from his body. Another form of mystic coolness in the Afro-Cuban Abakuá Society dramatically emerges during the funeral of a cult elder:[21]

> We arrive at the supreme moment, separat[ing] the soul of the member from the sacred skin of the drum [it is believed the spirit of the departed elder momentarily rests within the skin of a sacred friction drum, *Ekpe*, before leaving this world forever]. Next to the high priest, Isué, stands his helper, Mbakara, who carries a vessel half-filled with water. Isué chants and the soul of the departed member abandons the skin of the drum and travels into the vessel . . . "It is going to seek the water . . . Because water has the power of sustaining, within itself, the spirits of the dead and dominating them. Water attracts the souls of the dead; its coolness clarifies them, lends them tranquility. . . ."
>
> The spirit of the departed brother is [thus] dispatched to the mystic river . . . the priest . . . lights the gunpowder sprinkled over the chalked representation of an arrow leading from a circle drawn around the base of the drum within the secret chamber to a point beyond the door. The gunpowder is ignited. It burns immediately along the length of the drawing, expelling, in this way the soul of the dead man [from the drum to the water]. . . the carrier of the vessel of water then chants: May your soul arrive cool at the sacred river, cool as it once existed in union with our sacred drum.

We shall see shortly that in Dahomey broken pottery at a funeral signifies the shattering of life by death, the anguish of which is eased by pouring soothing liquid on the earth and by speaking beautiful phrases and words. By the same token, it seems to me, the use of gunpowder explosions in the Abakuá funeral in Cuba equals the breaking of the pots as a symbolic means of severing death from life. At the same time the use of cool water in the same ritual confronts, as it were, the heat of the explosion and the glitter of its traveling fire. Clearly, the river of the ancestors is attained in Cuba by means of the most dramatically orchestrated equilibrium.

The sign of the arrow as emblem of spiritual transition almost unquestionably derives from the great graphic traditions of the Cross River. In the latter territory there is a kind of pictographic script (*nsibidi*) of which the more public and secular manifestations have to do with love and social unity and the deeper signs with initiation, death, and punishment. This is, we might say, "cool writing," scripts whose coolness is a function of abiding concern with social purity and

reconciliation. Sultan Njoya of the Cameroon Grasslands was influenced by the signs of this script. At the beginning of this century, when he elaborated a new, syllabic form of writing, largely based on *nsibidi*, the old concerns remained:[22]

> When an oral civilization moves to become literate the first items recorded are the texts felt to be important, just as the first printed book in Europe was the Bible. When Sultan Njoya of the Bamun in the Cameroons invented a script, the first materials written down were the royal chronicle and a code of the customary law and the local pharmacopeia.

What Njoya attempted to make indelible—history, law, and the use of the leaves—combined aspects of leadership with herbalism. We think of the frequent correlation, linking good government with healing, in the concept, cool. Insight into the sorts of custom which bind together individuals and social groups, and which keep them alive and well, also characterizes the corresponding Afro-Cuban script, *anaforuana*, but we will not consider this fascinating continuity here.

Dahomey/Haiti

Comparison of funerals in Dahomey and Haiti elicits strongly related ritual strategies of dealing with the end of life. Death in Dahomey is heralded by metaphor, "fire has fallen heavily upon the family roof, communicating annihilation by heat, and reminiscent of the Igbo concept of the "fiery surface." The funeral follows. Water is sprinkled three times near the corpse on the ground, there is continuous percussion, and finally comes the moment when the man who digs the grave finishes his work.[23]

> Coming out of the grave, the eldest son gives the grave-digger (a small pot) filled with. . . the residue of the fruit of the palm-tree when oil is made . . . the digger takes the (pot), breaks it, and throws it and its contents into it . . . he re-enters the excavation, gathers up the pieces and takes them away. This ceremony . . . is intended to "cool the earth," that is, to cause it to allow the dead to lie peacefully in it.

On the one hand, irrevocable loss has been signalized by smashing pottery. This is widespread as a funeral custom in tropical Africa, and Afro-Americans in coastal Georgia questioned on this point have answered that broken pottery is deposited on their graves to insure that ties between the living and the dead are definitively broken, so that the dead will not return to haunt the house of the living.[24] On the other hand, the pouring of oil metaphorically eases the dead into the realm beyond. The soothing oil possibly also eases the return of the living to their normal concerns. The reestablishment of tranquility is underscored by the pouring of cool lubricant (the oil) at the point of intersection.

There is a partial echo of this rite in the culture of the north of Haiti. The custom of *casser-canari*[25] (smash the earthenware jar) marks the formal end of the funeral. When the jar is reduced to fragments, the vodun priest makes a libation of rum (water equivalent) over the shards and dust. The Dahomean synthesis of smashing and soothing, of making the transition both definitive yet easy, remains.

There is another transoceanic relationship to consider here, one that suggests that great heat is sublimated and controlled in Haitian mystic coolness. This relationship is specially manifest in rites of initiation or rebirth.

In Dahomey and Yorubaland a person sworn into the cult of the thunder-god, patron of warriors and lord of lightning, must prove upon initiation special mastery of the pain of heat. He must dance with a fire burning in a vessel on his head. He must literally balance heat with ease. He must also thrust his hands into a vessel containing boiling gruel without flinching.[26] He thus proves, by tasting heat with nonchalance, that his control is derived from his god, a possession actual and not feigned. This splendidly dramatic test apparently came to Haiti from the Dahomean and Yoruba cults of thunder to become the means of entrance into the entire vodun religion of the black folk of that important Caribbean black republic:[27]

> She smeared her hands with cold oil, took the novice's left hand from beneath the sheet and smeared that, too. Scooping a handful of the now seething mixture, she pressed it into the novice's hand and closed the fingers on it, for four or five seconds . . . This is the central moment of initiation, when the novice is made to grasp heat without flinching—a heat which will sear the flesh only if the (gods) are displeased through some lapse on the novice's part . . .

Thus we come back, at the beginning, as at the end, of life to the purity of self that is an imperative of the cool.

Akan, Neighbors/Surinam

Akan and the Akan-related ritual patterns, from the old Gold Coast, helped shape the aesthetic of the blacks of the interior of Surinam in South America. The link was forged in slavery, when blacks from the Gold Coast, including Akan, Gã, and other peoples were brought to Surinam in the 17th and 18th centuries.

A source for the understanding of the nature of this influence is the study of the making of a shrine for a northern Akan god: a brass bowl is filled with water and sacred ingredients. The particular objects immersed within the water, and the incantations which accompany the ritual, serve as cultural preparation for the reader.[28]

> A spirit may take possession of a man and he may appear to have gone mad . . . it is some spirit which had come upon the man . . . The one upon whom the spirit has come is now bidden to prepare a brass pan, and collect water, leaves, and "medicine" of specific kinds. The possessed one will dance, sometimes two days, with short intervals for rest, to the accompaniment of drums and singing. Quite suddenly he will leap into the air and catch something in both his hands (or he may plunge into the river and emerge holding something he has brought up).
> He will, in either case, hold this thing to his breast, and water will be at once sprinkled upon it to cool it, when it will be thrust into the roots pan and quickly covered up.
> The following ingredients are now prepared: clay from one of the more sacred rivers, like the Tano, and . . . medicinal plants and other objects . . .

any root that crosses a path, a projecting stump in a path over which passers-by would be likely to trip, also roots and stumps from under water, leaves–of a tree called *aya* . . . seen to be quivering on the tree even though no wind is shaking them–the leaves, bark, and roots of . . . the wizard's tree, a nugget of virgin gold . . . (an) . . . aggrey bead, and a long white bead called *gyanie*. The whole of these are pounded and placed in the pan, along the original objects already inside, while (an) incantation . . . is repeated . . .

The incantation establishes the meaning of the substance-enriched water: magic intelligence, to be addressed as a virtual person–"If a man be ill in the night or in the daytime, and we raise you aloft and place you upon the head, and we inquire of you, saying 'Is so-and-so about to die?', let the cause of the misfortune, which you tell him has come, be the real cause and not lies."[29]

Divinatory power, activated by placement upon the head, applies to another Akan custom, whereby men carrying a dead man in a coffin on their heads, can be magically directed by the corpse to halt at the house of the witch responsible for his death. When the shrine of the initiate, therefore, is lifted, like a coffin, to the head of the initiate, then to "speak" through him of sources of disorder, the shrine acquires the aura of a living watchful presence, come from the world of the dead. This again communicates what lies within the water: intelligence. A gloss upon this fundamental concept is provided in incantation, repeated after the initiate has placed the various objects which make up his shrine within the water: "O tree, we call Odum Abena, we are calling upon you . . . that we place in this shrine the thoughts that are in our head."[30]

Water as a metaphor of mind is present in the lore of the Gã of Accra. The Gã traditionally believe that mediation serves right living and that water is its sign. They also maintain that rain establishes balance and communication between heaven and earth, hence water in a vessel is also divine presence in shared moisture. God appears in water. And from this medium carefully kept in vessels, He reveals his messages to the priestess who relays his words to the world at large.[31]

In Surinam, where the custom of detecting witches by the corpse carried on the head exists as a hardy Akanism, we find that beliefs from the old Gold Coast about the connection between the purity of water and the world of the spirits have also taken root:[32]

> In Saramaka when a person is in serious danger or has a sudden fright, his *akaa* ("soul") immediately goes out of him into the river, from which it must later be called or summoned and, after interrogation (divination) about the cause of the problem, ritually reinstalled in the head of the person.

This custom recalls Akan, Gã, and neighboring sources. The Saramaka summoning of the errant soul from the river recalls in particular an aspect of Gã healing ritual in Ghana. Gã traditional healers coax the soul of an ailing person back into his person by means of offering that person an especially cool diet, particularly mushrooms, redolent of shade, coolness, and rain.[33]

Shade can equal coolness in a mystical sense of healing and the assuagement of sorcerous elements of disease and dissension in other African cultures. We have seen how Igbo correlate ritual coolness with the adequate presence of shade

trees.[34] In the Americas, Saramaka bracket coolness and shade under a single term, *koto*.[35] There is probably more to the frequency of umbrellas at the courts of African kings than mere prestige or physical comfort. In Surinam, where the most important of the black chiefs of the Piki Lio sits under an umbrella, shade in the council house distinctly symbolizes the cool of early morning and, by extension, good judgment: "Cool was their image for peace and health and fairness and deliberation and justice. Inside the council house, then, was a light which 'cooled the heart,' for heart and head are synonymous to the Bush Negro when he speaks of emotional states."[36]

There is another aspect of old Gold Coast ritual that has a bearing on custom in interior Surinam. Among the Brong of the northern Akan there is the *apo* festival, lasting eight days, in which ill health caused by harbored hatred is healed by sanctioned expressions of utter frankness. The *apo* rite is a time "when every man and woman, free man and slave, should have freedom to speak out just what was in their head, to tell their neighbors just what they thought of them, and of their actions, and not only their neighbors, but also the king or chief." This was the rationale: "When a man has spoken freely thus, he will feel his *sunsum* (soul or spirit) cool and quieted, and the *sunsum* of the other person against whom he has now openly spoken will be quieted also."[37] This sophisticated grasp of the consequences of repression was not lost in transit from the Gold Coast to Surinam.

Herskovits has recorded one coastal form of the same ceremony, among the blacks of Surinam, but the Saramaka and the Djuka, of the interior have, Price shows, a more abstract version, called *púu fiúfiú* ("remove the poison of the hate"), which seems close to the original African custom:[38]

In Saramaka *fiúfiú* is a state of masked hostility between two people—where people act cordial and friendly but harbor resentment, hurt, or jealousy; it is when people pretend friendship but speak badly of each other in private. The existence of such a state is revealed through divination, when someone, who may be a third party, falls ill.

Clearly, Price adds, this is in part a social mechanism, to keep people in line and prevent bad feelings from building up within a community. Then he says:[39]

Once discovered, *fiúfiú* must be removed by a rite which has many different technical variations, ranging from a simple procedure to expensive complex ritual. In simplest form, a ritual specialist simply takes a calabash of water plus kaolin (*keéti*), prays that the *fiúfiú* leave, has the two protagonists spray with the ritual solution from their mouths, on the idea that "what is caused by mouth can be cleansed or removed by mouth." Some such rites are very complex, with involved symbolism. But all are ceremonies of social purification, or reconciliation.

The striking thing here, I think, is that the spirit or interior spark of divinity within every man, when angered by involvement in hatred or jealousy, can strike down even third parties with illness. Impurity of intent and false cordiality angers the god within. Social purification, bringing matters into the open, is mandatory.

This great concern with the purity of self can be related not only to Akan sources but, of course, Cross Kiver and Lower Niger custom. In the old Gold Coast the mighty Odwira Festival seems to have projected a thirst for purity in strength to the highest level of national concern. The king takes a golden sword, moistens it with sheep blood and water, from the sacred rivers Tano, Abrotia, Akoba, and Apomesu, and says: "I sprinkle you with water in order that your power rise up again." He salutes the mighty Golden Stool with similar incantation: "I sprinkle water upon you, may our power return sharp and fierce."[40]

There is more than a symbolic reconciliation of the living with the dead. This is an aesthetic activation, turning ancient objects of thought into fresh sources of guidance and illumination. It is possible to argue, although this paper is not the place, that such was the importance of the sword and the throne, as emblems of renewed power in the cooling and purifying of the human royal soul in traditional Akan culture, that their embodied modes of characteristic decorative patterning, widely shared among the Akan and their northern and eastern neighbors, were to influence, partially but deeply, the art of Surinam.

In conclusion, the data, as a whole, communicate their own insight, a notion of black cool *as* antiquity, for as Ralph Ellison has put it, "We were older than they, in the sense of what it took to live in the world with others."[41]

NOTES

1. Personal communication, Professor Charles Bird, 3 April 1973.
2. William Morris, ed. *The American Heritage Dictionary* (New York: American Heritage Publishing Co., and Houghton Mifflin, 1969) p. 293.
3. Warren D'Azevedo, "The Artist Archetype in Gola Culture," paper presented at the Conference on the Traditional Artist in African Society, 28-30 May 1965, Tahoe Alumni Center, Lake Tahoe, California: Preprint No. 14, Desert Research Institute, University of Nevada, Reno pp. 31-32.
4. Personal communication, Professor Richard Price, 28 November 1972.
5. Reverend Samuel Crowther, *A Vocabulary of the Yoruba Language* (London: Seeleys, 1852) p. 278.
6. R.E. Broughall Woods, *A Short Introductory Dictionary of the Kaonde Language* (London: The Religious Tract Society, 1924) p. 159: *tarala* v. be cold, wet, green, raw, unripe: be silent, placid, untroubled (as the surface of the water), be serene, cease to pain, be tranquil.
7. T. G. Benson, *Kikuyu-English Dictionary* (Oxford: Clarendon Press, 1964) p. 164.
8. Personal communication, Leith Mullings, 21 October 1972.
9. Zora Neal Hurston, *Mules and Men* (New York: Harper & Row, reprint, 1970) p.90. Italicization of word, cool, mine.
10. Phillip Curtin, *The Atlantic Slave Trade: A Census* (Madison: University of Wisconsin, 1969) p. 144.
11. Price, *op. cit.*
12. Jacob Egharevba, *A Short History of Benin*, Third Edition (Ibadan: Ibadan University Press, 1960) p. 14.
13. A.I. Ogunbiyi, T. O. Adebowale and other petitioners, *Petition from The Ilobi Tribes of Oke-Odan District, Ilaro Division, Abeokuta Province, to His Excellency The Governor-in-Council, Lagos* (Lagos: The Samadu Press, 1931) par. 12. According to this "authorized version," Ilobi was founded by Adekanbi, surnamed Oba-ti-o-tutu, in 1483. This date cannot be substantiated. By 1553, it is also alleged, the third king of

Ilobi was reigning. It would appear that the concept, cool, is at least several centuries old in this district.

14. Curtin, *op. cit.*
15. Daryll Forde, *Yakō Studies* (London: Oxford University Press, 1964) p.232. There is a wealth of data about "cool" in Forde's excellent set of essays.
16. Richard Henderson, *The King in Every Man: Evolutionary Trends in Onitsha Ibo Society and Culture* (New Haven: Yale University Press, 1972) p. 151.
17. *Ibid.* p. 155.
18. *Ibid.* p. 251.
19. *Ibid.* p. 263.
20. *Ibid.* p. 155.
21. Lydia Cabrera, *La Sociedad Secreta Abakuá*, Reprint. (Miami: Ediciones, 1970) pp. 274–76, Translation mine.
22. Jan Vansina, "Once Upon a Time: Oral Traditions as History in Africa," *Daedalus* (Spring 1971) p. 443.
23. Melville J. Herskovits, *Dahomey: An Ancient West African Kingdom*, Vol. 1 (Evanston: Northwestern University Press, reprint, 1967) p. 354 ff.
24. Quoted in Robert Farris Thompson, "African Influence on the Art of the United States," Armstead L. Robinson (ed.) *Black Studies in the University* (New Haven: Yale University Press, 1969) p. 151.
25. Alfred Métraux, *Voodoo in Haiti* (New York: Schocken Books, 1972) pp. 252–55.
26. Pierre Verger, *Notes sur le Culte des Orisa et Vodun* (Dakar: I FAN, Mémoires de l'Institut Français d'Afrique Noire, 1957) p. 305.
27. Francis Huxley, *The Invisibles* (London: Rupert Hart-Davis, 1966) p. 139.
28. Capt. R.S. Rattray, *Ashanti* (Oxford: Clarendon Press, 1923) p. 147.
29. *Ibid.* p. 149.
30. *Ibid.* p. 148.
31. Marion Kilson, *Kpele Lala: Gã Religious Songs and Symbols* (Cambridge: Harvard University Press, 1971) p. 69.
32. Personal communication, Richard Price, 18 September 1972.
33. Personal communication, Leith Mullings, 21 October 1972.
34. Henderson, *op. cit.* p. 151.
35. Personal communication, Richard Price, 28 November 1972.
36. Melville J. and Frances S. Herskovits, *Rebel Destiny: Among the Bush Negroes of Dutch Guiana* (New York: McGraw Hill, 1934) p. 177.
37. Rattray, *Ashanti*, p. 148.
38. Price, *op. cit.*
39. *Ibid.*
40. Rattray, *Religion and Art in Ashanti*, (Oxford: Clarendon Press, 1927) pp. 137–38.
41. Ralph Ellison, *Invisible Man*, 1952 edition, p. 497.

3

Melody, Drone and Decoration

Underlying Structures and Surface Manifestations in Tongan Art and Society

Adrienne L. Kaeppler

The theoretical position taken in this paper is essentially that of ethnoscientific structuralism. Structural relationships among the arts and society are seen in terms of homology, that is, as consistent relationships between various cultural and social manifestations and the underlying structures that they express. The reader may also recognise the influence of techniques and theory used in linguistics, such as transformational grammar, which attempts to present a set of instructions on how to produce the cultural forms in question; and etic/emic distinctions derived from phonology, or, in other words, the Saussurean distinction between acts and system. These techniques, however, are not strictly "linguistic," but rather, are methods that can be productive in the analysis of various cultural phenomena including linguistics, society, and art. Structuralism here is given the requirement that the structure derived is recognized by members of the society as a set of principles with which they help to organize their lives—not necessarily verbalised as such, but derived from ethnographic data in several domains in which the structure consistently repeats itself.

Art is defined in this paper as "cultural forms that result from creative processes which manipulate movement, sound, words, or materials" and aesthetics as "ways of thinking about such forms." In my view,

> if we are to understand (rather than just appreciate) an aesthetic, or even an
> art style, it is essential to grasp the principles on which it is based, as perceived
> by the people of the culture which holds them. This underlying organisation
> is more important for understanding human behavior than an analysis of the

Reprinted from *Art in Society: Studies in Style, Sculpture and Aesthetics*, edited by Michael Greenhalgh and Vincent Megaw, London: Duckworth Press, 1978, pages 261–274 with permission of the author and publisher.

content of the item itself. Only after the principles of organisation have been deduced can we decide that any specific item either conforms to or fails to meet the standards recognised by the society. We want to know what meaning the formal characteristics have to the people being studied and how these regularities in structuring and presenting are expressive of a given group of people. (Kaeppler, 1971a, 176)

Unfortunately there is no established methodology for doing this and each researcher must find for himself what the relevant questions are for the society he studies and must try to delineate what is considered art in that society, what the aesthetic principles are for that society, and through what means an aesthetic experience may be obtained. In this paper I attempt to demonstrate not only how various artistic domains in Tonga partake of an underlying structure, but also how they are related to social organisation. The implication is that the various artistic and social domains are surface manifestations of underlying structures of the society. Further, I propose that the aesthetic experience arises, at least in part, from the realisation or awareness of underlying structure in specific works of art: that is, fundamental principles made manifest so that they can be comprehended.

An analysis of a variety of artistic and social domains in Tonga reveals similar conceptual structures in music, dance, material culture, and social organisation. There are no words in either English or Tongan which can be found to apply to the structural elements of these several domains. Their conceptual similarity, however, can be illustrated by using an analogy derived from Tongan music—i.e., melody or leading part (*fasi*), drone (*laulalo*) and decoration (*teuteu*). As used in this paper, the leading part consists of essential features, the drone defines or outlines the space in which the essential features operate, and the decoration is an elaboration of specific features which are not necessary for its existence or function (Table 1).

Traditional vocal music in Tonga was said to have had six parts: four men's parts and two women's parts. The most important parts, however, were said to be the *fasi* (melody or leading part) and *laulalo* (drone), while the other parts were "decoration" of the *fasi*. Today the traditional polyphony has been largely replaced by a six-part polyphony based on Western harmony and using, for the most part, Western pitch intervals. Of the terms used for the six traditional parts, four are largely obsolete while *fasi* and *laulalo* have been retained. *Laulalo* today refers to the base part, but in singing Tongan songs such as *lakalaka* (rather than church hymns), the base functions mainly as a drone (see Kaeppler, in press, for more detail). In both traditional polyphony and the more recent polyphony evolved from it, all parts are not consistent or even present. The parts usually present are *fasi* and *laulalo* while one or more decorative parts, improvised rather than prescribed, may be sung higher or lower than the *fasi* or may cross it in both directions. Decorative parts are preferred by many Tongans and the *fasi* sometimes disappears entirely, although the Tongans say they can hear it in their heads so that it is always conceptually present. Such part singing today is particularly characteristic of *lakalaka* songs. A total performance of *lakalaka* includes other artistic domains which have a similar conceptual structure.

TABLE 1 Analogies in Tongan art and society

	Vocal music (hiva)	Dance (faiva)	Musical Instruments	Overall Performance	Bark Cloth (ngatu)	Bark Cloth design	Material Culture	Societal Structure	Kin Group (kainga)
Melody/leading part (essential features)	Fasi main conveyor of text	Haka arm movements convey the 'story' by alluding to selected words of text	Melodic instruments used when human voice tabu or irrelevant	Sung poetry (in one to six parts)	Print design process (koka'anga) forms ngatu	Named motif e.g. fata, manulua, mata hihifi, tokelau-feletoa	Items of ceremonial use (koloa) (mats and barkcloth) [Sacred]	Chiefs, 'eiki (Chief of chiefs=Tu'i Tonga) (intermediate class, matapule, ceremonial attendants)	Tamai (father and father's brothers) also to some extent tu'ofefine (sisters) and mehekitanga (father's sisters)
Drone (space definers)	Laulalo holds performance together in rhythm and as a pitch basis to which leading part can refer	Lakalaka (step it out) leg movements keep time, rhythmic dimension	Nafa or tafua beaten with one stick as rhythmic drone. Bamboo stamping tubes played as a drone	Musical instruments	Beat inner bark, process tutu forms (feta'aki)	Straight lines (langanga or fuatanga)	Items of everyday use [Profane]	Commoners, tu'a	Ego and some family members e.g. tokoua (brothers), fa'e tangata (mother's brothers) also fa'e (mother and mother's sisters)
Decoration (elaboration of specific features)	Up to four decorative parts not prescribed	Fakateki head movement not choreographed or prescribed	Second nafa or tafua using two sticks decorates drone rhythm with complex beating (and different tones). Slit bamboo rattles decorated drone from stamping tubes	Dance	Hand decoration process (tohi ngatu)	Decoration of named motif (leuteu)	Items of decorative use (leuteu) (sisi, kahoa, teunga) [Celebrations, e.g. Kātoanga]	Decorative persons to the Tu'i Tonga, i.e. sister—Tu'i Tonga Fefine and sororal niece—Tamaha	Decorative persons 'ilamutu (sister's children), mokopuna'eiki (chiefly grandchildren), also to some extent tu'ofefine (sisters) and mehekitanga (fathers's sisters)

If we apply the concepts of leading part, drone, and decoration to dance, it is easily perceived that their structural analogies are with movements of the arms, legs and head respectively. The most important and essential movements in Tongan dance are *haka*, i.e., movements performed with the hands and arms, and are the medium for conveying the "story" of the text by visual means just as the *fasi* is the main conveyor of the text in the auditory dimension. The performer in Tongan dance is never an actor in the Western sense but a storyteller, who by movements of his arms and hands alludes (often in a nonrealistic manner) to selected words of the text. Movements are not narrative, yet the spectator (who understands the text) uses them to help him understand hidden poetic meanings. Leg movements are used mainly to keep time and add to the rhythmic dimension of the performance. Some dances are performed seated and small movements of the knees or feet keep the rhythmic pulse. The leg movements can be considered the conceptual analogue of the drone. Just as the drone realises audibly a pitch level as the substratum to hold the performance together, both in rhythm and as a basis to which the leading part can refer, the leg movements realise visually the movement substratum which holds the performance together rhythmically and represents a basis to which the *haka* (arm movements) can refer. Further, the *fakateki*, head movement, is added as a decorative element and can be considered the structural analogue of decorative vocal parts. The *fakateki* is not choreographed nor is it prescribed. Rather, it is added by the dancer—not as an essential element in the performance—but from an inner feeling of *māfana* or exhilaration. Thus, just as the decorative vocal parts are not essential (although desirable) to the realisation of the sound, the *fakateki* is not essential to the realisation of the movement. Yet both add *teuteu*, or decoration, to the vocal and visual drone and leading part.

Traditional musical instruments that formerly accompanied dance performances functioned as drone and decoration. The only melodic instruments in Tonga were the nose flute and panpipe. Nose flutes were said to have been played for awakening songs and "lullabies," and possibly functioned as a replacement for the human voice when the voice itself was tabu (for example, to awaken a chief) or irrelevant (for example, when poetic texts were not audible to other humans). Panpipes were said to have been played as a pleasurable pastime activity. Traditional dances, however, made use of wooden slit drums, bamboo stamping tubes, struck slit bamboos and a struck idiophone of bamboos wrapped in a mat. Both slit drum (*nafa*) and mat idiophone (*tafua*) may be played by two people (either on one instrument or two). One player sets the beat with one stick as a rhythmic drone, while the other player, using two sticks, decorates the drone rhythm with complex beating, which, at least in the case of the slit drum, has different tones depending on the part of the drum struck. Some dances, particularly the *me'elaufola*, were accompanied by bamboo stamping tubes of different lengths, "but all of them of the hollow or base sort" (Cook, 1784, i, 249). Although such instruments (now obsolete) would be capable of playing a melody, they were probably played in much the same manner as their counterparts in Fiji are played today, i.e., as drone (single or multiphonic). The stamping tube drone was accompanied by a second idiophone, made of longitudinally split bamboos,

which was also struck and can be said to have decorated the drone with a sound that was, in Cook's words "as acute as those produced by the others were grave" (Cook 1784, i, 250).

It would appear so far that the melody dimension (*fasi* in music and *haka* in dance) is the medium for conveying the most important element of the overall structure, i.e., that part that deals with meaning. The *fasi* melodic line carries the poetic text while the *haka* arm movements allude to selected, but important, words of the text. The lack of melodic instruments in *faiva*, traditional danced poems which tell stories but do not act them out, suggests that the function of musical instruments in these dances was not to convey meaning but to hold a performance together and decorate it.

If we consider the three aspects discussed so far as they occur together, they form a larger combination of leading part, drone, and decoration. The sung poetry—whether it be in one, two, three, or more parts—is basic and can be considered the leading part of the performance, while the musical instruments serving mainly as a rhythmic dimension function as a drone and the dance movements add the decoration.

To move now to the domain of material culture, let us begin with bark cloth which is the most important two-dimensional art form practised in Tonga today. The making of the bark cloth or *ngatu* can be shown to have a three-stage process comparable to drone, leading part, and decoration, but even more important, the design itself incorporates the analogy.

The fabrication of Tongan bark cloth has three main stages. The first stage is the beating of the inner bark of the paper mulberry plant, a process called *tútu*, which forms small pieces called *feta'aki*. The second stage consists of the pasting together of these small pieces and the printing of the design by rubbing dye onto the white cloth which is laid over a stencil, a process called *koka'anga*, which forms a large printed piece called *ngatu*. These two processes, I submit, are comparable to drone and leading part as expressed above. The beating of the *feta'aki* is often done by a woman alone or with help of her daughters, sisters, or other close female relatives. It is considered hard and boring work, and the sound produced is a drone much like the beating of the *nafa*, to which they compare it. Indeed, to announce the lifting of a tabu imposed on a village by the death of a chief, an anvil for beating *feta'aki*, rather than a slit drum, is beaten with a bark cloth beater, a ritual called *tukipotu*.

The second process, *koka'anga*, is done by a group of women who belong to a *kuataha*, a work group formed specifically for *koka'anga*. Here the *kupesi* or design is added to the white cloth while it is made into the proper size of a *ngatu*, i.e., about 4.25 x 23 metres. This is the most important process in the making of bark cloth and, although it is hard work, it is not boring for the women have an enjoyable time while they are working and eat well afterwards (the food being prepared and served by the men of the family of the woman who will own the *ngatu* being made that day). The whole process is comparable to leading part, and singing is often heard during *koka'anga*. The songs, however, are not "work" songs (*tua'a'alo*), a category which does exist in Tonga, but *hiva kakala* (sweet songs).

Only these two processes are necessary for making *ngatu* and the bark cloth can be used at this stage. The third stage is one of decoration and is not essential, but in the Tongan view should be done in order to make the *ngatu* complete. This stage, called *tohi ngatu*, is done by a woman alone or by her close female relatives and consists of painting over the design that has been printed from the stencil with dark brown paint and a brush made of a pandanus key. Depending on the skill (or patience) of the person(s) who does the *tohi ngatu*, the finished product may be precise and beautiful or it may be slipshod (*fepāeki*), but it adds the decorative element without which the *ngatu* is not complete.

More important than the manufacturing process to our interests here are the three parts of the design itself, comparable to drone, leading part and decoration. The three elements which make up the design of a *ngatu* are straight lines, a named design, and a decoration of the named design. There are two ways of making the *ngatu* into a large piece during *koka'anga*. In the usual method the lines run crosswise, having been made from a series of pegs which run down the centre and the long edges of the *papa* (the curved board on which the stencils are held in place) and the designs run across between the crosswise lines. In the more ceremonial bark cloth called *fuatanga* the lines run lengthwise and the finished piece is much more difficult to make. It is these drone lines that separate the two kinds of bark cloth, rather than the design motifs themselves, and form the frame for the arrangement of the motifs. A series of *kupesi* stencils attached to the *papa* include a named design which gives its name to the whole *ngatu* even though it may be only a small part of a whole series of stencils—just as the *fasi* may be only one small part of the six-part polyphony. The rest of the stencils add decoration to this named design. This decoration, or *teuteu*, as it is called in Tongan, is considered the more creative part of the design. Although the *teuteu* is not the essential part of the design, it is necessary to make the design complete. The *teuteu* may vary, but the named motif is standardised.

Consider the design in Fig. 1a in which the named motif *manulua* is decorated with diagonal and straight lines—the latter having equal space to the *manulua* motif. In Fig. 1b the named design is *fata* which is decorated with flowers, stars, and triangles. In the principal stencil itself which runs down the middle and each side one half of the area is *fata*, but in the overall design *fata* is only a small part. Sometimes *manulua* and *fata* are used as the decoration of other named motifs. These traditional designs are universally recognised in Tonga and today are often used as the *teuteu* or decoration of more modern tapa designs local to a village, which in recent times have become more and more realistic. For example, a flying fox might be depicted, indicating that the *ngatu* comes from Kolovai village. Also, the name of the principal motif(s) may be spelled out as part of the *kupesi*.

If we place bark cloth into the more comprehensive domain of material culture it can be considered as part of the leading part, for all objects belong to one of three categories—items of everyday use; items of ceremonial use called *koloa* or valuables, which include mats and bark cloth; and items of decorative use or *teuteu*, which include *sisi* or decorative girdles, *kahoa* or decorative necklaces, *teunga* or decorative costumes, and in former times, feather head-dresses and decorated combs. These

Figure 1 Ceremonial bark cloth. (a) *manulua* motif; (b) *fata* motif.

categories of material culture were (and are) used, respectively, during portions of their lives which might be called profane, or day-to-day living when ordinary objects are used; sacred, such as funerals or other rites of passage where *koloa* are used; and celebrations or *kātoanga* where *teuteu* come into their own. These categories of material culture are not mutually exclusive, but it is predominance of the type of material culture appropriate to the occasion that is important.

Let us move now to the social domain which can be considered the basis of the leading part, drone, and decoration trilogy. The leading part in Tongan society is certainly the chief's. But because of the complex ranking system, other individuals appear and disappear, weaving their way above and below, depending on the activity or situation. In the societal ranking system, chiefs (*'eiki*) are distinguished from commoners (*tu'a*), who would be analogous to the drone and define the space in which the chiefs play their leading part. The chief of chiefs is set apart and known as the *tu'i* (or king). An intermediate class between chiefs and commoners is the *matāpule* who are ceremonial attendants, who trace their origin either to the sky or to a foreign land such as Samoa. Traditionally the Tu'i Tonga, the sacred highest chief who descended from the sky god Tangaloa, was outranked by at least two people—his sister (the Tu'i Tonga Fefine) and his sororal niece (the Tamaha).[1] The Tu'i Tonga Fefine and the Tamaha can be considered a "decoration" of the Tu'i Tonga and such "decorative persons" can be found at all levels of Tongan society.[2] At the level of *kāinga*, or all kinsmen to whom one can bilaterally trace a relationship, sisters outrank brothers. The relationships of ego to members of the generation above depend on whether they are related through the father or mother—those related through the father being higher than ego while those related through the mother being lower than ego. Thus, as sisters outrank brothers and father's side outranks mother's side, the father's sister, *mehikitanga*, has the highest status. The relationships of ego to members of the generation below depend primarily on whether they are related through sisters

or brothers. A man's sister's children have higher social status than ego and also have a special term, *'ilamutu*. Thus, every man is outranked in social status by his sister and sororal offspring, just as the Tu'i Tonga is outranked by the Tu'i Tonga Fefine and Tamaha (Kaeppler, 1971b). These individuals are decorative persons of the *kāinga* and it is they who will be elevated on ceremonial occasions with deference and visual symbols of *teuteu* material culture, i.e. with *sisi*, *kahoa*, and *teunga* (see above). These individuals, however, have little power. Political power especially is the prerogative of the chiefs, while power within the *kāinga* is the prerogative of *tamai* (father and father's brothers).

Chiefs and *tamai*, I submit, are analogous to *fasi* or the leading part. They can be given additional prestige by the elevation of decorative kinsmen, especially during *kātoanga* and other ceremonial occasions. These decorative persons provide a way to demonstrate visually that, through prestigious marriages, the class rank of the decorative individuals may be higher than that of the chief or *tamai* himself, which may bring to him another dimension of prestige besides that inherent in his own birth. This latter dimension is usually manifested two or more generations below ego—for example if a man or his son marries a woman of higher rank, his grandchildren will outrank and "decorate" him. Such grandchildren are designated *mokopuna 'eiki* (chiefly grandchildren) and are acknowledged on the most important ceremonial occasions. During formal kava ceremonies, for example, a large pig is brought into the kava circle and divided, ostensibly to be eaten by the chiefs and *mātapule* in the kava circle, but actually to be ritually taken away from each of the individual participants by a relative of higher rank. Those who take this ritual food are *mokopuna 'eiki*, sororal offspring, or their descendants, i.e., the decorative kinsmen of the chiefs and *mātapule*.

In certain activities and on selected occasions several of these artistic and social domains coincide, producing a product more complex than simply a sum of the parts. For, while each domain has an aesthetic of its own, a convergence of domains presents all the prerequisites for an aesthetic experience. An occasion on which a number of domains coincide is the performance of a formal *lakalaka* at an official *kātoanga*. *Lakalaka* is a Polynesian counterpart of Western "total theatre" and the audience is completely involved in the performance. In a previous article (Kaeppler 1971a) I have analysed some of the aesthetic dimensions of *lakalaka* including craftsmanship in composition, appropriateness, skill and feeling of the performer and the inner state of the spectator. Here, I want to place *lakalaka* into a broader socio-cultural context to illustrate the convergence of several dimensions of leading-part, drone, and decoration.

Let us compare, first of all, the arrangement of *lakalaka* performers (Fig. 2) [p. 44] and the arrangement of the design elements on a large *ngatu* (bark cloth) (Fig. 3) [p. 45]. Performers are arranged in long lines—at least two, but more often three or four—much like the arrangement of motifs on a *ngatu*. The negative space between the rows of performers can be equated with the lines on a *ngatu* which were formed, almost incidently, by the pegs at the mid-line and sides of the *papa* (the pegs are used to hold a mesh of strings that form the background for the *kupesi* stencils and serve as another decorative element of the named motifs). Just as a *ngatu* has a named motif and decorative motifs arranged in rows

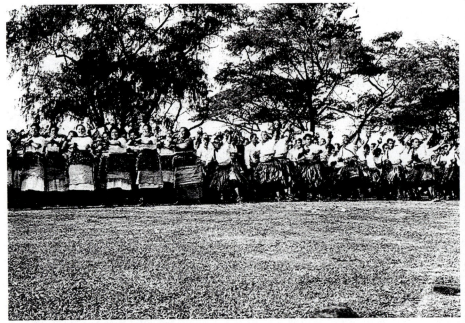

Figure 2 Lakalaka performers.

or long lines, so the *lakalaka* has named positions with other dancers unnamed but decorative. The named positions are held by those of chiefly lines (analogous to leading part) while other dancers are undifferentiated, arranged in long lines (analogous to a drone) and a few are decorative, especially the *mālie taha*, or best dancer. Further, just as a standard length or *ngatu* of four to seven *langanga*, called *fala'osi*, is divided at the centre, each half forming a *maokupu*, so the dancers are divided at the centre, half being male and half female. Just as the named design appears in each *maokupu* half, while the decoration of the two *maokupu* may be different, so the named positions are in each half and male and female dancers perform different sets of movements to decorate simultaneously a single poetic verse—i.e. selected words of the text are alluded to by each half of the performers in two different ways.

In addition, the individuals who hold the named positions, *vāhenga* and *fakapotu*, although they are of the chiefly lines as far as the societal structure is concerned, may also be "decorative individuals" as far as the individual chief of the village presenting the *lakalaka* is concerned. The *vāhenga* middle positions may be held by the chief's daughter for the female side or a high ranking female kinsman, while the male *vāhenga* may be his son, but often is a male of the category *'ilamutu*, e.g. his sister's son. The *fakapotu* end positions are usually held by *mokopuna 'eiki*, who may also represent another chiefly line of the village. Finally, *ta'ofii vāhenga*, i.e. individuals of *mātapule* (ceremonial attendant) lines, stand next to the two *vāhenga* and serve to separate the chiefs from the undifferentiated commoners, just as *mātapule* serve as liaison between chiefs and commoners in

used in rituals & dances

everyday life. A function of the *mālie taha*, best dancer, who stands third from the middle, is to decorate the movements of the chiefs. *Mālie taha* have impeccable arm movements, can be counted on to keep the time properly with their leg movements, and have *māfana* (inwardly exhilarating) head movements, thus decorating the chief in the same way that decorative motifs of a *ngatu* decorate the named design—and in the same overall layout.

Teuteu material culture also comes into its own during such performances. Individuals who decorate the chief of the dancing village (i.e. daughters, *'ilamutu*, and *mokopuna 'eiki*), but form the leading part/motif of the performance, wear *teunga* (decorative costumes), *sisi* (decorative girdles) and *kahoa* (decorative necklaces) which are often specific to individual chiefly lines. Traditionally, and sometimes today, the other performers (male and female) wear a length of bark cloth decorated with motifs that may indicate the village they are a part of, or related to. They, too, wear *sisi* and *kahoa* but usually less ostentatious ones than the *vāhenga* or *fakapotu*.

Thus, visually the performance has leading parts (essential features), drones (space definers) and decorations (elaborations) in several dimensions, while the poetry, sung polyphonically and decorated with movements, incorporates the analogy on yet other levels. A total understanding of all dimensions comes to only a few—usually other artisans who cultivate such knowledge of socio-cultural allusions. But even without complete understanding of all dimensions, the spectator is immersed in the artistic allusions of his society and can understand at least some of the correspondences immediately. At the end of a twenty to thirty

Figure 3 Large bark cloth (*ngatu*).

minute performance the dancing ground is alive with song and movements of the performers and empathetic movements (especially of the head, *fakateki*), applause and shouts of *"mālie faiva"* (bravo) of the spectators. No longer can each domain be analysed separately for there are levels and levels of decoration upon decoration, at least some of which are understood by everyone. Through these complex associations an aesthetic experience can be attained by performer and spectator alike.

It would appear that artistic works in Tonga have conceptual similarities in their underlying structure. Design space and design elements can only be combined in certain ways according to certain rules which are culturally understood by artist, performer and spectator. Areas are nearly always rectangular, divided into square compartments by lengthwise and crosswise lines. Squares are usually divided again by diagonal or straight lines forming triangles, squares and rectangles. Only at the last stage are curved lines added (if they are added at all) and such curves are always in relation to a straight line or a line that has crossed the square or rectangle. This is most apparent in bark cloth designs, but can also be seen in incised clubs, basketry, tattooing, prehistoric pottery, and even in a *lakalaka* dance where the dance space is a long rectangle divided in half (men on one half, women on the other half) and each performer having a sense of a square for himself. For the most part, leg movements are side to side and forward and back within this square. Curved lines come only in the *haka* arm movements giving to the surface structure a graceful curving appearance, especially in the women's movements. Polyphony, too, can be considered rectangular—the drone underscores the design space, while the *fasi* moves above it and decorative parts curve among them. The convergence of rectangles, squares and curves in varied artistic media create works of art and carry with them the possibility of aesthetic combinations and potential aesthetic experiences. I propose that aesthetic experiences, at least in Tonga, are realised when fundamental cultural principles are made specific in works of art (that is, when the deep structure is manifested in a cultural form resulting from creative processes which manipulate movement, sound, words or materials) and are comprehended as such by individuals.

From this analysis I draw several tentative conclusions:

1. Some underlying structural features have revealed themselves in an analysis of the ethnographic data, or if you will, in an analysis of the surface manifestations of various domains of Tongan art and society. These underlying features may be some of the unconscious, or at least unstated, principles by which individuals help to order their lives.
2. What the artisan does during creation may be essentially a series of transformational processes by which he converts the underlying principles or conceptualisations of these principles into a work of art which has potential for aesthetic experiences for those who comprehend (consciously or unconsciously) the underlying structure. I would further venture that it may be because the underlying structure is *not* comprehended by outsiders that they do not react to the surface stimuli of works of art in the same way as members of the society for which they were made.
3. I hesitate to propose rules or a grammar that will transform the underlying structure to generate works of art in Tonga, although Tongans continually demonstrated the processes to me (they seldom verbalised them, however, and never stated them as

rules). Simply stated, they usually began with what I have called the drones, long lines, or space definers, and used these as a reference for placement of the leading part (motif/*fasi*/*haka*/etc.) and in some ways the leading part can be considered as a decoration of the drone. Only when the drone and leading part were satisfactorily arranged were the more creative decorative parts added. Thus, in effect, the leading part decorates the drone and the "decoration" decorates the leading part.

4. How and why a specific arrangement is chosen is preeminently context-sensitive. For example, which direction the lines run in a bark cloth depends on its ultimate use, and which *lakalaka* will be chosen for performance depends on the occasion. This context-sensitivity is often apparent throughout the entire choice and arrangement of the movements, sounds, words, or materials.

5. It appears that the traditional function of the arts in Tonga has been to reflect and reinforce in a positive manner the sociopolitical system based on social status and societal rank. Although this is relatively easy to discern in material culture, other domains can now be seen to partake of the same underlying conceptual structure, in addition to what their surface manifestations tell us, and the more general statement can now be proposed with more credibility.

NOTES

1. Or anyone of the kinship category *'ilamutu* ("man speaking" children of *tuofefine* or "sister").
2. In Samoa a titled unmarried girl of the chief's family, the Taupou, was also considered an ornament of the chief's rank (Mead, 1930, 14).

REFERENCES

Cook, James, (1784), *A voyage to the Pacific Ocean . . . in the years 1776, 1777, 1778, 1779 and 1780,* London.

Kaeppler, A.L. (1971a), "Aesthetics of Tongan Dance," *Ethnomusicology* 15, 175–85.

Kaeppler, A.L. (1971b), "Rank in Tonga," *Ethnology* 10, 174–93.

Kaeppler, A.L., (in press), *Tongan Musical Genres in Ethnoscientific and Ethnohistoric Perspective.*

Mead, M., (1930), "Social Organisation of Manu'a," *Bishop Museum Bulletin,* 76.

4

The Beautiful and the Dangerous
Zuni Ritual and Cosmology as an Aesthetic System

Barbara Tedlock

I

Imagine a small western New Mexican village, its snow-lit streets lined with white Mercedes, quarter-ton pickups and Dodge vans. Villagers wrapped in black blankets and flowered shawls are standing next to visitors in blue velveteen blouses with rows of dime buttons and voluminous satin skirts. Their men are in black Stetson silver-banded hats, pressed jeans, Tony Lama boots and multi-colored Pendleton blankets. Strangers dressed in day-glo orange, pink and green ski jackets, stocking caps, hiking boots and mittens. All crowded together they are looking into newly constructed houses illuminated by bare light bulbs dangling from raw rafters edged with Woolworth's red fabric and flowered blue print calico. Cinderblock and plasterboard white walls are layered with striped serapes, Chimayó blankets, Navajo rugs, flowered fringed embroidered shawls, black silk from Mexico and purple, red and blue rayon from Czechoslovakia. Rows of Hopi cotton dance kilts and rain sashes; Isleta woven red and green belts; Navajo and Zuni silver concha belts and black mantas covered with silver brooches set with carved lapidary, rainbow mosaic, channel inlay, turquoise needlepoint, pink agate, alabaster, black cannel coal and bakelite from old '78s, coral, abalone shell, mother-of-pearl and horned oyster hang from poles suspended from the ceiling. Mule and white-tailed deer trophy-heads wearing squash-blossom, coral and chunk-turquoise necklaces are hammered up around the room over rearing buckskins above Arabian tapestries of Martin Luther King and the Kennedy brothers, The Last Supper, a herd of sheep with a haloed herder, horses, peacocks. [Fig. 1]

Reprinted in abridged form from *Conjunctions* Vol. 6:246–265, 1984 with permission of the author and publisher.

Figure 1 Zuni interior.

Against the far wall, near the corner of the room, stands a rectangular wooden tongue-and-groove slat altar carved and freshly painted with bears, mountain lions, coyotes, rattlesnakes, knife-wings, rainbows, sun, moon, morning and evening stars. On the linoleum floor before the altar stand rows of perfectly kernelled unblemished yellow corn-ears completely hidden in macaw, eagle, duck, bluejay and song-bird feathers. Their butt ends nestled individually into basketry holders enable them to stand upright securely. Each one clothed in beadwork, olivella shell, turquoise-nugget and branch-coral necklaces is a breath-heart of a medicine man or woman. A turquoise-studded sandpainting swells outward before them in great white cumulus scallops with a cornmeal road emerging from the center, trailing off across the length of the room to the front door. This meal road is lined for some distance with painted pottery jars containing mossy spring water, tadpoles, water-skates and baby watersnakes; a crystal ball that snows when nudged; Pima, Papago, Apache, Navajo, Chinese, and Pakistani baskets filled with tinkling all-colored corn kernels; small-handled pottery jars containing strong meal composed of white corn, ground-shell and gems; tiny pottery paint buckets. Various persons, including stuffed red-tailed hawks and golden eagles, inlaid antlers, jet bears and quartz mountain lions with tiny turquoise eyes wearing bead necklaces and arrowheads, are lined up one behind another along the meal-road facing the front door.

To the left of the altar is a white enameled waterbucket, wooden bench and large pottery jar drum with damp tautly-stretched buck-skin drumhead and bent willow-hoop drumstick on top. Three white-tailed deer silhouettes each with a thin red line from mouth to heart, chase one another round-and-round the belly of the jar standing on wooden planks covering the earthen resonating chamber. Directly behind it on the wall hang ten red round gourd rattles. Just to the right a dressed hide of an immense cinnamon bear with a red downy-eagle feather tied

to his forelock is stretched flat, stapled on top of a red Oaxaca blanket in a diagonal flying arc. Turquoise, spotted shell and coral necklaces with a large abalone pendent are draped about his neck, protruding at an angle into the room, thanks to a small wooden shelf under his chin. Just before him yellow-gray fire-making Badger, sporting a coral choker, is staple-gunned in midflight. Badger's white furry breath-road leads from his nose over his head down his back connecting Great Medicine Bear behind him to the Dance Hall of the Gods. [Fig. 2]

II

Suddenly, a man in red silk headband and brown buckskin moccasins steps forward and whacks the eagle-feathered four-directional mobile hanging suspended by a handspun-cotton string directly above the altar. Deep singing, eagle-bone piping, pottery drumming, lightning-quartz and turquoise gourd rattling of the medicine society choir shakes the steel window sashes. Here, and in several other Zuni homes, medicine society choirs begin all-night non-stop performances for the Shalako.

These ten-foot-tall masked persons are each constructed with a single long cottonwood pole in the center held upright by the masker who is surrounded by flexible willow hoops covered with Hopi dance kilts, white embroidered wedding mantas and fox skins with ancient stone axes concealed within their sashes. On top of the pole sits the turquoise helmet mask, outlined by a halo of spotted eagle plumes framed by turquoise-colored buffalo-shaped horns, with a red-dyed eagle breast feather dangling from the left tip and a plain white one from the right. Great black spherical protruding eyes are surrounded by white-paint crescent

Figure 2 Detail of Zuni interior with badger and bear skins.

moons. Tied to his long black bangs are four small yellow macaw breast feathers and just behind the eagle halo a bunch of long red macaw tail-feathers points upward. A handspun-cotton string dotted with fluffy-white eagle-down trails along behind on the full length of a black wig, weighted down by a chunk of iridescent abalone shell. Around his neck thousands of dollars of the finest turquoise and coral necklaces are hanging down below his glossy-black raven-feathered collar. Just above this raven ruff a tubular turquoise foot-long articulated wooden beak, rather more snoutlike with blunt-cut ends and black-and-white Milky Way teeth. [Fig. 3]

These wonderfully strange composite raw people (nonhuman beings) dance up and down the entire length of the room jingling their sleigh bells while blatting out deer calls, snorting and clapping their beaks, then suddenly turning, whirling and chasing small mud-colored clowns. The bodies and cotton masks of these clowns are painted orange-brown with sacred clay from the Zuni Land of the Dead. Ears and genitals stuffed with garden seeds and the dust of human footsteps protrude knoblike from their heads. Inside-out eyes plus doughnut and pouch-shaped mouths express eternal surprise and hunger. Without noses or hair and nude, except for small black raggy kilts and mantas, these Mudheads are the infertile offspring of the incestuous original human union of brother and sister. Each one of these ambiguous persons has a separate personality and gift. Their Father with a miniature rabbit snare dangling from his right ear-lobe brings native squash. The Speaker, who rarely speaks and when he does irreverently, bears yellow corn. Great Warrior Priest, the coward, has blue corn. Bat, who fears the dark and dresses in a woman's manta, holds the red corn. Small Horn thinks he

Figure 3 Shalako dance, Zuni Pueblo, c. 1915.
Photo courtesy Museum of New Mexico, #4904.

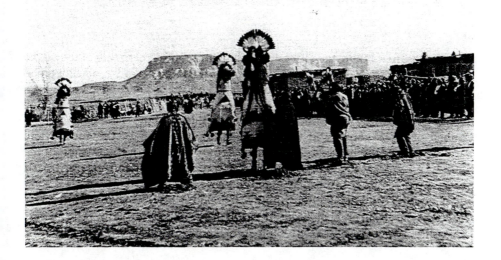

is invisible with his white corn. Small Mouth, who talks constantly, gives sweet corn. Old Buck, frisky and giggly as a young girl, has black corn. Game Keeper who lost two of his brothers to game hunters brings speckled corn. Water Drinker is always thirsty although he carries the water gourd. And finally, Old Youth, the advisor of the team, brings psychic knowledge locked within the veins of parched corn.

During Shalako they play bean-bag toss, hide-and-seek and other childish games, as well as teasing and chasing, and being chased by, the six giant Shalakos. In the early evening hours they make ridiculous speeches and tell embarrassing stories about the owners of the new homes. In a Badger Clan house a Mudhead tells an anecdote about a man of that house, who was commuting with a friend to their jobs in Gallup. One day the man came by early in the morning in his closed car to the house of his friend's lover: "Beep! Beep! Beep! Beep!" But the guy didn't come out. "Beeeeeeep! Beeeeeep!, Beeeeeep!" He still didn't come out. "Beeeeeeeeep! *Tosh kwayi? Tosh kwayi?*" ("Are you coming out? Are you coming out?"). The audience got a belly laugh over the actions of the man in the car, who is accused of several wrongdoings at once. First of all a member of a family hosting a Shalako should not work for wages during the year preceding the celebration, especially not in Gallup. On top of that, he is complicit in his friend's unfaithfulness, knowing in advance that he will find him not at his house but with his lover. And he is still further complicit in his question: *"Tosh kwayi?"* is a word play simultaneously indicating (in reverse order) that the friend is coming out of the house, emerging from his lover's body and reaching orgasm.

Between stints of joking Mudheads prove helpful in refastening costumes onto dancers, cuing performers who have forgotten song lyrics and miming the songs for the audience. Mudheads are simultaneously childish and mature, grandsons and grandfathers of the deified ancestors and nature spirits such as Shalako. Ironically these silly, simple, bumpy clowns, although they are the antithesis of the stately, smooth, complex Shalakos, are considered the most powerful, dangerous and untouchable of all masked gods. [Fig. 4]

III

In the largest new home, the four-and-one-half hour unison chanting of the sacred migration myth by the Council of Gods is underway. The narrative, accompanied by clanking of antelope-scapulae rattles shaken on the first strong stress in each line, recounts every stop at a spring along their original migration route to Zuni Pueblo or Itiwan'a, The Middle Place, The Middle Time. This five member Council of Gods consists of Longhorn (Sayatasha), head of the council and warrior priest of the north and winter; his deputy Huututu, warrior priest of the south and summer; the twin Yamuhakto, firewood carriers and warrior priests of east and west plus Shulaawitsi, the diminutive Fire God.

Longhorn and his deputy Huututu, named for his distinctive call "hu—tu—tu," both wear white embroidered shirts and dance kilts plus yellow, red and blue moccasins. These three hues are the minimal colors necessary for representing Rainbow, Sun Father's helper and daytime pathway of the gods. Tied around

Figure 4　Mudhead ceremony, Zuni Pueblo, 1923.
Photo courtesy Museum of New Mexico. #82315.

both heels is a small red cloth with a black-and-white-checkered porcupine-quillwork band representing Milky Way, Sun Father's other helper and nighttime pathway of the gods. Fawn-skin quivers dangle over their right shoulders and antelope-scapulae rattles hang from their right hands. Their white elk-skin helmet masks are surrounded by Milky Way black-and-white-checkered collars. Many valuable shell and turquoise necklaces hang about their necks, back and front. On top of their masks a reed cigarette filled with native tobacco and red paint is tied to a feathered prayer-wand with tips pointing forward along the warrior's eastward path. Black slit-eyes extend through and connect to their wooden ears.

There are several important differences between Longhorn and Huututu. Most notably, on the right side of Longhorn's mask there is a single gently curved turquoise-colored flat horn hung with black goat's wool: Sun Father's life-path draped with the blessings of big-drop black male rain and the crescent new moon, time of rebirth and initiation into the Dance Hall Rites. The mask's right-sidedness is underscored by the masker's asymmetrical strides, right foot first with left foot following and never advancing further than the right. His younger brother and deputy Huututu has matching bilaterally balanced and perfectly symmetrical mask and stride. Also, during Shalako, Longhorn chants of the northward turning sun of summer while Huututu chants of the southward turning sun of winter.

Their helpers, the twin Yamuhakto, wear Sun Father's turquoise helmet masks with cottonwood sticks on top balanced on each end by multicolored yarn

tassels. Their necks are surrounded by black-and-white-striped Milky Way buck-skin collars stuffed with black goat's wool and their bodies are splattered with ochre from the Land of the Dead, mixed with yellow flower-petals. Like Longhorn and Huututu, they wear Rainbow moccasins of yellow, blue and red with Milky Way quillwork anklets. They carry deer antlers and scapulae rattles in both hands that clatter as they jog in place. Long ago these twins were chosen as the guardians of forest glades within the rugged Zuni Mountains where deer live, deer being frequent bearers of twins.

Sun Father's speaker, the tiny Fire God Shulaawitsi, is impersonated in alternate years by a teenaged boy of the Badger clan (his mother's clan) or else by a child of Badger clan (his father's clan). His entire body and helmet mask are painted by five members of the Badger Clan with the blackness of the dark underground cave womb of origin then spotted with yellow, blue, red and white dots symbolizing glowing embers, corn kernels and the shimmery multicolored stars of Orion, the Pleiades and the Big and Little Dippers. Each man paints all the dots of a single color and each dot that runs is a promise forgotten. Hanging diagonally from his right shoulder down to his left hip is an inverted dappled fawn, filled with wild and domestic seeds. In his right hand he carries a long string of speckled cottontails, drake mallards with emerald heads and violet wing patches and several grey and copper ring-necked pheasants. In his left hand he holds a lit juniper torch. Each year at Shalako he kindles fire by friction to light his torch and then, with his ceremonial father, leads the Council of Gods into the village.

Accompanying the five member Council of Gods come two of the twelve Salimopiya, protectors of the six dance groups. Each one's body and mask is the color of one of the six cardinal and semicardinal directionals: north and northeast (yellow), west and northwest (blue-green), south and southwest (red), east and southeast (white), above or zenith (multicolored) and below or nadir (black). On top of their heads sits a sagebrush stick wound with yellow parrot, iridescent duck and sandhill crane feathers pointing westward behind them toward the Land of the Dead. On the sides of their masks are painted two large composite flowers consisting of petals from mariposa lilies, lupines, cardinal flowers and datura blossoms. This mixture of psychoactive yellow, blue, red and white flower petals embodies the priestly power of travel along Rainbow and Milky Way paths. Each Salimopiya has but one black double-billowed-cloud eye, similar to the masklike markings of the raccoon. Stiff raven ruffs and scores of turquoise and coral necklaces surround their necks. Strings of white and black corn kernels dangle down their backs and war pouches criss-cross their chests. They wear cotton dance kilts embroidered with butterflies and flowers and are barefooted with spruce anklets. They carry yucca whips: the right one, with tips forward, is used to whip and thus to purify people who have suffered from bad dreams or bad luck while the left one, with tips backward, conceals wild and domestic seeds that are being ritually strengthened for spring planting. These gods neither talk nor sing but give the deer call while running madly in place turning and twisting their heads sharply from side-to-side. Their breaths bring winter winds.

IV

Within the new homes in a room adjoining the Dance Hall of the Gods Zuni women serve hordes of Navajo, Hopi, Laguna and Anglo guests great steaming bowls of barbecued, roasted and stewed deer, mutton, turkey and beef with a special beautifully flavored sauce of small green Spanish tomatoes and dried peppery-mint flavored herbs. For a beverage there is a choice of coffee, tea or pop. Breads include Hopi blue-corn piki, Zuni sunflower and wheat, Navajo fry, Pueblo sourdough and Rainbow Bread. There are piles of jalapeño and long green chiles, bowls of pinto and white tepary beans with boiled squashes, pumpkins and potatoes plus apple, peach or pumpkin pie, corn pudding, cattail-flour muffins and Oreo Creme Cookies.

At dawn, men and women stand sprinkling strong jewel-studded cornmeal blessings filled with requests on the heads and shoulders of masked dancers and clowns. They are praying for themselves, their new homes, their village, their visitors and all cooked or daylight (human) and raw (nonhuman) persons on, in and over the earth. Their visitors, who are lured to Zuni from Asia, Europe, New York, Arizona, Los Angeles, Albuquerque, Santa Fe, the Pueblos of Hopi, Acoma, Laguna, Isleta, Santo Domingo and Taos or from neighboring Navajo homesteads by the opening twenty hours of this week-long public celebration are shyly peeping in the windows or brashly pushing into, and kindly but firmly being removed from, sacred spaces. Many are unaware that they also are participants in this great winter ritual. The front threshold, four walls and corners, ceiling and floor of the dance hall have been ritually rooted to withstand this great crowd representative of all cooked or daylight persons on earth. Even witches are expected and prepared for at Shalako time, for long ago at The Beginning the Twin War Gods decided to allow the first witch to join them during their migrations. Although he brought death, he also brought the sacred gift of yellow corn seeds which were needed in order to make Zuni women's flesh strong and valuable. Of course they were well aware that having him in this would not be good, but they also realized that they could not survive alone. All their wild and garden seeds together were not sufficient; yellow corn must complete them. In this way a witch was invited to be among the original Zunis.

The annual Shalako celebration is valuable to the degree that medicine choirs and dancing gods perform with power and accuracy in homes that are beautifully decorated with valuable textiles and jewelry. Ideally each of these new homes is filled to overflowing with admiring Zunis of all ages in new clean clothes while outside, hundreds of visitors wander around cold muddy plazas, briefly entering host homes to warm up, share a conversation and a meal. For on this opening night, not only Zunis and their visiting friends and ancestors partake of the feast, but even total strangers are welcomed into homes and fed by grandmothers, mothers, and daughters who are amused by their many guests, most especially by those from far away places who speak exotic languages. If any of these strangers should have a pleasant face and a kind heart, a mother may present her youngest child to be held, sung and talked to. For Zunis greatly value

multilingualism and hope that at least one of their many children might be a mockingbird, facile and expert at singing and speaking dozens of languages.

V

Zuni love of multilingualism is at the core of their sense of aesthetic value and cultural order. It is described in their language as *tso'ya*, meaning a combination of dynamic, multicolored, chromatic (in the musical sense), varied, new, exciting, clear and beautiful. In nature they apply their term to the rainbow, the last stages of a New Mexico sunset, stars and certain mammals, reptiles, birds, butterflies, flowers and herbs.

The structural iridescence of the rainbow, as Zunis capture it in pigments, consists of red, yellow and turquoise. Each of these colors, when used on masks, moccasins and altars, is carefully painted so as not to blend into the neighboring color. The New Mexico sky is also beautiful when, toward the end of a mackerel sunset, a watery-green tinge suddenly appears among the many-layered reds, yellows, blues and purples. This same color spectrum is also recognized in stars, planets and constellations. The fixed star Aldebaran (Lying Star) and the wanderer Mars (Great Star) are red while the Pleiades (Seeds), Orion's belt (In-A-Row) and the eleven stars of Taurus plus the Hyades (Stick-Game People) contain a scattering of yellow, blue, red and white stars.

Mammals, reptiles, birds and butterflies that are labeled *tso'ya* all share a combination of variegated coloration and dynamic behavior. For example, the white-tailed deer is beautiful because of its white rump hairs, which it can flare at will if alarmed. If the sun is right the flash can be seen for as far away as a mile. Likewise with the pronghorn antelope, whom naturalists have dubbed "the heliographer." In the case of deer, the lifting of the tail and flashing of the white rump is a behavior more frequently engaged in by does than bucks, who use it to guide their fawns through dimly-lit forest groves. The pronghorn antelope is doubly beautiful both for its flashing white rump and for its beautiful curving white neck stripes. Collared lizards have a combination of bluish highlights, light spots, orange and black neck bands on their green bodies, and a fierce nature. They are wary, bite readily and when they give chase dash along suddenly on their hind legs giving them the appearance of tiny dinosaurs.

The luminous long red, turquoise and yellow tail and wing plumage of military and scarlet macaws is highly valued and traded long distances at great expense for feathers for dance masks, wands and costumes. The drake mallard's iridescent emerald-green head flashes when these large ducks spring straight up into the air from the surface of a pond. This dramatic movement displays the mallard's brilliant white collar, white outer tail feathers, and violet wing patches bordered by black-and-white. Purple martin, sacred bird of the zenith, is beautiful because of its overall glossy blue-black coloration with sudden flaring iridescent rainbow colors that are revealed when, dipping and wheeling, rising and falling, they dart in pursuit of insects. These swallows are fierce fighters who easily repel much larger birds, including ravens. The wings of the Rocky Mountain swallowtail butterfly are bordered by a series of yellow spots heavily outlined in black. On

the hind wing, the series is paralleled by black-bordered zones of opalescent blue with the final zone occupied by a large round red shimmery spot. Their erratic flight course with its many instant changes of direction and the rainbowlike play of colors mark this large butterfly as beautiful.

Bouquets of mixed flowers consisting of at least four different species and colors, including white, are always beautiful, while a dozen red roses are never beautiful. Multicolored flower mixtures, composed of individual red, yellow, purple, blue and white petals, used in sand mosaics and body paints, are beautiful. Coriander and various peppery-tasting wild mints that cut through the blur of greasiness, suddenly refreshing the mouth, taste beautiful.

This multisensory aesthetic of the beautiful is displayed over and over again in Zuni culture. The costumes of masked dancers are multitextured and multi-colored, including silk, cotton and woolen textiles, hanks of multicolored yarn, plastic flowers, paper butterflies, bees and birds, popcorn, chili, feathers, evergreen branches, hides and furs of various animals, entire duck heads, cottonwood, willow and sagebrush sticks, silver and turquoise jewelry plus arrowhead and shell-encrusted leather bandoleers. Nearly all dance lines are dominated by one particular type of masked god but may include two or three men who choose to be individualists and dance as other gods. Although the masked dancers may not qualify as beautiful when considered in isolation, the addition of one or more unique masks produces this dynamic aesthetic for the dance line as a whole. The leader usually places such an individualist asymmetri-cally in the line rather than centering him. And if there are several individualist maskers he places them fifth, twelfth and fourteenth, for example, rather than bunching them together or evenly spacing them along the line. [Fig. 5]

Figure 5 Zuni masked dancers.

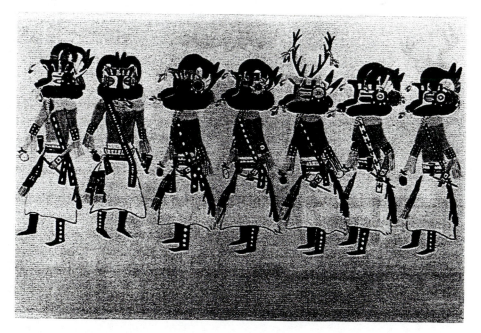

Dynamic asymmetry, another key component in the Zuni multicolored aesthetic of the beautiful, is present in the dress and behavior of Knifewing. This handsome but dangerous mythical bird with obsidian knives as wings flies as high as the eagle, in hearthside tales, then suddenly turns and swoops down to seduce young women. He is vain and wears an opalescent bandoleer of abalone and mother-of-pearl Rainbow with inset overlay of alternating jet-black and shell-white Milky Way. In wall paintings and in lapidary work his legs, wings and tail are represented in split bilateral symmetry while his head is turned sideways. In 1961 when President John F. Kennedy was officially adopted by the Zuni tribe he was presented with a prize-winning Knifewing bolo tie and, true to his amorous nature, named for this mythical bird.

The Zuni love of dynamic asymmetry is present also in mixed-media collages and other heterogeneous constructions such as bulletin boards covered with magazine illustrations of deer, snapshots of family members, postcards and blue, red and white ribbons won at exhibitions and sporting events. Wall assemblages of miniature plaster of Paris deer heads, antlers, peacock feathers, hats, pocket watches, old calendars, guns and plastic crucifixes. Teenaged sheep-herders' outdoor junk-sculptures combining sticks, rusted stoves, oil drums, beer bottles, brass bedposts, horse and cow skulls plus panties. [Figs. 6, 7]

Auditorily *tso'ya* describes newly composed masked-dance songs when two diatonic melodies, stretching to nearly an octave, each with its own tonality, set of tones and tonal relations, are united through a subtly embroidered refrain of chromatic riffs. Further, these melodies and riffs should produce a single complex stepped-diagonal construction that begins low and ends high. A beautiful performance of such a song consists of a loud and clearly enunciated delivery of the

Figure 6 Zuni bulletin board.

two octave range. A beautiful song text consists of simultaneously literal and allegorical levels of meaning. During the summer of 1972 the following beautiful song titled "They Went to the Moon Mother" appeared.

ho-ho-ho he-he-he
ho-ho-ho he-he-he

"Rejoice holy bundles, sacred bundles!
By means of your wise thoughts
there in the east your Moon Mother spoke,
 gave her word
when we went up there with the dragonfly,
 entered upon her road.
Rejoice! You will be granted many blessings
 flowing silt."
The Two Stars are saying this to all the sacred bundles
 here now mmmmmm.
The Lying Star says this to all the sacred bundles
 here now mmmmmm.

Maskers, rainmakers soaking the earth with rain
making lightning, thundering, coming, coming
stretching, stretching, stretching

hey-o hey-e neya, hey-o hey-e neya
awiyo-o heyena, awiyo-o heyeney
awiyo-o heye, awiyo-o
hahaha iihi hiya hiya
ha haha iihihi hiya hiya
hapiime, hapiime

By the Moon Mother's word
from the Middle Place all the way to Dawn lake
 your paths will be complete.
 you will reach old age."
I the masker say this to you the people
 here now mmmmmm.

A Zuni performer-composer explained to us that this song is simultaneously about two stars (Mars as morning star and Aldebaran as Lying Star) and two American astronauts each wearing two stars on his helmet, who may or may not have been lying about their ride to the Moon Mother on the White Man's dragonfly: a rocketship. They report back to the people on earth via their sacred rainmaking bundle, Houston Control, that the moon will bless them with silt, alluvial deposits of the kind thought by scientists to be on the moon and present in the Southwest after every heavy rain. The reiterated "stretching, stretching, stretching" refers to corn plants reaching out for the rain, people reaching old

Figure 7 Zuni outdoor junk sculpture.

age, and the rocketship reaching the moon. This song, a Zuni favorite that summer, was repeated more than twenty times by request of the Mudhead clowns who are the ultimate judges and critics of all masked performances.

The Zuni choral group known as the Olla Maidens, founded fifty years ago in order to perform masked-dance songs (without masks) at intertribal fairs and powwows, display the aesthetic of the beautiful both in their songs and in their traditional clothing. Each woman wears a black manta, white buckskin moccasins and leggings, a red and green sash and a large quantity of expensive turquoise, silver and coral jewelry. However, no two women wear the same blouse, under-skirt or cape. These hand-sewn garments are constructed of polyester-and-cotton fabric in bright highly saturated hues, with contrasting shiny-silk and rayon-ribbon trimmings; tangerine on cobalt, vermilion on emerald and plum on canary. Each woman also balances a polychrome water jar with deer-and-medallion design motifs on her head. These jars are beautiful both because the white-tailed deer is within swallowtail butterfly's house and because the elements on the belly of the jar are divided into vertical areas alternating between two different fields: one of horizontal bands and the other of large flower-petal or drumhead, hoop and flute medallions. Here sequential narrative time is frozen within simultaneous visual space. [Fig. 8]

VI

The principal natural referents of the term *attanni*, meaning powerful, dangerous, untouchable, dark, muffled, indistinct, shaggy, old and plain, are bear

and raven. Both are carrion eaters with an added special love of baby corn. Black bears, who can range in color into blues and cinnamons, have poor vision but acute hearing and a keen sense of smell. Although generally sluggish, bears can on occasion run very fast. Hunting primarily from ambush and by surprise, bears kill their victims by swatting them. Bearskins in the form of fur gloves and hide moccasins are an important part of the paraphernalia of medicine men and women. These powerful Zuni curers are an impressively shamanic group in their open-faced bearskin masks with gaping mouths full of sawteeth and red-leather tongues. Late at night, on the evenings following Shalako, they dance and leap around growling at people, gaze into huge crystals and dramatically perform on-the-spot cures.

Raven shakes his shaggy throat feathers and with his sharp roman beak rips into and eats practically anything. This sable hunter rides the wind circling for hours in a flat eaglelike glide, suddenly somersaulting and dropping from the height of 500 feet to grab a fawn or lamb for his supper. He is aggressive and raucous with a call that ranges from a series of hoarse melancholy croakings to lisps, buzzing noises and gulps. Raven feathers are used in constructing the collars of the Shalakos, Salimopiyas and other masked warriors.

Zunis also capture the aesthetic of the dangerous in the shaggy, dark, matted hair and costumes of murderous cannibalistic ogres; the clay-colored masks and bodies, raggy black mantas and kilts of Mudheads; as well as the crudely naturalistic snakes, toads, frogs, tadpoles, dragonflies, mountain lions, bears and other frightening and ambiguous beings painted on kiva walls and modeled out of clay, stone and bone as hunting fetishes and tied or tacked on to the edges and inside bottoms of fetish bowls. [Fig. 9] The dangerous sound aesthetic at Zuni is found primarily in the repertoire of the thirteen medicine societies. These curative songs have relatively short simple texts lacking altogether in the allegorical dimension of masked-dance songs and they are usually performed in Keresan, a language that only initiated medicine people can understand. The melodies lack chromatism and the sound of rattles blurs the perception of both words and

Figure 8 Zuni jar, circa 1900.

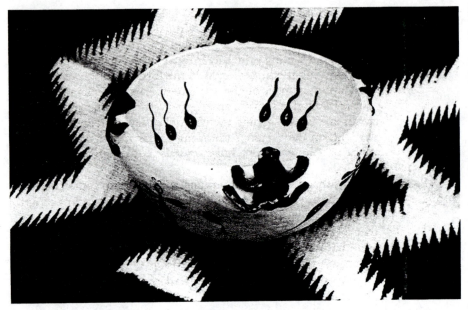

Figure 9 Zuni fetish bowl.

melody. During Shalako and other all-night ceremonies many dangerous short medicine songs are linked together into long strings by a through-composition technique.

This aesthetic of the dangerous has its roots in the hunting magic and bear possession of that ancient shamanic heritage Zunis share with other Native North Americans. Their complex expressions of the beautiful in Shalako wall decoration, ollas, masked-dance songs, masks and costumes belong to another ancient heritage, the Mesoamerican-Puebloan tradition. And it is in the meeting and interplay between these two aesthetics that Zuni Pueblo articulates its own mythopoetic religious core. For long ago, when the earth was still soft, the original twin sons of the Sun Father struck their staves, hung with shells and plumed with yellow, blue-green, red, white, black and dappled feathers on the earth and blew upon them. Suddenly there appeared amid the plumes four seeds of living beings: two speckled green and two dull white. The people were asked to choose and the strongest and most hasty chose the spotted green eggs. Later, when the eggs cracked and chicks issued forth their downy pinfeathers were yellow and blue, red and green. The people were very happy. But when the baby birds molted and attained sexual maturity, assuming their adult plumage, those from the beautiful dappled green eggs were black (ravens), while those from the plain eggs were bright red, yellow, orange and blue (macaws).

A classic Zuni exegetical comment upon this episode is "Oh well, Zunis always do like something pretty." The comic-tragic choice of the raven egg marked the separation of Zunis from other people who went away to the south, where macaws are now found. The beautiful eggs contained multicolored chicks that molted and matured into dangerous black ravens: for Zunis ever since, the

beautiful has had the dangerous somewhere near or even bursting into the midst of it. These aesthetics are interlocked in the predominantly beautiful interior Shalako night decoration, which however also includes dangerous watersnakes in black spring water and bears, beautiful gods in multicolored masks encircled by huge dark raven ruffs, wearing diagonal fawnskin pouches and shell-encrusted bandoleers, dancing to dangerous medicine songs.

PART TWO

THE ARTIST
AS INDIVIDUAL

Janet Catherine Berlo

Michelangelo, Goya, Picasso, O'Keeffe—in modern Western culture we are accustomed to linking the name and personal history of the artist with his or her works of art. Even those with only a passing familiarity with art can come up with the names of artists whose talent and vision have altered the course of art in their cultures. In contrast, few non-specialists can recognize the hand of an individual artist in the tribal world or call to mind the name of a specific weaver, ceramic artist, or sculptor. Why?

Unfortunately, most ethnographic art has been studied without regard to the individual identities of its makers. In many instances, we are lucky to have even a tribal designation or an approximate date for a work of art. Until recently, most tribal art was collected as generic, representative examples of a culture, rather than as examples of the work of an individual. (There have been exceptions to this, and the exceptions increase as we reach the end of the 20th century. See the bibliography at the end of this section.)

The essays in this section examine the work of individual artists of the 19th and 20th centuries in Zaire (central Africa), New Britain (Oceania), and in North America. In "The Buli Master and Other Hands," (page 68) Susan Vogel identifies a gifted 19th century carver of the Luba empire (in what is now Zaire). Because his name is lost to history, she calls this artist "the Buli Master," following the custom in European art history of identifying an artist either by a particularly expressive work or, as in this case, a geographic region. The Buli Master is recognized by his distinctive personal style of carving expressive faces and stooped, care-worn bodies. In this article, Vogel demonstrates the manner in which a careful analysis of such stylistic features allows us to retrieve the individual artist from the anonymity of the past. *This same process is evident in Bill Holm's essay (Will the Real Charles Edensaw Please Stand Up?: The Problem of Attribution in Northwest Coast Indian*

Art, page 86) on Charles Edensaw, a late 19th century Haida carver from Canada's Queen Charlotte Islands. Holm illustrates that an artist's characteristic choices of particular design elements, when used again and again, serve almost as an artistic "signature."

The only contemporary artists discussed in this chapter's essays are the Kilenge carvers Talania and Nake in New Britain (Adrian A. Gerbrands, *Talania and Nake, Master Carver and Apprentice: Two Woodcarvers from the Kilenge*, page 76). Like Charles Edensaw, their work straddles two cultures, for they not only carve objects for use within Kilenge society, but they also do commissions for outsiders, such as the visiting anthropologists who purchase their works for European museums.

In these articles, as well as in other studies conducted over the last century, we find that the definition of a master artist varies from culture to culture. On the Great Plains in the 19th and early 20th centuries, Cheyenne women who were accomplished artists belonged to the Quillworkers Guild. Within this guild, a master artist was defined as a woman who had singlehandedly quilled at least thirty robes, or had ornamented an entire tipi (including tipi cover, lining, and associated furnishings) without help (see Grinnell 1962; Marriott 1956; Powell 1977). Both spiritual power and personal prestige accrued from these accomplishments. Younger artists would turn for guidance and supervision to one of these high-ranking members of the women's artistic society. For Eskimo sculptors of Alaska, the definition of a master artist is akin to that provided by Gerbrands in his essay on the Kilenge in this section: he should be versatile, and excel in all media. Canons of excellence require that an expert Eskimo ivory carver should be able to execute three dimensional carvings as well as engravings. He must be able to fashion traditional objects, as well as those in a foreign idiom—even so far as to successfully complete a miniature engraving of Leonardo da Vinci's "Last Supper" on an ivory plaque (Ray 1961:134).

Haida carver Charles Edensaw, of the northwest coast of North America, fulfills the criteria for a master artist that the Kilenge hold far across the Pacific: like Talania, he was fluent in many media. Bill Holm discusses Edensaw's contributions in woodcarving, painting, metalwork, and stonecarving. Command of a range of media and materials continues to be a criterion for the master artist in Haida society, just as it was for Edensaw a century ago. The contemporary artists Robert Davidson and Bill Reid carve totem poles and other sculpture, design jewelry, and do commissions for individuals and institutions. To this repertory they have added the designing of silkscreen prints, a significant art form in modern northwest coast culture (see Stewart 1979; Shadbolt 1986).

It is interesting to note that all of the master artists discussed by the authors in this section had to cope with massive social changes during their lifetimes, and these social changes were reflected in their art. Susan Vogel suggests that the Buli Master's melancholy figures (who, after all, carry the weight of a seated human upon their heads) reflect the uneasiness felt by the Luba as Europeans increasingly encroached upon their world. Edensaw, Talania, and Nake are all artists witnessing wide-ranging changes in their cultures. While these changes do bring new audiences for their art, and new materials to work with, they also disrupt the social fabric of which their sculpture was an integral part (see also Johnson 1986, Routledge and Jackson 1990, and Berlo 1990).

We study the individual artist in Africa, Oceania, and the Americas for many of the same reasons we study the individual artist within our own traditions. In any culture, it is fascinating to chart how some artists of extraordinary talent abide by the canons of their culture and yet simultaneously proclaim their individuality by pushing at the limits of those canons. Susan Vogel says, "The Buli Master subtly violated the rules of his own artistic tradition by pushing beyond the limits of accepted stylization." In so doing, he created masterpieces of the 19th century Luba style. While only about 20 of his works remain, an understanding of them enriches our understanding of African sculpture in general, and the expressive possibilities of the human form. While a culture's art examined as a whole may express the values of that culture, individual artists can transcend cultural boundaries, touching the very roots of our common humanity.

BIBLIOGRAPHY

Note: In addition to references cited in the text, this bibliography also includes a sampling of works on individual artists.

Bascom, William. 1973. "A Yoruba Master Carver: Duga of Meko," in *The Traditional Artist in African Societies*, edited by Waren L. d'Azevedo. Bloomington: Indiana University Press.

Berlo, Janet Catherine. 1990. "Portraits of Dispossession in Plains Indian and Inuit Graphic Arts," *Art Journal*, vol. 49(2), pp.133-141.

Blodgett, Jean and Marie Bouchard. 1986. *Jessie Oonark: A Retrospective*. Winnipeg: Winnipeg Art Gallery.

Brody, Anne Marie and Vivien Johnson, eds. 1986. *Clifford Possum Tjapaltjarri: Paintings 1973-1986*. Westminster, England: Institute of Contemporary Arts.

Cohodas, Marvin. 1976. "Dat So La Lee's Basketry Design," *American Indian Art*, vol. 1 (4), pp.22-30.

Dunn, Dorothy. 1969. *1877: Plains Indian Sketchbooks of Zo-Tom and Howling Wolf. Flagstaff: Northland Press.

Grinnell, George Bird. 1962. *The Cheyenne Indians*. New York: Cooper Square Publishers.

Johnson, Barbara C. 1986. *Four Dan Sculptors: Continuity and Change*. San Francisco: De Young Museum.

Kaufmann, Christian. 1979. "Art and Artists in the Context of Kwoma Society," in *Exploring the Visual Arts of Oceania*, edited by Sidney M. Meade. Honolulu: University of Hawaii, pp.310-334.

Kernot, Bernie. 1984. "Maori Artists of Time Before," in *Te Maori: Maori Art from New Zealand Collections*, edited by Sidney M. Meade. New York: Abrams, Inc., pp.138-155.

Marriott, Alice. 1956. "The Trade Guild of the Southern Cheyenne Women," *Bulletin of the Oklahoma Anthropological Society*, vol. 4, pp.19-27.

Peterson, Karen Daniels. 1971. *Plains Indian Art from Fort Marion*. Norman: University of Oklahoma Press.

Peterson, Susan. 1977. *The Living Tradition of Maria Martinez*. Tokyo: Kodansha International.

Powell, Peter. 1977. "Beauty for New Life: An Introduction to Cheyenne and Lakota Sacred Art," in *The Native American Heritage*, edited by Evan Maurer. Lincoln: University of Nebraska Press, pp.33-56.

Ray, Dorothy Jean. 1961. *Artists of the Tundra and the Sea*. Seattle: University of Washington Press.

Routledge, Marie and Marion Jackson. 1990. *Pudlo: Thirty Years of Drawing*. Ottawa: National Gallery of Canada.

Shadbolt, Doris. 1986. *Bill Reid*. Seattle: University of Washington Press.

Stewart, Hilary. 1979. *Robert Davidson: Haida Printmaker*. Seattle: University of Washington Press.

Supree, Burton. 1977. *Bear's Heart*. Philadelphia: Lippencott.

Thompson, Robert Farris. 1969. "Abatan: A Master Potter of the Egbado Yoruba," in *Tradition and Creativity in Tribal Art*, edited by Daniel Biebuyck. Berkeley: University of California Press, pp.120-182.

5

The Buli Master, and Other Hands

Susan Mullin Vogel

In the late 1930s, a Belgian professor, Frans Olbrechts, realized that a group of Central African wood sculptures in a very distinctive style was not the product of a regional sub-style, but was the work of a single artist or workshop. At that time he could list ten such pieces, two of which came from the town of Buli, not far from Lake Tanganyika in eastern Zaire.[1] Today, 20 works can be identified by the artist who has become known to us as the Buli Master (see Fig. 1). He was the first anonymous master of traditional African art to be recognized and named. As information on African art accumulates, we are increasingly able to identify bodies of work by particular artists. In addition to the Buli Master, we can also identify neckrests by the Master of the Cascade Hairdo.

A majority of the Buli Master's works are stools with standing or kneeling female caryatid figures, but he also carved two stools supported by couples, two women holding bowls, two standing male ancestor figures, and a few smaller pieces. Like all African artists, he carved each object from a single piece of wood. The figures carved by the Buli Master are extremely similar, though their poses vary somewhat. All have a distinctive long face with arched brows that suggest an expression of suffering, and all have a particularly frail-looking, emaciated body in a stooped posture. The Buli Master's almost mannered personal style comes from the original way he blends expressionism and naturalism to achieve an emotional effect.

Buli, on the Lualaba River in what was the Belgian Congo in Olbrechts's time, was part of the Luba empire which held sway from the 16th to the 19th centuries. It is in an area populated by Luba of the Shankadi sub-group inter-

Reprinted in abridged form from *Art in America*, Vol. 68(5):132–142, 1980 with permission of the author and publisher.

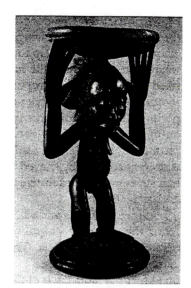

Figure 1
Ceremonial stool by the Buli Master,
Luba-Hemba. Wood, 24" high.
Metropolitan Museum.

mixed with eastern Luba (Kunda) peoples, and is bordered by the related Luba-Hemba. At the confluence of two rivers, Buli was a crossroads that attracted people of various origins, first as a chief's village and later as a colonial administrative town.

In traditional Luba culture, caryatid stools were the exclusive property of rulers such as clan heads, chiefs and kings, who used them for formal receptions. They functioned as symbols of authority, and, because virtuoso carving was expensive, they were also emblems of wealth and prestige. Most of these stools have a single female caryatid, though there are occasional male figures or double caryatids of the same or opposite sexes. The sex of the caryatid figure is said to be politically symbolic, corresponding to the kind of succession (matrilinear or patrilinear) through which the stool passed, and the authority it represented. Most Luba clans are matrilineal.[2]

Bowl figures depict a kneeling or seated woman holding a decorated vessel in her hands. Such objects, part of a chief's regalia, were used in rituals as containers for kaolin, a white clay with important medicinal and symbolic properties. These figures, called *Mboko* by the Luba, have erroneously been interpreted as "mendicant figures" in the West. Hardly beggars, the figures represented with bowls are women of high status, wearing elaborate coiffures and covered with cosmetic scarifications; they are shown in attitudes of respect, not supplication.

Neckrests were used as sleeping pillows by both men and women to protect the ornate hairdos they once wore. Like stools, neckrests are often supported by a standing or kneeling caryatid figure, often female. Many were tour-de-force carvings decorated far beyond the requirements of function to become prestige objects or gifts for presentation to important people.

Neckrests, bowl figures and stools all depict the traditional hairdos that were especially striking in this part of Africa. One explorer in the area called the people

of the district the "headdress people," and an engraving of coiffures appears in the *Last Journals* of Dr. Livingstone, who passed near Buli on his last voyage. These elaborate hairdos took up to 50 hours to produce and could not be done by the wearer. In many cases the hair was worked over a framework of cane and was fixed with oil and clay. Properly cared for, such a coiffure would last two or three months. As elsewhere, styles came in and out of fashion. Within a given area and period, different coiffures marked the different stages in a person's life. For example, unmarried women, married women and women who had just given birth to their first child, could each be identified by their hairdos. Widows and widowers commonly shaved their heads in mourning. It is interesting that most hair styles were not exclusive to the members of one sex, but were worn by women and men alike.

Since coiffures varied from one region to another, they can be helpful in fixing the origin of sculptures. Those seen on most Buli figures are also found on Luba-Hemba objects. The typical Hemba four-lobed coiffure is made by gathering all the hair into four loose bunches—one center top and bottom, and one on either side. Each of these is braided, and the four braids are crossed over and attached. Their tapering forms are reproduced in sculpture as a flat textured cross sometimes adorned with massive copper pins.

In the Luba-Shankadi area, hairdos have more variety, but all seem to include at least one full transverse, fan-shaped sweep of hair. We call those arranged in tiers, one above the other, "cascade" hairdos. Among the Shankadi, another form of permanent body decoration was common: both front incisors were chipped or filed on a diagonal line, creating a triangular opening between the two front teeth.

An important characteristic of Luba-area figure sculpture is the textured decoration, mainly on the abdomen and lower back, that represents cosmetic scarification. This practice was once widespread in Africa, where the most extensive scarification—sometimes completely covering the face and torso—was in the Congo River basin, including the Luba area. Scarification was usually done by a specialist who worked in stages. Most men and women were scarified as adolescents or young adults, sometimes as part of a traditional initiation. Scarification could be used to identify a person as a member of a group (clan, age group, cult), in some cases indicating the level within the group, and was also done as part of traditional immunizations against diseases, poisons and snake venom. The most extensive and ornate scarifications, however, were done purely for esthetic effect. Such patterned scars were beautiful both to the eye and the touch—indeed many were considered erotic. This operation, painful as it was, involved only the skin, and was far less drastic than several kinds of cosmetic surgery common in our culture.

Though virtually all Luba artists are interested in scarification and coiffure, one of them consistently gives such exuberant emphasis to the latter that he has become known to us as the Master of the Cascade Hairdo (see Fig. 2). This artist is the creator of a series of charming neckrests supported by small sculptures; no larger works by his hand are known. He is a miniaturist at heart who puts a great deal of effort into refined workmanship and delicacy of carving. His works can

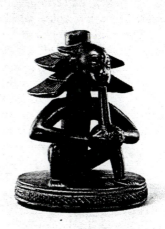

Figure 2
Neckrest by the Master of the Cascade Hairdo
(missing platform). Wood, 5" high.
Metropolitan Museum.

be recognized by a dramatic treatment of the sweeping fan-shaped coiffure for which he is named, by his use of balanced asymmetrical poses, and by his fondness for active, open compositions. Often triangular openings under the arms and legs repeat the diagonal wedges of the hair. His sculptures lack volume; they are all sharp angles and thin linear forms, made even more active by a torsion of the body.

He is constantly experimenting and rarely repeats himself, even within the narrow limits of the neckrest format. His pieces have a playful quality and are often unusually narrative; figures are shown doing something or gesturing in a way seldom seen in African art. He nevertheless always stays within the confines of the Luba neckrest format, which requires a round base with at least part of a vertical central post supporting a curved platform. The Master of the Cascade Hairdo never fails to provide a visual line of support down the center of his compositions.

In their different ways, both the Master of the Cascade Hairdo and the Buli Master subordinate all details to an underlying structure. In the case of the Buli Master, however, this structure is so particular that it constitutes a sort of signature in his works. He almost always places a void at the center bottom of a composition that has all its bulk and movement at the top. He uses slightly unbalanced compositions in a way totally alien to traditional African art, especially to traditional Luba-Hemba art. Where Hemba stools are built on measured rhythms, right angles and vertical lines, Buli stools use diagonals to give activity and a kind of instability to the composition.

The Buli stool in the Metropolitan Museum is a case in point. Unlike other Hemba weight-bearing figures, which have short sturdy legs with a static, square opening between them, this stool has unusually long, well separated legs that form a space at the bottom of the central axis right under the main line of stress.

The entire sculpture looks somewhat top heavy. It grows in volume and complexity as it rises from the simple feet and slender legs to the large detailed head with its heavy, patterned coiffure. The exaggerated hands, pierced and surrounded by active voids, add breadth and vitality to the top of the sculpture.

The Buli Master uses a similar composition for a neckrest which shows a torsion in the body and a skewing of the hair and platform that give the top of the sculpture an unsettling movement. In this tiny object he has introduced four distinct horizontal axes—in the body, the face, the hair, and the platform. The rhythm of this piece also accelerates at the top, where he concentrates all the complexity of the textures and volumes. Again the head is bowed and greatly enlarged, and the hands are rendered to convey emotion.

In stools supported by kneeling caryatids, the Buli Master carves figures that are not firmly planted on a base like other Luba examples, but touch the base only at their knees and toes. This placement creates a void under the legs when seen in profile; seen from the front, his kneeling women have a triangular space between their thin thighs. In a bowl-bearing figure he has gone so far as to create a sculpture so literally unbalanced that it will not stand unaided, though the well finished buttocks and roughly cut-off feet make it clear that this figure was never meant to sit. It is probably no accident that the figure will stand properly if the bowl is filled with a weight sufficient to counter-balance the trunk of the body.

The "long faced" style that distinguishes sculptures by the Buli Master is highly original. In addition to the high forehead with mournfully raised brows, the elongated face with prominent cheekbones and somewhat aquiline nose and, typically, a small-breasted body with emaciated limbs, his works share other characteristic details. Buli figures consistently depict the Hemba four-lobed hairdo, as well as particular ornamental scars on the stomach and lower back. Very idiosyncratic, also, is the treatment of the hands as enlarged, with splayed fingers that are rod-like and blunt ended, usually with expressionistic effect.

An eye attuned to Western art may be misled by African dynamism to see all African art as equally expressionistic. Traditional African art (mainly religious or political in inspiration) is, in fact, a classical art in its insistence upon order and conformity to tradition, and in its low regard for radical innovations and personal expression. The degree and manner of conceptualization are pre-established for the traditional artist by the sculptural tradition of his people. He would be criticized for exaggerating or distorting it. African art's concern with controlled emotion, balance and proportion, and its general restraint, make it fundamentally classical. African art is not particularly involved in the depiction of passions, and rarely deals with motion, gesture or interactions between people. In fact, it almost never depicts real individuals, and it is almost never narrative. If European Expressionism is "the search for expressiveness of style by means of exaggerations and distortions of line and color,"[3] then it is ironic that African art should ever have been an inspiration to that historical tendency. Because it does not seek to duplicate nature, African art does not distort the forms of nature. *On its own terms*, African art never exaggerates.

The Buli Master subtly violated the rules of his own artistic tradition by pushing beyond the limits of accepted stylization. The hands of his stool figures

are just a little too big and too yearningly curved for Hemba art. They draw attention to themselves in a way that betrays a lack of the required composure and restraint. "Coolness" is a fundamental principle of African esthetics, and the hands carved by the Buli Master are not "cool." (See Thompson, Part One.)

On the affective level, the Buli Master often departs from tradition. His faces and bodies are strikingly individual and almost seem to depict someone in particular, where other Luba figures are generalized and idealized.[4] His women are neither ageless nor expressionless; rather, their thin legs and dry fallen breasts suggest that they are not young. Their stooped posture and a sense of the burden they carry are typical of Buli objects, while other African caryatids seem unconcerned with the bearing of weight. Buli sculptures have a personal, emotional quality so common in the art of the West, and so very uncommon in African art, that its great originality may escape us. The artist who carved these women, with their bowed heads, downturned lips and arching brows, broke radically with his forebears. Where other Luba figures are impassive, his often seem mournful—too dignified to be sentimental, but closer to that sort of pathos than other traditional African art.

The Buli Master blends expressionism and naturalism in a personal way that is rare in traditional African art. The unbalanced bowl figure mentioned previously, for example, shows a crouching woman with an emaciated torso. Her breasts fall forward naturalistically, suggesting gravity and the softness of flesh, but her hands are exaggerated and grasp the bowl with large, rod-like fingers. Her stooped posture is unusual in Luba treatments of this theme; most bowl figures sit or kneel firmly on the ground. The Buli Master has shortened the lower legs of this figure in order to tighten the composition and to emphasize the unbroken bend of the bony back. Her deep crouch, and the way her head is bowed over the bowl inject an emotional overtone lacking in other Luba examples.

Despite his fame, surprisingly little serious scholarship has been devoted to the Buli Master, and though his works are frequently published, a definitive corpus remains to be established. William Fagg has suggested that the Buli Master created only some of the works in the Buli style, the remainder having been carved by lesser followers or members of a workshop. Olbrechts himself left this possibility open in his first description of the Buli style, though he later became convinced that all the pieces he knew were by the same hand. Fagg, who is one of the small number of scholars to have written on the Buli Master, originally felt that there was a single master.[5] Later he argued that those Buli style works carved in soft wood were by the Master, and that others—weaker sculptures in hard wood—could be assigned to perhaps two lesser hands.[6]

If analogy elsewhere in Africa holds true for the Luba area and the Buli Master, then the type of wood cannot be taken as an indication of authorship. In many places, it is not the sculptor who determines the kind of wood to be used for a particular piece; the choice may be made by the patron or can be based on advice from a diviner. Artists also received indications from spirits, often in dreams, of which kind of wood, or sometimes which specific tree, was most propitious to cut. A particular soft wood used by Luba sculptors is called "good fortune" in Luba. There are differences of quality among the works assigned to

the Buli Master, but such differences can occur among the works of any artist. The 20 sculptures known so far (more will probably appear) are perfectly believable as the output of one man.

If, as I am convinced, there was only one Buli Master, a recent discovery gives some clues to who he may have been. A standing male ancestor figure in Buli style recently came to light in a Hemba village about 100 kilometers north of Buli. Oral traditions about this figure record the name of its maker as Ngongo ya Chintu, an artist from Kateba village in the same region. The distance between Kateba and Buli is not surprising, for exceptionally prized works of art could become scattered over a wide area. Kings and chiefs (and we know one resided at Buli) brought to their courts renowned sculptors from far away. In other cases, people traveled considerable distances to obtain the works of great sculptors. The patron often went to the artist's home village and remained there all during the execution of the work—sometimes a period of a couple of months. The sketchy evidence that we have suggests that Ngongo ya Chintu was a famous artist, for his name and his extraordinary skill are still recalled by the owners of this recently recorded male ancestor figure.

The unusual blending of elements from Hemba, Shankadi and Eastern Luba art in the Buli Master's work may reflect the preferences of different patrons or the influences he felt as he traveled through Luba-Shankadi, Eastern Luba, and Luba-Hemba ethnic areas. Luba-Shankadi art tends to be linear and decorative with an important use of voids. Figures often have relatively small heads, and the distinctive fan-shaped or cascade hairdo. Unlike most African sculpture, Shankadi pieces are often not blackened, but are left the natural color of the wood. The Buli Master shows Shankadi influence in the frequently light color of his sculptures and in the importance he accords to voids. Distinct from the Shankadi, Eastern Luba artists use extensive, textured scarifications and full volumes in their works; a large head with a high domed forehead is typical. The attenuated limbs of Eastern Luba figures are not found in Buli sculptures, but the disproportionately large head is.

Of the three styles, that of the Luba-Hemba is the most naturalistic, characterized by supple forms and a lyrical quality. Where Shankadi and Eastern Luba caryatids sit on their heels, Hemba caryatids usually stand on sturdy legs and undetailed feet with enlarged hands turned forward; they wear the distinctive four-lobed hairdo. The Buli Master plays with the exaggeration of the hands used by Hemba sculptors, but his naturalism is more inventive than theirs and is modified by his expressionistic tendencies.

The oral traditions regarding Ngongo ya Chintu have led the scholar François Neyt to date his work about 1830 on the basis of the generations of owners the male ancestor figure is known to have had. The condition of the Buli Master sculptures themselves, however, would lead one to believe that he lived much later, at the end of the 19th century. Most of his works known to scholars were brought to Europe by explorers, military men, colonial officials, traders, and missionaries in the closing years of the 19th century and the first decade of the 20th. Though a number of these sculptures are carved in extremely soft wood, most show only superficial damage and little sign of use. These fresh-looking

pieces appear to have been carved not long before they were taken to Europe, and one concludes that the others must also have been made about the same time—that is, probably not long before 1890. (The stool in the Metropolitan Museum collection is one of the few Buli objects with insect damage and the typical patina produced by use. It probably remained in Africa longer than the others, perhaps until the 1920s.)

The innovative style of these works and their pessimistic vision would also tend, more indirectly, to confirm a late 19th-century (rather than an early 19th-century) date for the Buli Master. Pre-colonial African art expresses a belief in an existence beyond time and death. Luba figures do not represent real living people, but some more immutable vision of humanity that withstands the death of the individual and indeed gives no intimation of the frailty of old age and infirmity. By contrast, the Buli Master's thin, stooped caryatids suggest age and mortality. One might see in his oeuvre a sensitive individual's reaction to the changes he saw about him, and a reflection of the doubts his confident society began to feel as it came increasingly into contact with the vastly alien, and infinitely more confident, Europe of the Victorian era. His works may express an early intimation of the profound disruptions that were about to be wrought on traditional Luba society and its rulers. Luba caryatids are firmly planted and effortlessly hold up the seat of the stool, but the Buli Master's have a precarious, unbalanced quality. The unstable images he created—especially in stools which were the support of kings—may express a premonition that the forces newly unleashed in his world would soon unseat those kings.

NOTES

1. Frans Olbrechts, *Les Arts Plastiques du Congo Belge*, Brussels, 1959.
2. François Neyt, "Une sculpture de Buli inédite" in *Bulletin de la Société Royale Belge d'Anthropologie et de Préhistoire*, 1960, pp. 104–119.
3. Peter and Linda Murray, *Dictionary of Art and Artists*, Praeger, New York and Washington, 1965.
4. Though this issue is still debated, African artists do not seem to have used models in any regular way. They did sometimes make portraits, but mainly as generalized images. They rarely concerned themselves with what we would consider an accurate duplication of features.
5. William Fagg, "A Master Sculptor of the Eastern Congo," *Man*, April 1948, pp. 37-38.
6. William Fagg, *Tribes and Forms in African Art*, London, 1966, p. 103.

6

Talania and Nake, Master Carver and Apprentice
Two Woodcarvers from the Kilenge (Western New Britain)

Adrian A. Gerbrands

The Kilenge live in the most western part of New Britain in an area roughly demarcated to the east by a line from Borgen Bay in the north to the Itne River in the south and delimited to the west by the coastline. The Kilenge number some 3,500. Of these about a thousand live on the northwest tip of New Britain in a group of five major villages situated close to each other on the beach and known collectively also as Kilenge. The five seaside villages constituting Kilenge are from west to east: Potne, Kurvok, Ongaia, Ulimainge and Waremo. The other Kilenge live in some 35 villages dispersed over the area with an average of 70 to 80 souls per village. In spite of the fact that the patrol post and the government hospital are 30 km. away in Borgen Bay, Kilenge-on-the-Beach in many respects is the real capital of the area. Ten kilometres away at Cape Gloucester is an airstrip dating from the last war. There is an old bush road in part built during the war by the Japanese and today practicable for four-wheel drive vehicles. This road runs from the patrol post via the airstrip to Kilenge and beyond to Sag-sag (for a map of the Kilenge area see Dark, 1974, 8). The Anglicans have an old mission in Sag-sag, and the Catholic mission established itself in the thirties in Kilenge-on-the-Beach.

The Kilenge maintain trade relations with what could be called the Huon Gulf and West New Britain culture area. This area seems to embrace the Bali and Vitu Islands in the east, Kombei, Kaliai, Bariai, Kilenge, the Siassi Islands, the Tami Islands and some coastal cultures of the Huon peninsula (Dark, 1973, 51; Harding, 1967, map on p. 262). However, as the Kilenge are primarily agriculturists and fishermen, their role in the trading system is more a passive

Reprinted in abridged form from *Art in Society: Studies in Style, Sculpture and Aesthetics*, edited by Michael Greenhalgh and Vincent Megaw, London: Duckworth Press, 1978, pages 193-205 with permission of the publisher.

one in contrast to the role played formerly by the people from the Tami Islands and in modern times by those from the Siassi Islands. These are the real seafarers and the aggressive overseas traders. Harding has analysed in detail the trading system. According to him the products of trade include several foodstuffs, craft goods like earthenware pots, wooden bowls, hand drums, bows and arrows, and valuables like boars' tusks, dogs' teeth, turtle-shell bracelets and shell money (Harding, 1967, 27-60; 131-32). However, there also existed, and up to a degree even exists today, a dispersion of an "artistic tradition" closely linked with and probably even superimposed on the trading system as described by Harding. The centre from which this "artistic tradition" emanated seems to have been the Tami Islands. Even today older people in Kilenge still refer respectfully to Tami as the place where their fathers and grandfathers went to acquire a really "good" drum, or a mask, or a taro ladle. Analysis of museum collections made around the turn of the century and afterwards demonstrates that many of the art forms found today in Kilenge have or have had their counterparts in the Tami region, the only clear exception probably being the neckrests which abound in Tami, but which are completely absent in Kilenge.

We have insufficient information to state with certainty that aside from the actual art *forms* their original meaning and function, in other words, their *content*, was borrowed and assimilated. This seems not unlikely, however, since Harding has explained that an important, if not essential aspect of the trading system in the Huon Gulf-West New Britain culture area was the kinship ties with which the important traders were linked with their trading partners across the whole area (Harding, 1967, 158-64). Trading parties often had to stay for relatively long periods *en route* waiting for the turning of the trade winds to bring them back to their ports of origin. During such a forced detention the traders very likely not only had a chance to establish or to reinforce kinship ties, but also had ample time to familiarise themselves with the art forms and their meaning and function.

One of the aspects of the cultural context of the arts thus diffused seems to have been the concept of the *namos tame*, the master artist. In 1967, when Philip Dark and I were doing fieldwork among the Kilenge, some of the older Big Men still remembered the names of a few of the *namos tame* from the Siassi Islands. Dark has stated that the concept of *namos* refers to something beautiful, something good or aesthetically pleasing, and hence in a way comparable with the Western concept of "art" (Dark, 1974, 19). However, there is probably more to the Kilenge idea of *namos*. Dark refers to the aspect of "skill" needed to perform a good work of art in the eyes of the Kilenge: "the application of skill and knowledge according to aesthetic canons, resulting in the production of works of art" (Dark, 1974,19). At Kilenge in 1970, for example, I filmed in great detail the performance with *nausang* masks, taking close-ups of the masks while they were dancing and occasionally following them in their movements in close-up. As I was reloading the camera after one such shot, Makele, himself a well-known carver, came to compliment me in saying that I, too, was a *namos tame*. Earlier, in 1967, I once had to do some repairs on a tape-recorder. While I was busy with screwdriver and pliers, Talania, who had been watching me silently for a long time, finally exclaimed that I, really, was a true *namos tame*.

If one puts together the scraps of information we have about the *namos tame* one gets a picture, somewhat vague, of a universal artist, a primitive Michelangelo; at one and the same time a master carver of wood and of turtle-shell armlets; an excellent executor of the painted designs on canoe prows, on the side-pieces of the big *vukumo* mask and on the triangular headpieces of the *sia* dancers; the designer of the *naulum*, the ceremonial men's house, and the supervisor of its building operations; the best man to arrange both tastefully and securely the hundred or more long, slender sticks each with a small tuft of feathers fixed at its end, which together are to form the crest of the *vukumo* mask; the man to create the intricate decoration of white cockatoo feathers on the top of the triangular headpieces of the *sia* dancers; a gifted dancer, drummer and singer and probably also a renowned magician knowing how to cast spells and how to use herbs for good or for evil.

Among the Kilenge each village has a number of *namos*, or artists, though one perhaps should better call them craftsmen instead of artists. The Kilenge recognise that not all *namos* are equally good in all the artistic activities described above, that some are good canoe builders, but do not know how to paint the proper design on its prows and so forth. Only the rare artist who excels in all or in many of the arts, and whose skills are recognised by everyone, is considered worthy to be called *namos tame*. With the epithet goes a considerable amount of prestige. Still, among the select group of *namos tame* some are held in higher esteem than others. It is hard to say what could have been the original reason for the difference in rank among the *namos tame*. Probably it was a combination of underlying factors, his artistic qualities, his magic power, the social status of the family group to which he belonged and maybe even his personality. Really great *namos tame* are nowadays no longer to be found among the Kilenge, partly because the *raison d'être* of much of the art is fading away in Kilenge society, but partly probably also because one gets the impression that the truly great masters are to be found in the past, that their greatness in fact is to a great measure a function of history.

Talania, or, to give him his full name, Talania Aritio, is one of the top artists of Ongaia, one of the sub-villages of the Kilenge group (Fig. 1). Dark has written about him: "a 'deep' character; slow but considered, reserved but profound; an intellectual, who demanded of himself the exact emotion for the right artistic act" (Dark, 1974, 20). Though one of the top artists of Kilenge, he is perhaps not quite a *namos tame* in the classic Kilenge sense. This could be because he is not one of the really Big Men in the village. He has to take orders from more influential men: from Chief Tule to make him a wooden *nausang* mask (which Chief Tule then sold at a good price to a white collector); from Chief Navonna of the Waremo sub-village to take charge of a workshop where several men had started carving *nausang* masks hoping to sell them the same way they knew Chief Tule had succeeded in doing (but the scheme collapsed because most of the men had little if any artistic talent); from Paramount Chief Aisapo to assist in the building of a new men's house (*naulum*), to execute personally part of the woodcarvings that were to decorate the new building and to supervise the carving by other *namos*; from one of the chiefs of the sub-village of Ulumainge to shape for him the hull

Figure 1 The master artist (*namos tamc*) Talania of Ongaia village, Kilenge, West New Britain photographed in 1967 while working on a *nausang* mask. Talania is using a modern European hammer and chisel while in the background are visitors from neighbouring villages who have come to admire his work.

of a new dugout canoe and to paint its prows with the correct designs; to arrange for that same chief the feathers of the white cockatoo in his headdress for the *sia* dance.

Talania, however, has not always accepted these orders without protest. Sometimes his reluctance has been simply because he was not in the mood, or because he had planned to go working in his gardens, but occasionally also for reasons of aesthetic prestige, as in 1967, when he participated in the building of the new men's house in Ongaia under the direction of Paramount Chief Aisapo. Aisapo was not a bad carver himself; he had decided that the carved wall planks were to be decorated with mythological crocodiles, each with its distinguishing features, like a specific arrangement of the basic colours red, black and white, or objects they held in their mouths (a pig, a man's leg, and so forth). There were to be eight of such planks, one on either side of the entrance which was made in the middle of each of the four side walls of the square building. The carvings on the planks represented mythological animals which "belonged" to the sibs (*namon ainge*). Their emotional value was much like that of an heraldic animal on a coat of arms, with little if any totemic significance. Inside the *naulum* the sibs had their simple bamboo sitting- or sleeping-benches behind the planks carved with their respective animals.

Originally, the eight planks were all to be decorated with mythological crocodiles, except for one, which "belonged" to the family of the late *namos tame* Maracos and which was to carry that family's emblem, a double-headed lizard called Palogiva. The planks were cut from trees with axes and adzes. To facilitate transportation out of the jungle down to the beach of Ongaia, much of the rough shaping of the planks and the designs was done on the spot in the jungle. Here Aisapo and under him Talania were directing several men working on the planks, using charcoal to sketch the outlines of the animals on the planks. Talania had already been showing signs of reluctance to obey the directions given by Aisapo and when he came to work the plank of his own family group, instead of sketching yet another crocodile, he drew a *naurama* design, that is, two human mask faces of the *nausang* type, interconnected by a double headed serpent. As soon as Aisapo got word that Talania was about to carve a *naurama* instead of a crocodile, he flatly forbade Talania to use that design on his plank, as his family did not own the "copyright" on it. Talania maintained that in this case the question of "copyright" was not relevant, because in his opinion the *naurama* was a free design which could be used by anyone wishing to do so. For half an hour or so the two opponents argued about the matter, or more precisely they spoke in a low voice to people standing nearby, avoiding addressing each other directly. In the end Aisapo won and Talania stopped the work on the *naurama* design. He sat down sulkily and it was not until many days later that he started to carve a new plank, without, however, yielding completely to Aisapo's wishes, for, instead of the crocodile Aisapo had wanted him to carve, he made a beautiful shark. He copied it from a cardboard carton on which it figures as the trademark of a certain make of Scandinavian chisels. This time Talania won, for indeed this now was an original and totally non-copyright design! At the same time it fitted well within the general stylistic system, as there was little trouble in finding a story in which a shark played a role of some kind or another. Some weeks later, when the *naulum* was ready, Talania turned back to the original plank on which he had started the condemned *naurama* design. He finished it in a few days and sold it to the author. It is now in the Rijksmuseum voor Volkenkunde, Leiden.

Another occasion when Talania got quite upset was during the initial stages of the rebuilding of the Giginge Ulumainge *naulum*, one of the two men's houses in the sub-village Ulumainge. This *naulum* had been demolished many years ago and had never been rebuilt. All that remained was a number of large stones on the fringes of an empty area near the shore in the middle of the village. Some of the stones were ritual seats on which *nausang* masks were propped up during their appearance. Other stones, it was told, had been brought there from high up in the mountains by mythical founding heroes of the *naulum*.

In June 1973 the Big Men of the *naulum* decided that the men's house was to be rebuilt. The first steps in its reconstruction were the cutting of two house-posts which were to support the roof-beams. The posts were some 5 metres long and were placed some two metres apart in the middle of the square ground-plan of the *naulum*. Two holes were then dug in the sandy beach, to take the upright poles. It is essential that the poles are the same length once they stand upright. To this end the holes have to be equally deep and the poles have to be

cut to the same length before they are put upright in the holes. In theory all this sounds both simple and obvious. In practice, however, it means that often one of the poles turns out to be higher than the other once they have actually been erected. It is for this reason that usually a *namos tame* is requested to supervise these critical building operations. In this way, Talania was called up. However, when the Master arrived on the building site, other people had already started and, as was to be expected, one of the poles stood about 50 centimetres higher than the other! Talania was furious and, sneering at the amateur architects, refused to raise a finger to help them. But after they had lifted the longest pole out of its hole and had clumsily started measuring its length, the length of the pole still standing and the depth of the hole, and all this amidst a heated debate with much shouting back and forth, Talania could stand it no longer. He pushed away the crowd and started to work silently and with assurance. With a minimum of words he took the necessary measurements using a long stick as a yardstick. Quietly he gave instructions how much to deepen the hole, and finally stood aside self-assured and proud when at last the two poles stood upright again in the sandy beach, this time of precisely equal height.

Unlike Talania Nake was not a *namos tame* but only a *namos* and was very likely always to remain one (Fig. 2). Dark has characterised him as "nervous, a fidget, a cork that bobbed on the waters of everyday life, quick to feel passing nuances and to turn them to his advantage; in fact Nake was a bit of an operator,

Figure 2 The artist (*namos*) Nake of Potne village, Kilenge, West New Britain photographed in 1967 while working on a *nausang* mask.

but, when engaged with his art, a different man, a man solely concentrating on the work developing under his hand. Nake was the laboured impressionist" (Dark, 1974, 19-20). He lived in the Potne sub-village with his wife Koko and a number of children. Their oldest son was a soldier in the army and was stationed at Madang on the New Guinea mainland. Socially speaking the family held a marginal position. On the one side Nake very much wanted to be a Big Man, though on the other side he knew perfectly well that he never would achieve that status, born as he was of a small family in Kumbalup village on the north-east coast of Umboi Island. He knew he had to manoeuvre cautiously so as not to attract too much attention and hence the jealousy of the Kilenge notables, yet he so much wanted to be big and important like them. Seen against this social background, it becomes understandable why Nake tried time and again to find compensation elsewhere, especially by seeking contact with outsiders like anthropologists visiting the village, arranging special performances for them, or adding to traditional performances peculiar new features.

The ambivalence of his attitude also manifested itself in the fact that he seldom failed to show up during a traditional festivity organised in his own Potne village or in neighbouring Ongaia. When, however, he thought it time to organise something himself, as for example to celebrate the occasion of his soldier son coming home on leave to marry a village girl, he preferred to entertain in the White Man's way, that is, he organised a so-called "sing-sing Rabaul." This implied that he provided more beer and whisky than he could afford and that he invited young people to dance the twist to the music of guitars or of a tape-recorder.

As a consequence he showed a lively interest in exploiting every possible opportunity of making money. He was an active member of the local cooperative, but he did not hesitate to sell his copra to the mission when the Father offered higher prices. Also he had realised quickly that good money could be made out of the sale of artifacts to whites, be they officials passing through the area, visiting missionaries, plain tourists, or anthropologists. He had his first experience of such sales in 1966 when Philip Dark asked him to carve a drum. Though he readily accepted to do so, he ran into trouble when it came to decorating the centre part of it with the same *naurama* design already mentioned. He could only solve this problem by asking Talania to do the design for him (Dark, 1974, 41 and Figs. 99, 100, 101). The second time he had to seek Talania's assistance was in 1967 when he had offered to sell me a drum too. When asked what kind of decoration I preferred to have on the centre part of his drum, I selected a stylised *nausang* mask face such as appeared on a turtle shell armlet he had in his possession. Nake reluctantly confessed that the design was too difficult for him to execute, but that he would ask Talania to do it for him. Talania indeed did one face, after which Nake copied the others from the one Talania had done. All Talania got from this was a feeling of superiority, for, as Dark remarks "Talania is giving him a hand partly because he is a friend of Nake's and partly because artists help each other out" (Dark, 1974, 41).

Talania had already given Nake a hand somewhat earlier, in 1967, and the assistance on this occasion was very far from insignificant. Early that year Dark had patiently exercised gentle persuasion on Talania to carve a wooden mask of

the *nausang* type. He had for a long time been very reluctant to do so because for Talania to carve a *nausang* for purely "profane" reasons was something which could not be done easily. At long last, however, he had given in and promised to carve one. He also agreed to have the whole process documented by still photography and on movie film.[1]

When the day came to go to the forest to cut the tree which was to provide the wood for the mask, not only Talania appeared but Nake as well. Having been told by Talania about the venture he had quickly seized upon the opportunity to join and thus to learn how to make *nausang* masks under Talania's guidance. For this indeed was an excellent opportunity, as Nake had never carved a *nausang* before, and Talania was known to be very good in carving masks. Moreover, Nake smelled money: wasn't it agreed that Talania's mask would be bought from him? So, why not make a second one at the same time, it surely would be bought too! Talania accepted Nake's intrusion with the same, almost paternal benevolence he had shown before when Nake came to him for help because he was at a loss as to how to execute the decoration on the drums.

The two carvers started to work in a secluded spot, hidden from the women. There was little if any formal teaching by Talania. Nake, being a trained carver, knew already how to use his tools: axes, adzes and chisels of various sizes. He worked a bit slower than Talania, watching him out of the corner of his eye and once in a while, but rarely, asking his advice. Usually Talania answered with a few words only, pointing rather vaguely to where Nake should take away some wood. Only at the very beginning did Talania take the trouble to outline with his fingers the shape of the mask on Nake's piece of wood. On one occasion, when Talania was absent for a short while, Nake quickly copied with the help of a length of grass the dimensions of Talania's mask and transferred these to his own mask. After about three weeks of intermittent work the masks were ready, painted with the proper designs and decorated with fresh leaves and a feathered stick (*nasale*)

Figure 3
Nausang mask carved and painted
by Talania. The mask is now
in the collection of the Rijksmuseum
voor Volkenkunde, Leiden.

Figure 4
Nausang mask carved and painted
by Nake. The mask is now in the
collection of the Rijksmuseum voor
Volkenkunde, Leiden.

stuck in the upper part of the mask. Comparing the two masks one had to admit
that the quality of Nake's mask was not much less than Talania's. Which indeed
was no mean achievement for a *namos* who had never made one before! Nake
had been right in his surmise: I acquired his mask, and at the same price as
Talania's. Both masks are now also in the Rijksmuseum voor Volkenkunde (Figs.
3 and 4).

The Big Men of Kilenge had been watching the enterprise with keen
interest, especially the financial outcome of it. When it became clear that the
author had indeed bought the two masks, Chief Tule immediately used his power
to order two other masks which he in turn also sold to me. This time, however,
the carvers did not receive any payment except for the food they were given
during the days they worked on the masks.

Nake, having learned how to carve *nausang* masks, soon started a business
of his own. First he made a mask for one of his friends in the Kurvok sub-village,
a man also named Talania. He kept the mask for his own use, being an ardent
nausang dancer. Then Nake made himself a secluded workshop behind his house
and started making masks on order mainly for whites. By 1973 two of these
workshops existed in Kilenge-on-the-Beach. One was independently run by Nake
for his own profit, the other was managed in a more professional way by members
of the family of the famous *namos tame* Maracos who had died in 1965. One of
Maracos's sons, Joseph Ailama, more or less successfully tried to sell the masks
their workshop produced to curio shops and museums in Papua, New Guinea,
in Australia, and elsewhere. The family had even acquired a Polaroid camera with
which they planned to take photographs of the masks and send these to prospec-
tive buyers. The main carver was Maracos' other son Makele, a sensitive middle-
aged man and a gifted artist, as was his colleague and friend Talania. As he was
a severe asthma sufferer, however, his poor health prevented the workshop from
producing large numbers of masks, at least of masks having a certain quality. For

when Makele suffered one of the long and severe attacks of his illness, others tried to carve, but mostly failed to produce anything but the poorest junk, which was, however, still sold occasionally to an ignorant tourist looking only for a nice piece to decorate the walls of his home.

The other "traditional" aspect of this enterprise was that most of the money received from the sale of masks was to be handed to Pareki, who was the most important member of the Maracos family (his father had been an older brother of Maracos). Unfortunately no information is available about the number of masks produced and sold by these two workshops. A very rough guess would be a mask a month by each of the workshops at the most, but probably it was much less.

NOTES

1. *Nausang* masks are wooden masks representing superhuman beings. They are very sacred and secret. Even today women and uninitiated boys are not allowed to see the masks. *Nausang* perform at the circumcision of a Big Man's first born son and in former times, they were powerful and dreaded agents of social control. Each mask bears a distinguishing design painted on it in black, red and white. An individual, man and woman alike, inherits the right to use the design from the ancestors, usually preferring the one that was inherited through the most powerful line (Gerbrands, 1972).

REFERENCES

Dark, P.J.C. 1969. "The changing world of the Kilenge, a New Guinea people." *Lore*, 19, 74-84.

Dark, P.J.C. 1973. "Kilenge big man art," in A. Forge (ed.), *Primitive Art and Society*. London, 49-69.

Dark, P.J.C. 1974. *Kilenge Life and Art: A Look at a New Guinea People*. London.

Gerbrands, A.A. 1971a. *Dance of the nataptavo masks*, 20 minutes 16 mm colour film.

Gerbrands, A.A. 1971b. *Vukumo mask, construction and performance*, 17 minutes 16 mm colour film.

Gerbrands, A.A. 1971c. *Sia chorus*, 20 minutes 16 mm colour film.

Gerbrands, A.A. 1972. *Nausang masks, Part 2: Performance*, 35 minutes 16 mm colour film. All four films were produced and distributed by the Foundation for Film and Science, Utrecht, Netherlands.

Harding, T.G. 1973. *Voyagers of the Vitiaz Strait*. Seattle and London.

7

Will the Real Charles Edensaw Please Stand Up?
The Problem of Attribution in Northwest Coast Indian Art

Bill Holm

Does it really matter if an argillite chest was made by Charles Edensaw or Tom Price, or a mask or frontlet was carved by John Robson or Charlie James or Willie Seaweed? None of these artists will profit by the recognition. Just the same I believe there are good reasons why we might want to know and recognize the works of individual artists of the Northwest Coast, whether or not we know their names. For one thing, it's important just to recognize the fact of individual creativity in cultures other than our own. A few years ago I wrote an article about the art of the Kwakiutl master artist, Willie Seaweed (Holm, 1974). One reason for writing it was to make a point for recognition of the individuality of the "faceless" artists in tribal societies. I believe we slight the creativity of a group of people if we don't recognize the differences in the work of individuals within the group. In our own art tradition the "name's the thing." Names sell. An attribution, accurate or not, to a "name" artist like Willie Seaweed or Charles Edensaw will put extra dollars into a dealer's pocket.

But there's another good reason to spend the time and effort needed to be able to identify individual work. One of the few practical ways to pin down an art tradition to a particular place or time is to solidly identify one of the participants in that tradition. And besides this practical reason, I really would like to know—as well as it's possible to know—who did what. I'd like to be able to look at a fine mask or rattle or painted box and know where it came from. I'd like to be able to recognize the artist in the object, even though I may never be able to know his name. And I want to experience—even though that experience has to be vicarious and imperfect—the choices and decisions that artist made.

Reprinted in abridged form from *The World Is as Sharp as a Knife: An Anthology in Honour of Wilson Duff*, edited by Donald N. Abbott, Victoria: British Columbia Provincial Museum, 1981, pages 175–200 with permission of the author and publisher.

I believe it is possible to recognize what those choices were. The more thoroughly we understand the underlying structure of an art tradition the more clearly those choices stand out. Northwest Coast artists worked within regional art traditions which are gradually being more and more clearly defined. The northern two-dimensional aspect of the broad Northwest Coast tradition is so highly structured and logical that even slight individual variations can be recognized easily. But the fact that one piece differs from another isn't enough for attribution. Attribution is possible because artists make discrete choices in what they do or don't do. In northern Northwest Coast two-dimensional art the choices are primarily in the design elements which can be selected from the traditional available supply, the relationship of those elements to each other, and their physical form. The choices aren't limitless—certain elements and certain relationships must be used or the structure falls apart. Many of the choices made by Northwest Coast artists were, or rather are, intellectually made. Northern two-dimensional art is flourishing again and the best artists are developing individual styles within the system just as their predecessors did. They base their choices on the satisfaction they derive from the appearance of the forms and combinations.

Artists copy one another. If this weren't true there wouldn't be a recognizable art tradition in the world. By copying I mean that they choose what is personally satisfying in the work of other artists and incorporate it into their own work. At the same time they consciously or unconsciously alter these chosen elements and put their own stylistic stamp on their own work. When artists work closely together, especially as master and apprentice or as collaborators (both common on the Northwest Coast) their work is likely to be very similar (Holm, 1974:74, 78). So regional styles developed. We can easily tell the difference between Haida totem poles and poles of the Tlingit, Tsimshian or Kwakiutl. At the same time, typical poles of Massett are recognizably different from those of Prince of Wales Island, Skidegate, Tanu and Anthony Island—and those are different from each other. And within these village or regional schools the styles of individuals can be seen.

Unfortunately those who collected most of the art which we see today, from the earliest European and Euro-American seafarers trading for curiosities to present day dealers, have had little or no interest in learning or recording the name of any artist (unless today he might be Charles Edensaw or Willie Seaweed), or even the location of his "shop." A few of the more systematic collectors of the turn of the century did occasionally record this kind of information, but even George Emmons, Charles Newcombe, Franz Boas and John Swanton were usually frustratingly silent about the artists. As far as I can find Adrian Jacobsen mentioned an artist's name only once in his notes and journals, and that in a quotation from another person from whom he had requested information about a Haida totem pole he had purchased (Jacobsen, 1977:26). But Jacobsen did record that he had commissioned the "most renowned wood-carver among the Bella Bella" (Jacobsen, 1977:10) to make the magnificent chief's seat for the Berlin Museum (Von Sydow, 1923). We have to thank him for giving us this very convenient peg on which to hang our theories about a Bella Bella style in 1881. Little scraps of information like this shine out like diamonds in the gravel.

Another of these sparklers is a single note in the catalogue of the Northwest Coast collections of the American Museum of Natural History. Dr. I. R. Powell collected a group of masks and sculptured figures of shamans in 1882 and described them as being unlike the masks used by the Haida themselves, and made for sale by an artist of Massett named Quaa-telth. They are part of a large group of very similar masks and figures scattered among collections in North America and Europe. They are portrait-like masks, many of them with moveable features (Fig. 1), wooden figures of shamans (Fig.2), a few dance headdress frontlets bearing "portraits" of young Haida women and several distinctive rattles combining a bear's head with a human figure. In extreme contrast to the elegant Haida princesses there are also extant a two-headed man, a dignified Sphinx[1] and at least four naturalistic representations of the shrunken corpse of a Haida shaman (Fig. 3).

Marius Barbeau mentioned the carver Charles Gwaytihl in his *Haida Carvers in Argillite* (Barbeau, 1957:178-79). The few biographical details he recorded agree in the main with the recollection of Mrs. Florence Davidson of Massett who knew the carver as a very old man before his death sometime prior to 1920. She called him qʷaitił, which she translated "Wets the Island." She said, as had Barbeau, that he carved masks and figures of wood, and didn't carve argillite. The British Columbia Provincial Museum has a remarkable collection of eight Gwaytihl masks, most of which were shown in the Vancouver Art Gallery's 1967 exhibition *Arts of the Raven*. At that time there was some speculation (based in part on the early 1880s Massett provenience) that they were the work of Charles Edensaw. One of Wilson Duff's responsibilities in the planning of that exhibition was an Edensaw gallery. Wilson had really just begun his intense interest in Edensaw, and he tentatively identified a large number of pieces as Edensaw's

Figure 1 Mask attributed to Gwaytihl. British Columbia Provincial Museum #10664.

Figure 2 Shaman figure attributed to Gwaytihl.American Museum of Natural History #16/396.

Figure 3 Dead shaman figure attributed to Gwaytihl. Princeton University Museum #5160.

work. Wilson, Bill Reid and I did not agree on all these attributions at the time, but our understanding of the characteristics of Edensaw's work was very rudimentary, and most of the choices were left to stand. Wisely, it seems now, Wilson didn't make an Edensaw attribution on the Gwaytihl masks, but the notion still lingers on. One of his masks was recently purchased by a museum for a very high price which was based in part on an Edensaw identification.

It's certain that we'll never know the names of most of the Indian artists whose work survives in collections. Still I think there is good reason to try to identify as many pieces as possible with known individuals. The Gwaytihl example is a good one. Because we know a few solidly documented pieces by this artist we are aware that we're dealing with another man's work, and we can avoid lumping him with other known artists like Charlie Edensaw. We can see that the individual characteristics of his work are significant and not just variants within a single artist's style.

Of course it's impossible to assign a maker to every piece, or even to identify every piece of a known artist's work. Artists' styles change over the years. Edensaw, for example, was born about 1839 and died in 1920, a life of about 80 years. That means that his productive life was probably over half a century. During those years he lived and worked at Massett, Skidegate, Port Simpson, Kasaan and probably other places where no doubt he picked up ideas from other artists and their work. Even so I believe we can start from a single example, or several stylistically alike examples, and project that artist's style back and forward over his career and attribute work to his hand. Because northern Northwest Coast two-dimensional art is so highly structured it's entirely possible for one who has a good understanding of that structure to recognize very subtle variations on the standard, and these variations define artists' styles. It's very interesting to me to see how individualistic these styles came to be, and how closely each artist adhered to his own way of doing things over considerable stretches of time.

Some styles are very distinctive. Others are less easily separated and seem to be the styles of artists who were strongly influenced by one another. There were probably whole regional styles which we misread as the works of single artists. A good example of this is the large number of painted objects, particularly boxes and chests, which were made at Bella Bella over an apparently long period of time in the last century and the early years of this century. These all share really distinctive characteristics which make them stand out from similar objects from other places. We do know the names of a few of the latter day practitioners of this school so there's now no doubt that we are dealing with several artists. So far I'm satisfied to call these pieces "Bella Bella." The settee that Captain Jacobsen commissioned in 1881 is a fine example of this style.

Boxes with these very specific formal characteristics have been collected all over the coast, but I'm sure they were made at Bella Bella. The details of the style are quite easy to recognize. Some of the basic characteristics are very thin formlines in a wide open composition, extremely nonconcentric, *small* inner ovoids and single hatching (that is, hatching in one direction only, usually from upper right to lower left) in the secondary U forms (Figs. 4, 5). There are many other, but more subtle, points of distinction, but this list should suffice to show that this can be seen as a distinct style of painting.

In contrast to the open, light, feeling of the Bella Bella examples are many pieces, some of them very old, which are characterized by massive semi-angular formlines with very constricted background space and narrow tertiary areas

Figure 4
Box. Bella Bella.
Burke Museum #1-10803.

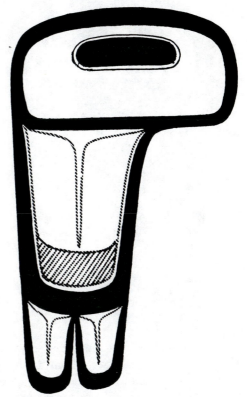

Figure 5
Formline wing
design: Bella Bella.

(Figs. 6, 7). Between these extremes are numberless individual styles. I doubt if complete sense can ever be made of this mountain of material, but it is worth working at.

SIGNIFICANT CHARACTERISTICS

What are the significant characteristics which stamp the work of an artist on the Northwest Coast? Just as the paintings of European artists of the past can be identified by scholarly experts through stylistic clues, the masterpieces of the coast can be separated on the basis of objectively described characteristics. But these characteristics must be significant. That is they must represent choices which each artist makes that are unlike those made by others. There are certain aspects of Northwest Coast art which are of little use in attribution. Subject matter is one of these. Since the artists who produced most of the great pieces were professionals in a very real sense—formally trained, working on commission for others (and paid for their work), and *typically* producing for chiefs of the opposite phratry—there is very little use in attributing on the basis of crest ownership. On the other hand the same artists, carving argillite and wooden poles for sale to non-Indians, frequently used their own crests and stories as subjects. It is unsafe to rely on subject matter alone as a means of identifying artists.

Attribution based on the type of object is almost completely futile. An extreme of this futility in object-based attribution is Marius Barbeau's iden-

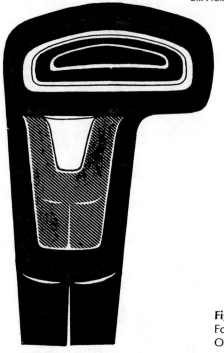

Figure 6
Formline wing design.
Old Northern style.

tification of all argillite and wooden whistles and flutes as the work of George Gunya (Barbeau, 1957:4-9). Gunya may well have made flutes of argillite, but those so attributed by Barbeau run the full range of Haida styles and culminate in a pair of clearly Kwakiutl winter dance whistles, of which he writes "Although they are said to have been found at Blunden Harbour in the Kwakiutl country to the south, they undoubtedly are Haida pieces from the hand of George Gunya" (Barbeau, 1957:9). These two whistles were purchased by C. F. Newcombe from Willie Seaweed at Blunden Harbour in 1914 and are typically Kwakiutl in every way. Marius Barbeau was very active in assigning work to the hands of individual artists. Initially it appears that he made these assignments on the basis of information given him by the native owners of the objects or by people who knew the artists' work directly, or could cite traditions of the origin of the pieces. This is the best seen in his work on the art of the upper Skeena River, *Totem Poles of the Gitksan* (Barbeau, 1929). Later, and most prominently in his book *Haida Carvers in Argillite* (Barbeau, 1957), he went far beyond his earlier method in identifying the work of Haida artists. Sadly for the state of understanding of areal and individual styles in Northwest Coast Indian art, and Haida art in particular, Marius Barbeau's conclusions were really meaningless, based on irrelevant data. The results have been confusion and misunderstanding.

HAIDA ARTISTS

I shall examine the work of two Haida artists—Charles Edensaw and Gwaytihl—and describe what makes their styles distinctive and recognizable. These artists were contemporaries, born in the mid-nineteenth century and living into the

twentieth. They certainly knew each other. Both produced objects for sale to their own people and to outsiders.

I have already mentioned the work of Gwaytihl and that most of his known production consists of masks and carved figures made for sale to collectors. These are all naturalistic, with only the stylization of the eyes and eyebrows and the dress and decoration of the people he portrayed to show clearly that they come from the Northwest Coast. Yet even though they are portrait-like, Gwaytihl's stamp is on all of them.

Naturalistic portrait-like masks and figures were not a novel idea for Haida carvers when Gwaytihl began to make them, but most of his known (or recognizable) work consists of such objects. Judging from his evident skill and experience he must have been carving for a long time before the early 1880s when almost all the documented examples of his carving were collected. It may yet be possible to extend his productive career back in time by recognizing his hand in earlier pieces.

His post-1880 "portraits" share many distinct characteristics. Fortunately for attribution, Gwaytihl, although more cognizant of human anatomy than his contemporaries, developed conventions of representation which he repeated in almost all his carvings. His subjects have small eyes, by Haida carving standards,

Figure 7 Tlingit chest. De Menil collection.

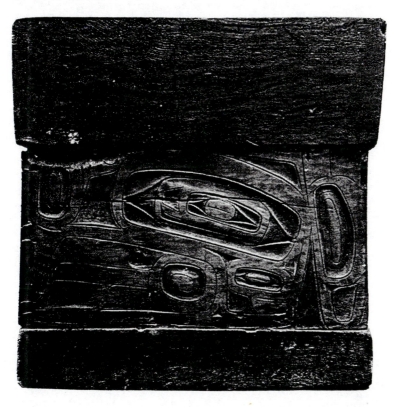

on a moderate orb (Fig. 8a). The eyelids are open, with little or no constriction, and they have a narrow black rim. The inner ovoid is round. The space between the long, narrow and slightly arched brows and the eye is wide and shallowly recessed. The orbs continue well below the eyes before giving way to full round cheeks. These cheeks have a naturalistic relationship to the corners of the mouth, which are slightly recessed. The lips are narrow and rounded, tending to be less ribbon-like and more naturalistic than is usual for Haida sculpture. The nose is very narrow and rather long, with small unflared nostrils. Full cheeks merge smoothly with a prominent, rounded chin. Rounded and somewhat prominent chins like these are also seen on some very early, and probably Haida, portrait-like masks.

One of the most individualistic conventions of Gwaytihl's sculpture is the form of the ears. They are rendered naturalistically but invariably stand well out and taper at the bottom to a small lobe. This form is unique to Gwaytihl's work. I have never seen ears like these on any other Northwest Coast carvings.

Gwaytihl regularly rendered the hair on his masks and carvings in a naturalistic manner, modelling well-defined locks and curls and texturing the surface with fine parallel grooves (Fig. 1). At least one mask has attached hair and many are fitted with fur moustaches and beards. A few have moveable eyebrows of furred skin (Fig. 1). Gwaytihl also frequently added nose rings, ear pendants and small lip pins to his wooden faces and he sometimes mechanized his masks to move eyes, lower eyelids, raise brows and open lips (Fig. 1). With all this he retained his conventionalized proportion and form of the facial features. Gwaytihl's portrait masks are small, barely large enough to fit on a face. Those with mechanized features, particularly eyes, are cluttered in the inside with strings and moving parts which makes them difficult or impractical to wear. This is consistent with the statements that the masks were made for sale to foreigners and not for Haida use.

Figure 8 Typical eye structure for two Haida artists: (a) Gwaytihl, (b) Edensaw.

(a) (b)

Unlike most Haida sculptured figures, even those of argillite, Gwaytihl's wooden shamans frequently strike animated poses. Anatomy is carefully observed. This is most apparent in the dead shaman series, in which the skeletal structure is carefully rendered. Sunken features and desiccated skin stretched over the skull are skillfully depicted (Fig. 3).

It may have been the character of the two-dimensional painting on the shamans' aprons which originally suggested an Edensaw connection—open medium weight formlines, rather rounded, with frequent use of true line bordering ground areas. But careful comparison shows many differences from Edensaw's work. Gwaytihl's choices of elements and relationships are more conservative and his ovoids and Us are more angular than Edensaw's, at least for the post-1880 period (Fig. 2).

Charles Edensaw

When Wilson Duff, Bill Reid and I were busy selecting the objects to be shown in the *Arts of the Raven* exhibition, our conversations frequently revolved around the subject of attribution. We wanted to feature an individual master artist in one of the galleries, and the natural and unanimous choice was Charles Edensaw. Wilson took primary responsibility for that part of the exhibit and set about the very difficult task of identifying the work to be shown. It seemed to me at the time that we were basing many of our notions about attribution, both general—on a tribal level—and specific, in regard to individual artist's work, on very subjective ideas. I believed then, as I still do, that styles can be analyzed by isolating specific characteristics which can be described in objective terms. What we call "feelings" about identification of art objects are based on our subconscious analysis of just such solid characteristics. We should be able to delve beneath those "gut reactions" and isolate consciously the myriad data which our brains have been fed. It seemed to me that Edensaw's flat, formline decoration was distinctive and recognizable, and since such a high percentage of northern art included at least some two-dimensional surface detail it would be worth while to try this kind of isolation of Edensaw's characteristics. I attempted this in a three-page (and very tentative) outline titled *What Makes an "Edensaw"? (2-D Version)*. Looking back on that beginning attempt after ten years of intermittent searching for the means to identify Edensaw's and other's work, I find that there is really nothing I would change now, and very little new to add. Yet during those years, apparently ignoring the lack of these identifying signs, I took some pieces to be Edensaw's which I now firmly believe, bolstered by identification of other artists' styles, not to be his.

Charles Edensaw's two-dimensional design from at least the last two decades of the nineteenth century until the end of his productive career sometime early in the twentieth century exemplifies the work of a highly competent, imaginative artist with absolute mastery of the tradition in which he worked, and who had developed a very personal version of that tradition. That that version was fully formed by 1880 is shown by a bracelet (Fig. 9b) in the National Museum of Man which would be very difficult to separate from Edensaw's work of thirty years after its collection date of 1879. Careful direct comparison does show significant,

Figure 9 Bracelets attributed to Edensaw: (a) Canadian Museum of Civilization, Ottawa VII B 103b; (b) Canadian Museum of Civilization, Ottawa VII B 103a; (c) University of British Columbia Museum of Anthropology A8093.

if subtle, differences which seem to be part of a continuous progression of the change in his style. Interestingly another bracelet (Fig. 9a) collected at the same time illustrates an even earlier version of Edensaw's style.

The formline art of Charles Edensaw, at least in this later period, is unique and easily distinguished from all other work except that of copyists or certain artists who were heavily influenced by him. There is a chance that some of these Edensaw-like works are actually from his hand, although most of them have details which are unlikely to have been part of his repertoire of choices. The first impression one has of an Edensaw flat design, be it in engraved silver or argillite, or in painting on wood or basketry, is of an open, freely flowing grid of medium to narrow width formlines, very rounded in the Us and ovoids (Fig. 9c). Many late works have ovoids and Us whose ends are arcs of circles. Formline width varies as is usual in northern flat art, but the variations are moderate—the upper rims of ovoids for example are little wider than the lower edges, which also tend to be straight or even slightly convex. Ovoids which are concave on the lower edge are rare in Edensaw's work after 1880. Completely circular ovoids are seen (Figs. 10, 11, 12), and very short, rounded ovoids with flattened bases are common. Consistent with these features is the lack of strong non-concentricity in ovoid complexes. That is, inner ovoids in eyes and joints tend to be nearly centred in the tertiary space within the surrounding formline ovoid. Any non-concentricity is usually very subtle if present at all. If the inner ovoid is surrounded by an eyelid line, the ovoid is very short or even circular, and the eyelid line forms long, open points extending nearly to the outer edge of the eyesocket space (Fig. 11). The eyelid points are only slightly below the centre of the inner ovoid. Inner ovoids of this type are frequently elaborated with the typical C shaped relief, tangent to the top of, and similar in form to the relieved ovoid. Edensaw also favoured the complete ovoid relief in inner ovoids, usually non-concentric (Fig. 12).

Figure 10 Detail of argillite platter attributed to Edensaw. National Museum of Ireland #704.1894.

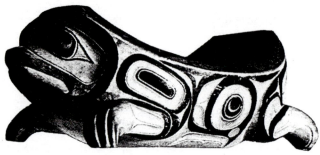

Figure 11 Frog bowl attributed to Edensaw. UBC Museum of Anthropology #A7054.

Tertiary spaces are also handled in characteristic ways. In relief carved pieces, especially in silver or argillite, the sockets of the long eyelid form of eye are smoothly hollowed, leaving a narrow flat rim at the eyelid line (Fig. 10). The same technique was followed in the larger eye and joint sockets without pointed eyelids. Very narrow sockets were sometimes bevel cut, sloping down to the inner edge. Frequently in silver engraving, where the scale is very small, and probably in the interest of keeping the design open and uncluttered, Edensaw eliminated the recessing of the socket altogether, and many large joints have only a single, or occasionally a double engraved line separating the inner ovoid from its surrounding formline (Fig. 9). Typically these inner ovoids are of the "salmon trout's head" type. An interesting and unusual feature of some of them, for example in the two 1879 bracelets, is the elimination of the formline which would ordinarily form the lower jaw of the figure, leaving the mouth area to form a partial tertiary "socket" (Fig. 9a, b). These forms of rendering the juncture of inner and formline ovoid are among several nearly exclusive Edensaw design characteristics which taken together may objectively identify his work.

Figure 12 Spruce root hat. Painting attributed to Edensaw. Hauberg Collection.

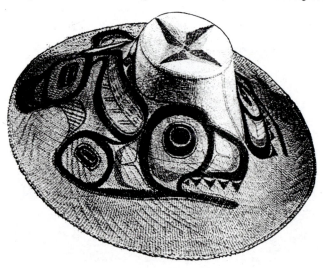

Another favourite design unit was an inner ovoid much like a simple "salmon trout's head" without a lower jaw. Although not unknown in other artist's work it was more frequently used by Charles Edensaw than by any other (Fig. 13). Another form which seems almost exclusively his is a variant on the stylized face, used as a joint, in which the eyebrow and upper eyelid line are eliminated and the lower eyelid line sweeps down and around the large, round eye (Figs. 14a, 15). If Edensaw was not entirely alone in his use of this concept, he was its most frequent user and probably its inventor. In his work its form distinguishes it from those from other hands.

Primary and secondary Us and the tertiary spaces they define are perfectly consistent in form with Edensaw's characteristic ovoids. They are smoothly rounded, moderately swelling and of medium weight. Legs of secondary Us are very narrow. In engraving, the crosshatched tertiary areas are almost always bordered with a double engraved line (Figs. 9, 15). Edensaw frequently applied this detail to areas which would normally be considered as ground. Whether or not he conceived them as ground areas or transposed them by his tertiary line into tertiary units cannot be known. Since he freely alternated between fine crosshatching and hollowing of true tertiary areas, we can get no clue from these techniques. In any case the double line outline of crosshatched space is an Edensaw trademark. When these tertiary (or ground) areas are elaborated with a split, as they frequently are in his work, the split is open and its sides smoothly curved—almost, but not quite, arcs of circles. The open space in the split is engraved, usually with single-hatched lines.

Sometime before 1879 Charles Edensaw began to incorporate variations on a distinctive design complex in his engraving on silver and argillite, and more rarely in painting and wood carvings. In my 1967 paper I called this design "stacked Us" (Fig. 16). More than any other detail the stacked U complex

Figure 13 Spruce root hat. Painting attributed to Edensaw. Denver Art Museum #YHI28.

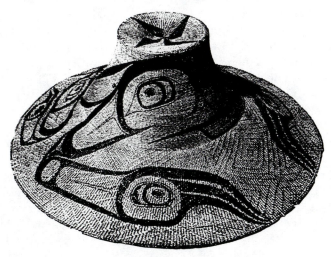

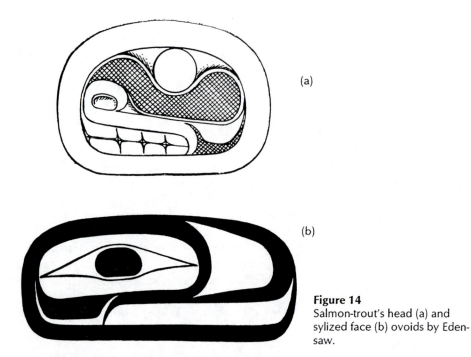

(a)

(b)

Figure 14
Salmon-trout's head (a) and
sylized face (b) ovoids by Eden-
saw.

identifies Edensaw's late work. A very narrow secondary formline U divides the
space enclosed in a primary U almost across the centre. Enclosed in this secondary
U is either a pair of solid Us with typically rounded ends, or a tertiary split U,
crosshatched or hollowed. The remaining space, beyond the dividing secondary
U, is elaborated similarly, but with the opposite design. In a few examples the
design opposite the pair of Us is a solid crosshatched U, bordered with a tertiary
line, rather than a split U. Almost every known Edensaw engraving in silver or
argillite incorporates at least one pair of examples of the stacked U complex, and
a great many have several. Even the tiny argillite poles from the Cunningham
collection abound with them in spite of their diminutive scale. Barbeau illustrated
these poles, which he attributed to Isaac Chapman, in his *Haida Carvers in Argillite*.
Of the 36 poles shown there, 16 (Figs. 187, 188, 189, 191, 192, 194, 197, 198, 199,
203, 208r, 209, 210, 211, 213 and 214) are actually by Charles Edensaw (Barbeau,
1957:178–99).

 Although the stacked U detail as employed by Edensaw is uniquely his, it
was developed by him from a fairly common U complex found in northern
formline designs from at least the earliest historical period. This was a secondary
complex of a pair of formline or solid Us based on another formline or solid U,
the whole enclosed in a primary formline U (Fig. 7). It is Edensaw's consistent
use of the design, his modification of the proportions of the parts, his innovative
transposition of the upper and lower details and his distinctive formline style
which make the complex so nearly a signature. In contrast, he rarely used one of

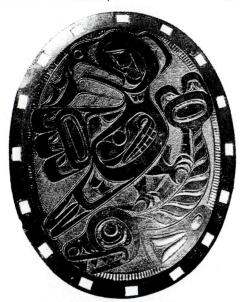

Figure 15
Argillite platter attributed to
Edensaw. Canadian Museum of
Civilization, Ottawa #VII B 824.

the otherwise most common U complexes—the tertiary U enclosing a pair of secondary Us. His choice for a simple U complex, especially in painting, was the very standard primary U enclosing a thin legged secondary formline U, which in turn encloses a tertiary split U (Fig. 17). A decorative detail which Barbeau correctly mentioned as being characteristically Edensaw is the border of "godroons" and ropelike carving on argillite platters and chest lids (Figs. 10, 15). They were not exclusively his, but he used them with great frequency.

There are extant a number of bracelets of very light gauge silver which are shallowly engraved with relatively simple designs incorporating many of the

Figure 16 Stacked U complexes, after Edensaw.

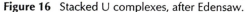

Figure 17 Formline wing design, after Edensaw.

features mentioned above. They usually exhibit single hatching rather than **crosshatching** in the ground and tertiary areas and if any sockets are hollowed it **is only** those of the figure's eyes, and then very shallowly. If these bracelets have **truly characteristic** Edensaw formlines and design complexes I am inclined to regard them as his work. Some of these bracelet designs were copied by other artists, but the work is usually so inferior and the elements so distorted that they should not be confused with original Edensaw pieces.

The older of the two 1879 bracelets exhibits features which suggest the form of Edensaw's earlier style (Fig. 9a). Less smoothly flowing formlines result from more angular ovoids and somewhat awkward junctures. Ground and tertiary forms (which result from the relationship of adjacent primary formlines) are less integrated with the whole composition than in later work. A number of argillite carvings—the Bear's Mouth house models in the Vancouver Centennial Museum (AA 54, 55, 56, 57) and the Alaska State Museum are examples—illustrate this earlier and somewhat less elegant structure while already incorporating Edensaw traits such as the double outlines of tertiary and ground spaces and rudimentary stacked Us. More massive and angular formlines with greater width variation, and more frequent use of the tertiary U-double secondary U complex characterize these early pieces.

A spectacular transitional piece is the carved and painted settee (BCPM 1296) which Newcombe collected from Edensaw in 1901 but which must have been made several decades before. Conceptually the huge frog is like much later designs (Fig. 13) even to the primary colour shift from black to red in the mouth, but the angularity is pre-1879 at latest. Stacked Us, mouthless and circular "salmon trout's head" ovoids and other typically Edensaw features appear in the design.

Interestingly, 18 painted spruce root hats which I have seen and firmly believe to have been painted by Charles Edensaw share a top painting of a four-pointed star with each point divided alternately red and black (Figs. 12, 13). Are these top paintings the artist's signature? I'm more and more inclined to believe it. Several other hats which seem to be Edensaw's work, but which differ in composition from those 18 have an all red four-pointed star design (Holm,

1965, Fig. 7). They may be by another painter yet unidentified, or perhaps represent earlier Edensaw work.

Edensaw's Sculpture. The most solidly documented sculptural pieces by Charles Edensaw are the model totem poles and the house model commissioned by John Swanton for the American Museum of Natural History and illustrated, along with a similar group of models by the Skidegate carver, John Robson, in his *Contributions to the Ethnology of the Haida* (Swanton, 1909:Pl. 1-8). The pictures were later published by Marius Barbeau in *Haida Carvers in Argillite* and all attributed to Edensaw. That the two styles are superficially similar is certainly true, but analysis of their details makes it quite possible to identify each artist's work. Edensaw's sculpture, at least as represented in small poles, frontlets and argillite and ivory carvings, exhibits features which are just as distinctive as in his flat work. In addition all the poles and models have two-dimensional detail in wings, fins and ears which can corroborate the attribution.

As in the flat designs there is an overall feeling of movement, openness and integration of positive forms and background. The same principles which govern the organization of his formline designs operate in the carved pieces. Parts tend to be smoothly rounded. The limbs of the various creatures are rounded in cross section. Because they are smoothly modelled and compact they have a chubby effect. They are bent at the elbows and knees, and the fingers and claws (often three in number) grasp purposefully, a detail which helps in no small measure to relate the interlocked figures to one another.

It is in the eye and eyesocket area of the Northwest Coast sculpture that tribal and individual identities can be most quickly differentiated. Edensaw chose and consistently used a unique eye form which superficially resembles that used by other artists but which has recognizable differences from them (Figs. 8, 18). The eye itself is on a well-rounded orb, and features a round iris enclosed in open, tapered lids with a well-defined rim. As in the flat designs the points of the lids are not dropped much below the centre of the eye. Above the upper lid the socket is fairly wide and shallowly recessed, retaining the feeling of the underlying orb. The most distinctive feature, however, is the treatment of the area under the eye. Here, the upper cheek plane intersects the eye orb immediately below the lower eyelid line. There is usually no hollowing of the socket below the eye, except the recessed definition of the eyelid line. In human faces and in more naturalistically rendered animal faces there is no defined ovoid eyesocket. This common feature of Haida sculpture is eliminated in favour of rounded cheek planes. Even where the more stylized eye socket is used, the orb-upper cheek plane intersection remains an identifying feature.

The eyebrows are smoothly curved, wider near the centre and tapering to usually rounded ends. The lips are often slightly rounded and tapered toward the corners of the mouth. Naturalistic human faces have correspondingly natural modelling of the lips. Human and animal nostrils are defined and rounded. Teeth tend to be small, numerous and rounded. Unlike Gwaytihl's naturalistic faces, the chins are not prominent and the ears, if present, are simple semi-circular forms without naturalistic detail.

Figure 18
Argillite pole attributed to Edensaw.
Johnson collection.

Edensaw's small sculptural pieces impress one with the great attention which has been given to intergrating each part of each figure to the whole composition. Because of the smooth roundness of the limbs, the relative vertical shortness of animal faces, the large open eyes and small round nostrils, these carvings have a somewhat gentle, appealing quality. Fortunately they also have superb design and proportion, coupled with masterful handling of detail, which preserves their power as sculpture.

Edensaw produced a number of carved animal-form bowls in wood and in argillite which are easily identified by the characteristics of their sculptural and two-dimensional details (Fig. 11). Interestingly I know of only two masks which can be solidly attributed to him on stylistic or documentary grounds (Fig. 19 and American Museum of Natural History). I have seen *no* complex argillite figure groups or pipes and only one argillite shaman figure which I feel can be safely attributed to Edensaw's hand, although many of these have been so identified over the years. There are a number of headdress frontlets which must surely be by him and at least one (American Museum of Natural History 16/241: Holm and Reid, 1976:177) which is not only stylistically a perfect example but is identified as being made by Tahaygen, Charles Edensaw's personal Haida name. Several other frontlets which I once thought to be his (Holm and Reid, 1976:176–77) I am now certain are not.

Several large poles have been attributed to Charles Edensaw (British Columbia Provincial Museum 1 and 2, Übersee Museum). These poles differ from the documented models as full sized poles generally do. It is certainly possible they are the work of Edensaw. If so, it should be relatively easy to identify others he may have carved by careful comparison of poles, or even old photographs, with these three. However, the Provincial Museum house-posts are quite similar to the large pole formerly in the Museum fur Völkerkunde in Berlin which seems to be solidly documented as the work of Edensaw's uncle, Albert Edward Edensaw.

IS ATTRIBUTION REALLY POSSIBLE?

Is it really possible or practical to attribute authorship of a Northwest Coast art object to an individual artist on the basis of style? I believe it is, with certain obvious limitations. It would be ridiculous to suggest that we could group all Northwest Coast art objects, by artists, without error. Even those artists whose work is best known and most solidly documented produced pieces which must puzzle us. Still there is much which can be identified. The possibilities and problems are illustrated in the case of the most prolific and best known Haida artist, Charles Edensaw. There are many pieces which I feel confident to be his work. They display all the characteristics exhibited by works known without any

Figure 19 Mask attributed to Edensaw. Photo courtesy Pitt Rivers Museum, Oxford University.

doubt to be his, and none of those characteristics not seen in his documented works. On the other hand there are some which seem to conform to an Edensaw style but which must be very early—from his formative years—or very late and produced during his decline. Some which seem Edensaw-like have strange distortions of conventional shapes, rigid rules of structure broken illogically, anachronisms such as master's forms in novice's composition, which set them apart from the consistently characteristic work of the artist. It's quite possible to make mistakes. I've made many of them, a few of which I have recognized and hopefully corrected. More careful comparisons, yet to be uncovered documentation and better understanding of the ways in which artists develop may improve our chances for accurate attribution. We know a lot more about the subject than we did a few years ago, but there is still much to learn.

NOTES

1. Since writing this paper I have received catalogue information from the British Museum which describes the Sphinx as having been "carved by Simeon Stilthda, a Haida, from a picture in an illustrated Bible shown him by the Rev. Mr. Collinson between 1874–1878." If this information is accurate some of the other pieces attributed to Gwaytihl may actually be by another associated carver.

BIBLIOGRAPHY

Barbeau, Marius. 1929. "Totem Poles of the Gitksan," *Bulletin 61*, Anthropological Series 12. National Museum of Canada, Ottawa.
——. 1957. "Haida Carvers in Argillite," *Bulletin 139. National Museum of Canada, Ottawa.*
Duff, Wilson with Bill Holm and Bill Reid. 1967. *Arts of the Raven: Masterworks by the Northwest Coast Indian.* Vancouver: The Vancouver Art Gallery.
Holm, Bill. 1965. *Northwest Coast Indian Art: An Analysis of Form.* Seattle: University of Washington Press.
——. 1967. "What Makes an Edensaw? (2-D Version)," unpublished note.
——. 1974. "Structure and Design," in *Boxes and Bowls: Decorated Containers by Nineteenth Century Haida, Tlingit, Bella Bella, and Tsimshian Indian Artists.* Washington D.C.: Renwick Gallery, Simthsonian Institution Press.
—— and Bill Reid. 1975. *Form and Freedom: A Dialogue on Northwest Coast Indian Art.* Houston: Institute for the Arts, Rice University.
Jacobsen, Adrian. 1977. *Alaskan Voyages.* Translated by Erna Gunther. Chicago: University of Chicago Press.
Swanton, John. 1909. "Contributions to the Ethnology of the Haida," *Memoirs of the American Museum of Natural History,* Vol. VIII.
von Sydow, Eckart. 1923. "Die Kunst der Naturvölker und der Vorzeit," *Propyläen Kunstgeschichte I.* Berlin.

PART THREE

ART AND SOCIAL STRUCTURE

Lee Anne Wilson

Most contemporary Americans are familiar with the idea that art objects are status symbols reflecting the wealth and culture of the owners. This is by no means a unique concept. In most societies art objects are not only intimately linked to concepts of status and wealth, but they are also used to empower rulers, enforce laws, pass judgements, reinforce socially acceptable behavior, uphold tradition, communicate core values, and otherwise maintain the fabric of society.

In Africa, for example, two main types of government are common—a society of elders, or a divine or semi-divine ruler. A number of tribes in northwestern Liberia and southern Sierra Leone have a society of male elders known as the Poro Society, which functions as the main governing body through the medium of masks. In contrast to this all male body is the female Sande Society (see Warren d'Azevedo on the Gola, *Mask Makers and Myth in Western Liberia*, page 111 and Ruth B. Phillips on the Mende, *Masking in Mende Sande Society Initiation Rituals*, page 231) whose members also don masks. While male masked societies are common in many areas of the world, it is most unusual for women to wear face masks. The west coast of Africa is virtually the only area where women have a masked society comparable to that of the men. This does not mean, however, that women are completely excluded from male masking activities. Monni Adams (1986) has demonstrated that women among the Western Wè of the Ivory Coast play essential roles in support of male masked festivals, although the women never don masks. In other areas of the world activities associated primarily with women are frequently necessary for completion of seemingly male-dominated ceremonies.

Wearing masks to provide governance is an intentional choice since, in most areas, when an individual dons a mask and costume he or she is no longer thought of as human but actually becomes the spirit represented by the mask. In this sense it is the spirit rather than a tribal member who does the judging, enforces the laws,

carries out punishments, or announces new ideas. Thus, no single individual is responsible for making such weighty decisions. In actual fact, it is the group members who jointly and with a great deal of discussion arrive at the solution.

In areas of Africa ruled by a divine king, such as the Kuba discussed in the article by Monni Adams (*Kuba Embroidered Cloth*, page 133) or the royal city of Benin as revealed by Paula Girshick Ben-Amos (*Human and Animals in Benin Art*, page 152) the process of government ultimately rests in the hands of one individual rather than with a group. However, since this one individual is descended directly from mythic ancestors, he rules by divine intervention. In this sense, the rule of the divine king descends from the supernatural just as that pronounced by the masked spirit of the society of elders does, thus relieving any one individual from complete responsibility while at the same time adding divine sanction.

Across the Pacific, in the Hawaiian Islands, Tom Cummins (*Kinshape: the Design of the Hawaiian Feather Cloak*, page 165) shows us that an individual's kinship ties and rank are made visible by specific items of apparel: elaborate feather cloaks. In addition, these feather cloaks are important symbols of rulership. In this manner they are comparable to the beaded crowns of the Yoruba of Nigeria, Africa, which serve to both elevate and contain the power of the ruler (see Thompson 1972). While these objects make manifest the status of the ruler, the ruler must not abuse them or their power will be turned against him.

Art objects can also indicate family or individual status. For example, Stanley Walens (*The Weight of My Name Is a Mountain of Blankets: Potlatch Ceremonies*, page 184) discusses ownership as a means of demonstrating status and rank among the tribes of the northwest coast of North America. Among these tribes, virtually everything is "owned," from actual physical objects (such as elaborately carved and painted boxes and bowls, spoons made from mountain sheep horn, and complex woven garments known as "Chilkat" blankets) to membership rights (to belong to one or more "secret" societies), to hunting and fishing territories, to family or clan myths, names, and ancestors. Even the right to sing a specific song is the property of an individual. Ownership of all these "things" is passed down from one generation to another, usually through the mother's brother (uncle) in a carefully circumscribed pattern and serves to define the owner's place within the group. But the transfer of ownership must be witnessed and the witnesses must be properly reimbursed for their time and trouble in attending the elaborate ceremonies of transfer called *potlatches*. In this sense, the transfer of ownership becomes part of an elaborate system of reciprocal gift giving that serves to redistribute wealth while at the same time affirming status and consolidating group loyalty. Thus, for the northwest coast groups, tangible objects as well as more ephemeral concepts are essential to maintain the social structure.

In many groups throughout the world, peer pressure (in the form of how or how not to behave) is often made manifest through art objects. This is especially apparent in groups where masked societies are essential for maintaining both social and ritual cohesion. For example, among the Afikpo Ibo (Ottenberg 1972) of southeastern Nigeria, Africa, as well as the Hopi (Hieb 1972 & 1985) of the southwestern United States, elaborate masked ceremonies serve ritual, social, and political ends (see Part Four). In these and other groups, masked and/or costumed figures serve to remind the people of proper behavior, often by acting in improper

ways, thus provoking ridicule and laughter. Not only do these figures relieve tension in societies which have strict codes of behavior, but they also reinforce proper modes of behavior by saying, in a sense, "Don't do as I do."

Another important aspect of masked societies is their ability to inculcate traditional values in the youth of the society. This is often accomplished through training sessions called bush schools. Since many masked societies are for men only, the bush schools often prepare young men for eventual assumption of their proper roles in adult male society. However, both Ruth Phillips (page 231) and Warren d'Azevedo (page 111) discuss how the female Sande Society complements the male Poro Society, providing parallel paths to knowledge and access to adult power, and ultimately preparing young girls for their roles as wives, mothers, artists, dancers, and healers (see Boone 1986).

As Fraser and Cole (1972) have shown, art is intimately linked to leadership, authority, skill, power, and tradition. The ruler may own, commission and distribute specific works of art as a means of enhancing his role. Other objects may contain the authority to bestow rulership on their owner, while still others uphold the traditional values of the society, or even pass them on to the next generation. In this fashion art objects, along with their inherent meanings and associated codes of behavior, serve to maintain and mend the fabric of society.

Bibliography

Note: In addition to references cited in the text, this bibliography also includes a sampling of related works on the role of art in society.

Adams, Monni. 1986. "Women and Masks among the Western Wè of Ivory Coast," *African Arts*, vol. 19(2), pp. 46-55, 90.

Boone, Sylvia Arden. 1986. *Radiance from the Waters: Ideals of Feminine Beauty in Mende Art.*New Haven: Yale University Press.

Brown, Betty Ann. 1984. "Mixtec Masking Traditions in Oaxaca," in *Arte Vivo, Living Traditions in Mexican Folk Art*, edited by James R. Ramsey. Memphis, Tennessee: Memphis State University, pp. 59-67.

Cole, Herbert M. and Chike C. Aniakor. 1984. *Igbo Arts: Community and Cosmos*. Los Angeles: *Museum of Cultural History, University of California.*

Fraser, Douglas and Herbert M. Cole, editors. 1972. *African Art and Leadership*. Madison: The University of Wisconsin Press.

Hieb, Louis A. 1972. "Meaning and Mismeaning: Toward an Understanding of the Ritual Clown," from *New Perspectives on the Pueblos*, edited by Alfonso Ortiz. Albuquerque: School of American Research Book, University of New Mexico Press, pp. 163-195.

———. 1985. "The Language of Dance: Communicative Dimensions of Hopi Katsina Dances," in *Phoebus 4, A Journal of Art History*, edited by Anthony L. Gully. Tempe: Arizona State University, pp. 32-42

Jonaitis, Aldona. 1986. *Art of the Northern Tlingit.* Seattle: University of Washington Press.

MacAloon, John J. 1982. "Sociation and Sociability in Political Celebrations," from *Celebration, Studies in Festival and Ritual*, edited by Victor Turner. Washington, D.C.: Smithsonian Institution Press, pp. 255-271.

McLeod, M.D. 1981. "The Court and Regalia," in *The Asante*, by M.D. McLeod. London: British Museum Publications, Ltd., pp. 87-111.

Newton, Douglas. 1971. *Crocodile and Cassowary: Religious Art of the Upper Sepik River, New Guinea.*New York: The Museum of Primitive Art.

Ottenberg, Simon. 1972. "Humorous Masks and Serious Politics among Afikpo Ibo," in *African Art and Leadership*, edited by Douglas Fraser and Herbert M. Cole. Madison: The University of Wisconsin Press, pp. 99-121.

Powell, Father Peter J. 1977. "Beauty for New Life: An Introduction to Cheyenne and Lakota Sacred Art," in *The Native American Heritage*, edited by Evan Mauer. Chicago: The Art Institute of Chicago, pp. 32-56.

Rose, Roger G. 1980. *Hawaii: the Royal Isles*. Honolulu: The Bernice P. Bishop Museum Press.

Rudy, Suzanne. 1972. "Royal Sculpture in the Cameroons Grasslands," in *African Art and Leadership*, edited by Douglas Fraser and Herbert M. Cole. Madison: The University of Wisconsin Press, pp. 123-135.

Sieber, Roy. 1966. "Masks as Agents of Social Control," in *The Many Faces of Primitive Art*, edited by Douglas Fraser. Englewood Cliffs, New Jersey: Prentice-Hall, Inc., pp. 257-263.

Thompson, Robert F. 1974. "Dan Masks and the Forces of Balance," in *African Art in Motion*. Los Angeles: University of California Press, pp. 159-170.

——.1972. "The Sign of the Divine King: Yoruba Bead-embroidered Crowns with Veil and Bird Decorations," in *African Art and Leadership*, edited by Douglas Fraser and Herbert M. Cole. Madison: The University of Wisconsin Press, pp. 227-260.

8

Mask Makers and Myth in Western Liberia

Warren L. d'Azevedo

This paper is concerned with the role and status of certain woodcarvers among the Gola and some adjacent peoples of western Liberia. These craftsmen perform a unique service which highlights the function of a particular kind of personality and creative ability in the tribal societies of the region. They are the makers of the supreme objects of aesthetic appreciation and ritual deference, yet woodcarvers are persons of ambivalent social character who are seldom eligible for a titled position among the custodians of tradition and sacred institutions. In the following pages I will describe a situation in which the virtuoso craftsman emerges as the creative artist at odds with his society, while at the same time being accommodated by a symbolic and traditionally validated role which orients his talent to a prime social task.

The material upon which this discussion is based was collected among the Gola, Vai, and De chiefdoms of the coastal section of western Liberia. These peoples constitute a segment of what has been termed the "Poro cluster" of tribes whose distribution and relatively common cultural features have been described elsewhere [d'Azevedo, 1962 (1) and (2)]. Briefly, however, it may be pointed out that the Poro-type pantribal and intertribal male association has its most intensive distribution among the Mande-speaking and Mel-speaking peoples of north-western Liberia and southern Sierra Leone. Closely connected with Poro is the Sande (or Bundu) female associations which are localized as lodges among the women of specific chiefdoms. They are also spread throughout the region and have a wider distribution than Poro. The tribes of this cluster are divided into numerous petty chiefdoms traditionally controlled by the landowning

Reprinted in abridged form from *Primitive Art and Society*, edited by Anthony Forge, London: Oxford University Press, 1973, pages 125-150 with permission of the author and publisher.

patrilineages of the founders of each unit. The economy is based upon intensive slash-and-burn agriculture with supplementary hunting and fishing. Warfare, trade, population mobility, and periodic confederacies have characterized relations among groups for centuries.

THE MYTH

The greatest public dramas of life are played out in the cycle of ceremonies connected with the recruitment and maintenance of membership in the all-powerful and universal male and female secret associations. The major theme of these dramas is the unresolved rivalry between the sexes and the unrelenting struggle of the ancestors—together with their ancient tutelaries among the nature spirits—to ensure the integrity and continuity of the community. The actors are the uninitiated youth, all the adult men of Poro, all the adult women of Sande, the sacred elders representing the ancestors, and the masked impersonators of the nature spirits who are allied with the founders of the country.

The plot which ties the cycle together is simple and is derived from myth which explains the origin of crucial institutions. In the beginning, it is said, there was Sande. Women were the custodians of all ritual and the spiritual powers necessary for defending sacred tradition in the interests of the ancestors. The initiation and training of females for their roles as wives and mothers was a central task in which the entire community participated. The generations spring from the wombs of women, and it is the secret knowledge of women which ensures the fertility of families, of the land, and of all nature. For this reason, women have always been more diligent than men in the tending of ancestral graves and in the guarding of the shrines of spirits who protect the land.

The primacy of Sande in general myth among the Gola is attributed to the conditions attending their origin as a people. It is believed that all "real" Gola of the extended territory which they occupy today may trace their descent patrilineally (or ambipatrilineally) to the ancient lineages of chiefdoms in an interior homeland region known as Kongba. Thus, the founding ancestors of these legendary units constitute the original ancestors of all the Gola, though local genealogies seldom include them except to name the migrant ancestor who is claimed to be the link to Kongba. The original lineages and chiefdoms emerged under a charter between the founders of Kongba and the autochthonous nature spirits whose land they occupied. The particular class of spirits to whom the founders were obligated for patronage were those who resided under the waters—the "water people." These spirits helped the ancient Gola to drive away monsters from the territory, and guaranteed the fertility of the land. In return they required an exchange of women in marriages that would validate a co-operative alliance between the human and spirit communities.

Thus the spiritual male and female spouses of the founders became the ancestral tutelaries whose descendants formed similar alliances with complementary human descent groups in each succeeding generation. Moreover, in each generation there were to be certain human beings assigned to the special role of regulating commerce between human beings and the water spirits. These persons

were designated by titles which passed down through specific core lineages of those founders who originally held such positions. The first *Mazo* was, therefore, the woman chosen among the founding families to carry out this task. The title became a property of her patrilineage, while one of her elder male lineage mates was given the title of *Mama fuwɔ* to serve as her sponsor in sacred office. The *Mazo* and her "brother" were responsible for the organization and control of all women of the legendary Gola chiefdoms in order to inculcate in them the crucial tradition of alliance with the nature spirits, their sacred role as potential wives and procreators in two worlds, and their special responsibilities with regard to the propitiation of two classes of ancestors. This is how, it is said, Sande came into being.

In Sande ritual, the *Zogbɛ* is the masked impersonation of the male water spirit of a lineage—parallel to that of the *Mazo's* core lineage—in the spirit community (Figure 1). During sessions of Sande, or at any time when his services are required, he asserts the ancient rights of his "people" by venturing into the human community in visible form to officiate and to ensure the continuity of the charter. The women of Sande are referred to as his "wives," and human males are not to interfere with any of the demands that might be made upon their own wives or their female relatives while Sande is in session (Figure 2). In a populous chiefdom there may be many *Zogbea* visiting from the other world, each presiding over a band of women assigned by the local *Mazo*. During the session, women are said to "control the country." Their normal activities are curtailed by rigorous involvement in the complex rites and numerous tasks of "cleansing the land," training initiates, and tending ancestral shrines. Men complain that their own interests are being neglected, but the powers of Sande are great and its work must be carried out for the good of all.

In brief outline, these are the essential features of Sande as they are expressed in general myth. The myths of the founding of new chiefdoms in the

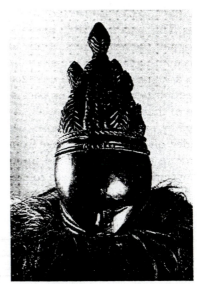

Figure 1
The mask of a *Zogbe* of Gola Sande.

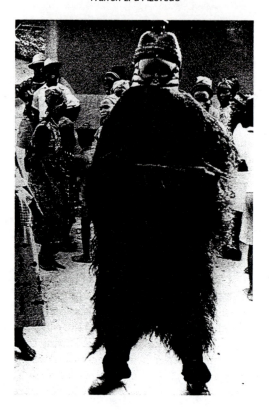

Figure 2 A *Zogbe* with Sande attendants.

expanded territory of the Gola are local restatements of the grand design, and ritual is an enactment of modified commitments to the ancient charter. The founding ancestor is directed by a diviner to make a pact with the local nature spirits. This pact invariably involves a "friendship" with a woman of the spirit world, and the assignment of one of the founder's female relatives to a similar alliance with a male relative of his spirit spouse. Just as the founder is frequently given a vague genealogical connection with the lineages of Kongba, the local nature spirits with whom the pact is made are thought to have kinsmen among those of their kind who were allied with the original Gola. Local Sande lodges are led by a succession of women who inherit the title from a core lineage of the founder, often the same lineage from which kings and other officials are selected. Therefore emphasis is placed upon sacred obligations to local ancestors and nature spirits, but always with reference to the stipulations of the grand charter, the sacred lore of Gola origin.

In the ancient days of peace and perfect social order—long before the Gola began to migrate from Kongba—it is said that Sande was the single and all-powerful sacred institution. Though men ruled, women controlled all communal intercourse with the ancestors and their spirit guardians, and men submitted to female domination in ritual matters. It is even suggested, in some versions of this

women in control of ritual

lore, that Gola men had not learned about circumcision in those distant days. But there came a time of terrible wars in which enemies attacked and tried to destroy the country. When the men of the Gola chiefdoms attempted to organize themselves for defence, the women resisted because it interfered with the activities of Sande. In their view, Sande, alone, with its powerful spiritual guardians would be sufficient to protect the land and its people. But the attacks continued and the situation became desperate. Furthermore, men learned that women cannot be trusted with the secrets of war; for though they jealously kept the secrets of Sande from men, they would speak out the plans of men to their enemies. This is how the ancient Gola men learned what every man knows today. A man cannot trust his wife unless she is from his own family, for a woman is loyal only to her own kin and to Sande. A woman can betray her husband's family and chiefdom.

Thus women and war brought about Poro. With war came disaster, and women could not understand it or cope with it. As a consequence, it was necessary for men to find a special instrument of power of their own. They searched the forests of the interior until they discovered an awful being, much like the monsters which had once roamed the land and had been driven out by the ancestors and their spirit allies. The being was captured, and certain brave men were assigned the task of subduing and tending it. They, and certain qualified descendants of their lineages came to be known as the *Dazoa* of Poro, the highest and most sacred officials of the men's secret organization. The strange being they had captured became the Great Spirit of Poro whose aspect was so frightful that women could not look upon it, and even the *Zogbea* were reluctant to test its power. Armed with their new spirit, the men were able to subdue the women. Boys began to be taken from the care of their mothers at an early age in order to prepare them for the rigours of manhood. They were removed from all female company to teach them obedience to their elders, secret signs by which they would recognize their fellows, endurance of all kinds of hardship, self-reliance, the arts of war, as well as co-operation and absolute loyalty to the Poro. Women and strangers were told that the boys had been "eaten" by the Poro Spirit which would eventually give birth to them in a new adult form. Circumcision was explained as part of the process of being reborn. The Poro Spirit removed all that was "childish and useless" in order to produce men. During the Poro session the Great Spirit was never seen by outsiders. It remained in the seclusion of the secret forest grove of Poro guarded by a *Dazo* and the leading men. But its terrible voice could be heard admonishing the boys and raging to be set free among the uninitiated of the community.

When the Poro became strong, the women beseeched the men to remove their Great Spirit and allow things to be as they were. But the men refused. They did, however, agree to an arrangement. The *Mazoa* of Sande and the new *Dazoa* of Poro decided that each association would take its turn of control over the country. The Poro would have four years to carry out its tasks, and the Sande three years. At the end of its session the presiding association would remove its spiritual powers from its grove to allow for the entrance of the other. Since that time, the number four has been the sign of men, and the number three the sign for women.

THE ENACTMENT

*Poro/
Sande
switch*

In all the extended chiefdoms of the Gola, the endless rotation of Sande and Poro sessions are co-ordinated by the *Dazoa* who are responsible for various sections of territory inhabited by Gola. The Poro sessions do not begin until all the chiefdoms have completed the sessions of Sande and there has been a year or more of interval "so that the country can rest." Then the *Dazoa* secretly confer and send word among the groves of the chiefdoms that Poro is about to claim the country. Just as in the ancient days of origin, the Poro Spirit is led stealthily into the chiefdom and confined in the local Poro grove. Word spreads that it has been brought from the deep interior forests and that it is wild and hungry after its long absence. Young boys and uninitiated men begin to disappear causing consternation to mothers and quiet satisfaction to fathers.

When all is in readiness, a *Dazo* appears in each of the chiefdoms and announces that the time has come for men to assume leadership again. At the sacred towns of the groves he heads a procession of all the men of Poro to the Sande enclosure where the *Mazo* and the leading women of Sande are waiting. The *Dazo* requests that she turn over her power and send the *Zogbe* protectors back to the forests and rivers whence they came. He informs her that the Great Spirit of the men is already in the Poro grove and that it has begun to gather boys for training. The *Mazo* confers with her attendants and reluctantly agrees. At that moment the Poro Spirit is heard singing in the grove. It sings of its great hunger, and begs that uninitiated boys be brought to it for food.

During the following weeks all the boys of appropriate age disappear from the villages of the chiefdom, and uninitiated men are ambushed on the roads and will not be seen again until the end of the session. It is explained to the women that though they have been eaten by the Poro Spirit, they will be born again from its stomach in a new, clean, and manly form. It is a time when women weep for their lost sons and men smile wisely because of the return of masculine principles to the world. There is much rejoicing among men, and emblems of male supremacy and strength appear at all feasts and public ceremony. Foremost among these are the masked figures, the "dancing images," which represent spirits controlled by the various subgroups of local Poro. One of these figures is known as *Gbetu* whose magnificent helmet mask and awesome acrobatic feats create an atmosphere of intense excitement at feasts and other ceremonies (Figures 3, 4).

*Gbetu
male
mask*

However, these masked figures do not have the same ritual importance as the visible *Zogbe* of Sande or the invisible Great Spirit of Poro. They are the "entertainers" or "mummers" of Poro and represent minor spirits who have been brought to enhance the ceremonies of men. They are handled by their attendants as scarcely tamed animals who must be whipped, cajoled, and contained. This is a symbolic projection of the role of the great Poro Spirit which must be rigorously controlled by the men of Poro to restrain it from doing harm to the community.

At the end of the four-year Poro session, it is announced that the Great Spirit is about to give birth to newly adult males. A mass mourning ceremony takes place as a wake for the boys who had "died" four years before. The ceremony

4 years of initiation?!

Figure 3 A *Gbetu* of Gola Poro being presented at a festival.

concludes with the entrance of the initiates into town, their bodies rubbed with clay, and their faces and movements those of dazed strangers. They do not recognize their mothers or other female relatives. They must be encouraged by gifts and endearments to speak or to look at human beings. This condition lasts

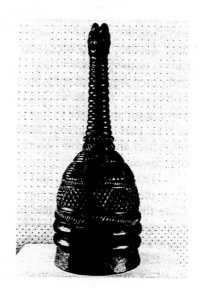

Figure 4
The mask of a *Gbetu* of Gola Poro.

for days until they are ritually "washed" by the elders of Poro. They are dressed in all the finery their families can afford and are placed on display in the centre of the town. Their first act is to demand food, but they show their new independence and male vigour by wringing the necks of chickens brought to them as gifts. They address their female relatives authoritatively and maintain an attitude of aloof contempt for all commonplace human emotions. The final ceremony is marked by their public performance of the skills they have learned during the Poro session. There are exhibits of dancing, musicianship, and crafts after which they return to their homes accompanied by proud parents.

Within a short time the women of Sande will have laid the plans for reinstatement of their own session. At last they approach the chief and elders of the chiefdom with the request that the *Dazo* return and remove the Great Poro Spirit from the country. When the time is finally agreed upon, the *Dazo* is called to conduct the ceremony of transition. His demeanour is one of great reluctance and annoyance. Why has he been disturbed? In what way have the women shown that they have earned the right to take over the country? Each day he dances in the central clearing of the town surrounded by his musicians and the men of Poro. He continues to deny the solicitations of the *Mazo*. At last he relents, and a time is specified for the removal of the Poro Spirit. The women are ordered into their houses along with all the uninitiated, and the shutters and doors are closed. The Great Spirit can be heard singing sadly as it is led by the men from their grove and through the town. At moments it rebels and howls in anguish. It must be dragged forcibly, and its teeth leave long grooves in the dirt of the paths. At last it is gone, and the sound of guns being fired indicate that the men have succeeded in driving it away in the company of its keeper, the *Dazo*.

The *Mazo* is summoned from her house to meet with the elders of Poro in the centre of the town. They hand her the emblem of power of the secret societies. The moment this transaction takes place, she and her attendants shriek with joy and call the women to take over the country. The men flee into the houses as the *Zogbea* and their singing women attendants stream from the sacred Sande grove and from the various houses of the town. The *Zogbea* rush here and there, waving their spears at tardy men, and the women cry warning that the country will now return to proper leadership. The entire day is spent exacting fines from chiefs and other important men for the "crimes" that have been committed during the rule of men. They admonish children and remind them of their duties. Towards evening the men dare to move about more freely. They are invited by the women to take part in a joyous festival during the night, but are warned to remain respectful and humble before the *Zogbea*, "our new husbands who have come to rule the land."

This cycle of male and female secret society activity is part of the rhythmic chronology of tribal life and may be said to mark the decades of passing time while the agricultural cycle marks the years. Individuals frequently determine their ages by the number of farms since their birth as well as by the name of the secret society session in which they were initiated. The institutionalization of male and female principles in two compulsory organizations, each with its own structure of administration and its own secret body of knowledge, has a profound

ly pervasive influence throughout every aspect of culture. It qualifies all interpersonal relationships by its rigorous codification of male and female roles and by its pressure to conformity with traditional concepts of ideal social order involving absolute obedience to authority as represented by the hierarchies of age, lineage status, and official position. The notion of "secrecy" is a paramount value in this system—secrecy between men and women, secrecy between the aged and the young, and secrecy between the initiated and uninitiated.

The most common expression of this mutual exclusiveness of spheres of knowledge is the continual reference to "women's business," "men's business," or "society business." Men will disclaim any knowledge of the content of Sande ritual or training, and women adamantly deny any curiosity concerning the mysteries of Poro. Children must never inquire into these matters, and non-initiates are warned that banishment or worse will befall anyone whose eyes, ears, and minds are not closed to all mysteries which lie behind the public performances of the secret associations.

In this context, the mutual exclusiveness of activities and information creates the necessity for intermediaries between Poro and Sande. These roles are performed by certain of the elder women and men who carry sacred titles in the local organizations. All such persons are assigned the general title of *zo*. Thus, the *Mazo* and the *Dazo* are the titled heads of the Sande and Poro respectively. The *Mazo* is aided by three or four elder women attendants who are also *zonya* (plural), and there are a number of colleagues and assistants of the *Dazo* in each Poro lodge. All such persons are *zonya*, and their specific titles are conferred by Poro and Sande in accordance with criteria of age, service, personality attributes, and required lineage status. The formal title of *zo* may also be conferred on certain other respected elders who are masters of crucial knowledge and skills that have benefited the entire community. Such persons may be respected herbalists, diviners, bone healers, snakebite curers, or special craftsmen. Elder blacksmiths who have been permanent residents of the community and who are members of high ranking lineages are invariably *zonya*. The term *zo* is also used informally as a reference to any admired and proficient individual in the same sense as we speak of someone as a "master" or "expert," but this is quite distinct from the use of the title for the traditional offices.

The leading official *zonya* are said to be beyond the age which restricts their involvement to one or other of the secret associations. Their age and experience are considered to have removed them from the petty rivalries of local lineage segments, from the temptations and irresponsibilities of younger persons, or from the passions and immediate concerns of sexuality and procreation. They are the "grandparents" of the people and are about to join the ancestors. The *Mazo* and her attendants are women who know all matters pertaining to Sande and who have also learned the major secrets of Poro from their counterparts in the male organization. The *Dazo* and his aides are also informed of the mysteries of Sande. It is through the agency of these elders that the continuity and mutual co-operation of the sacred institutions is maintained through each generation. The average person views this commerce between the closely guarded provinces of male and female authority

with awe, and a high degree of charisma is associated with the roles of those who move freely in this regard.

This charisma is shared to some degree by the *zo* specialists who perform necessary services for both Poro and Sande which require knowledge of sacred procedures. The blacksmith is a prime example of such a role in that he is not only master of the resources and techniques of metallurgy which provide the implements of agriculture and warfare, but he is the secret maker of certain emblems of sacred office as well as of the tools of circumcision and scarification for both associations. In this position he commands information about the most secret rituals. To some extent other *zo* specialists perform duties which might take them, under certain carefully arranged conditions, into the groves of the society of the opposite sex. It is this peculiar aspect of their roles which is a basic feature of official *zo*-ship.

MASK MAKERS AND THE PERSONAL MYTH

Among the specialists who perform crucial services for both Poro and Sande, the position of the master woodcarver is unique. Despite the fact that the woodcarver is the creator of the masks which represent the most powerful supernatural guardians of the secret societies, I know of no instance where the formal title of *zo* has been assigned to a woodcarver during the period of his most productive activity as a craftsman. The product of the woodcarver's art is central to the public drama of Sande. He participates intimately in the affairs of the woman's organization to a degree allowed to no other man excepting the eldest sacred officials. His involvement in the secret stagecraft and technology of ritual is every bit as important as that of the blacksmith. Yet the carver, regardless of the excellence of his work, appears to be excluded from the company of the *zonya*.

As these matters are subject to the most extreme secrecy and sanction, it is rarely possible for the investigator to inquire directly about them. I spent more than a year among the Gola and other neighbouring peoples before I encountered woodcarvers who would reveal that they were producers of masks, and it was much longer before I was able to discuss these materials with them or with any other person. Fear of exposure is intense, for heavy fines and disgrace can follow the discovery that an individual has converted sacred objects to the external market or has revealed the conditions of their production.

I found, however, that woodcarvers were quite willing to discuss any aspect of their craft and to produce examples of it for non-traditional purposes as long as they could be assured of being undetected by those members of their own culture who would bring them to account. This was not true of any of the official *zonya* whose circumspection and limited tolerance with regard to questions concerning Sande and Poro is a standard response. It seemed to me, therefore, that woodcarvers represented something quite unusual among those persons who were involved by skill and knowledge in the preparation of the impressive effects and illusions of public ritual. It appeared that they were less moved by the social value of their role than by subjective concerns such as recognition for the masterpieces for which they cannot receive direct public acclaim. These early

impressions proved to be well-founded, and subsequent observation has confirmed my view that the woodcarver in this area represents, in personal orientation as well as social status, many of the characteristics which are associated with our own concept of the artist.

Vocational specialization is not highly developed among the coastal groups of western Liberia. There are few full-time specialists of any kind, and these invariably supplement their incomes by farming or periodic shifts to alternative pursuits. The professional *zonya* are relieved of direct subsistence tasks due to their age and hereditary status within the large and relatively wealthy lineages of the founders of a chiefdom. Political offices are also hereditary and provide, at least for major chiefs, the emoluments and services which make a full-time political vocation possible. Among craftsmen, it is only the local official blacksmith who can be said to be a full-time professional supported by the local community. His position is also an hereditary one, and the nature of his craft is such that there is a continuous demand for his products locally, and a traditional assignment of community labour to assist him in farming and other subsistence activities.

Professionalism, aside from the above vocations, is achieved only by those who appeal to a wider area of demand than that of the local community, or by those who are supported as clients of wealthy patrons. Thus, itinerancy and patronage are requirements of any full-time specialization which does not carry the traditional credentials of local sponsorship. Highly skilled singers, dancers, musicians, and craftsmen may make their services available throughout a region and are frequently solicited from distant chiefdoms of other tribes. In the past they were part of the heterogeneous retinues of great chiefs, and were often the instruments of competition for prestige among powerful rulers. In more recent times there has been some replacement of these traditional supports of specialization by new external spheres of demand created by foreigners and by national government interest in tribal culture.

With the exception of the locally sponsored *zonya*, an aura of mixed distrust and admiration surrounds the full-time specialist of any kind. As persons of exceptional ability, they are no longer fully dependent upon sponsorship or approval from their own families, or from the community of their origin. They are likely to shift their loyalties in accordance with the fortunes of patronage. Every local group of any prominence has its own roster of talented amateur craftsmen and performers who contribute to the on-going economic, recreational, and ceremonial needs of the community. The community can also rely to some extent on its own healers and diviners who are permanent residents engaged in part-time practice. But few people can avail themselves of the services of the famous specialist whose name has spread far and wide, who has become associated with legends of remarkable successes, and who is sought after by the wealthy and the great. Their talent seems to be derived from special powers that others lack, and their individualism and apparent freedom of choice is attributed to the kind of "luck" that comes from commerce with private supernatural agencies.

supernatural

Spirit
friends

Almost without exception, renowned specialists are believed to be sponsored by one of a variety of possible tutelaries among the classes of *jīna* who are thought to engage in "friendships" with certain human beings. Such tutelaries are called *neme* among the Gola, a term which means literally "the thing belonging to one," but they are also spoken of as "friends." All great and successful persons are suspected of having a spiritual liaison of this sort. The *neme* relationship is both feared and envied. Since it is often kept secret, there is no way for the average person to be certain that it exists except by careful observation of the behaviour and fortunes of those suspected. Among the venerable *zonya* there are those who are known to be sponsored by a powerful *jīna*. Yet they have the gratitude and trust of the community because their private spiritual guardian has been inherited by them from among the totemic spirits who have been associated with their ancestors since time immemorial. Though the *zo* may not always speak freely of this spiritual connection, the fact of its existence and, usually, the conditions of its consummation are matters of public tradition.

There are, on the other hand, many free-roving *jīna* who seek mutually rewarding friendships with human beings. Such friendships may be established before a person is born, or they may come later in life as a result of dream or a waking encounter. There are good and bad *jīna* just as there are good and bad human beings. An evil or ambitious person may become the ready instrument of an evil spirit. Most persons claim that they have, at one time or another, rejected the advances of *jīna* who approach them with seductive promises of love and luck. The rejection must be emphatic, for once a pact is made the *jīna* has complete power over one and will wreck vengeance if it is broken. A good human being may make a private pact with a free-roving *jīna*, but such pacts are usually made early in life, or even by the human soul before a person's birth. Sudden and unexpected success at the expense of others is always attributed to either sorcery or to a newly established pact with an evil *jīna*, whereas consistent excellence in a line of work is usually attributed to a benign and lifelong spiritual friendship. From the point of view of the average person, however, any such phenomena are considered precariously unpredictable and fraught with danger for the community.

In this context, a clear distinction must be made between the notions of communal and private spiritual guardianship. As pointed out above, the spiritual sponsorship of the honoured *zonya* is derived from the totemic tutelaries of the ancestors of the high-status descent groups of the community. These are closely connected with the supernatural beings who are represented in Sande ritual. The ancestors acting through their living agents, the sacred elders, demonstrate the essence of the myth which unites the community with its ancient protectors among the autochthonous nature spirits of the locality. It is under these conditions that the *neme* concept is expressed on the level of communal tradition and organization. At the same time, there are numerous opportunities for the private pursuit of fortune through the auspices of human or supernatural patrons. The use of personal sources of power or luck is considered to be the most direct means to advantage. It does not require the arduous courting of public favour, the obsequious obedience to one's elders, or the ascribed virtues of wealthy family

or high lineage rank. But the risks to self and family are great, for the powerful controls exerted by the sacred institutions are neither effective nor enforceable under these conditions.

The personality characteristics often associated with renowned independent specialists are conceit and lack of humility before superiors. These are traits which are said to accompany the aggressive assurance which comes from having a strong private tutelary. It is much the same behaviour which one might expect from a person who is backed by a powerful human patron who protects him from the indignation of others and encourages his wilfulness as a reflection of the patron's own prestige. Great chiefs of the past were surrounded by "followers" or clients, many of whom were from foreign chiefdoms and not connected by ties of kinship to the local community. These were warriors, diviners, entertainers, and craftsmen of all sorts who had become attached to the ruler's household. The favouritism afforded them was frequently the source of friction within the chiefdom, for they were partially insulated from the sanction of local kinship groups or secret associations. Such persons were sometimes referred to as the "spoiled children of the king" whose fate depended entirely upon the fortunes of the chiefdom and the whims of the royal household.

In the case of individuals thought to have private supernatural sponsorship, the traits of pride and arrogance might be even more pronounced and less susceptible of regulation. This was particularly true of highly skilled persons whose products or services were so superior to those of others that they were in constant demand despite their strange behaviour. Not all specialists were in this category, for many disclaimed any supernatural guidance. But others, among whom were usually the most famous, tended to proclaim and dramatize their spiritual resources. Some who presented themselves in this light commanded the respect due only to the official *zonya*. It might be said of such a person that "he is a true *zo* for his work," which is a high form of praise, but also indicates that he is a *zo* without portfolio, so to speak. One might also hear the expressions "he is a *zo* before his time," or, "he has crowned himself *zo*," suggesting awareness of the ambition and striving for recognition that is frequently a component of the personality of the talented and popular person.

Though these characteristics were in the past, and are today associated with all specialists whose excellence appears to be derived from private connection with supernatural agents, they are said to be especially evident among those whose skills are demonstrated in public display, and who exhibit themselves or their works at festivals and ceremonies. Famous singers, dancers, musicians, story tellers, and masters of legerdemain are commissioned to participate in these events, and many others come unsolicited to collect gifts. Much of the quality of any great gathering, whether it be a funeral feast, a celebration for a dignitary, or the festivity surrounding ritual, is provided by the excitement of competition for public recognition among these performers. Great female singers, in particular, are centres of attention. Many of them are already legend because of their important lovers, their endurance and creativity as leaders of songs, their beauty, and the personal myth of supernatural inspiration which they help to perpetuate. Such women often claim to have a *jÍna* lover who trains their voice and brings

them songs. The *jīna* is not jealous of human husbands or lovers, but is a ruthless taskmaster of their talent and success. Singers are often childless and they will state that barrenness is a condition imposed by their *neme*.

A similar aura of private sacrifice and supernatural liaison surrounds other exceptional performers and artisans whose fame has spread far and who seem to have found alternatives to the limited avenues of advancement in the local community. They are most often young or in the prime of life. They flaunt their unusual deportment and supernatural connections in ways that would be unacceptable from the average person. Yet they may be persons of low birth, disreputable and untrustworthy in all else, and quite unlikely candidates for *zo*-ship even in old age.

The master woodcarver has a special place in this category of persons. As maker of the prime ritual objects of Poro and especially Sande, his craft and his activities are under continual scrutiny. Without his expert services, the required perfection and impressiveness of the masks which represent the spiritual power of the secret societies would not be achieved. Among the Gola, Vai, and De, of the coastal Liberian section of Poro tribes, these masks constitute not only the epitomy of the woodcarver's art, but are a major focus of aesthetic and ritual values. Unlike some of the more populous tribes of the interior, where guild specialization and numerous secret associations in addition to Poro and Sande create conditions for a greater variety and productiveness in woodcarving forms, the coastal tribes concentrate on a few basic types of masks and figurines.[1]

Not all men known as woodcarvers produce masks for the secret societies. Woodcarving, like other skills, is generalized in so far as many young men carve combs, dolls, toys, swagger sticks, and utensils as part of their training in Poro as well as for gifts and petty trade. But the term *yun hema ku* (one who carves wood) is usually applied to a man for whom this activity is a recognized vocation and who is at least suspected of having carved objects of ritual importance. He is also a man whose skill is considered to be extraordinary and who is believed to be inspired by a tutelary. Among woodcarvers themselves there is considerable difference of opinion as to whether supernatural guidance is a necessary factor in superior workmanship and success. Those who claim to receive their "ideas" directly through a "dream" which comes as a gift of a *jīna* friend are emphatic in claiming ascendancy to such work, and state that they are able to recognize the work of "dreamers" as against those who do not dream. When confronted by the fact that a certain carver whom they have praised denies supernatural aid, these men will take the position that the denial is a subterfuge. On the other hand, some carvers who seem honestly to deny any consciousness of supernatural guidance will admit the possibility that they are given such aid without their knowledge. They are also prone to admire the dramatic stance of those excellent carvers who claim to be "dreamers," and who attribute each new work to the productive exchange of the *neme* relationship.

Once the woodcarver has participated in the production of Sande or Poro masks that actually appear in public, he has become a peculiar individual of a type for which there is no counterpart in the culture. The objects he produces are not to be thought of as having been made by human hands but are, rather,

the visible form of a supernatural being. The more remarkable his execution of the mask, the greater is the reinforcement of the desired public illusion, and the greater is his surreptitiously acknowledged fame. No one is ever to allude to a mask as having been made, or to refer to this aspect of the woodcarver's craft. Children are severely punished for even inquiring about such things, and adults may be fined heavily for an inadvertent slip in public. I found that most very young people claimed never to have considered the possibility of local human workmanship being involved in the production of these masks, and adults who claimed to have wondered about it in their youth say that they had concluded that all such things had been made long ago and were passed down by the ancestors.

Those few who will discuss these matters freely describe their youthful discovery that such objects were made by living men as having evoked in them the most intense anxiety. It seemed unbelievable that ordinary men could have made such marvellous things, and they claim never to quite get over this feeling. For this reason it is still a very shocking experience for rural villagers or their children to come across one of these masks in the shop of an urban trader. Fear and indignation are followed by attempts to track down the source of the illicit object and to punish the betrayer of the secrets. I have noticed in such situations that people do not always recognize the work they see as authentic, but think of it as a possible copy made by an unscrupulous Mandingo or other foreign craftsman. This response is, I think, genuine, for few people in the more traditional sections of the interior see these masks apart from their public presentation in ritual, and tend to perceive them quite differently when these conditions are not operative. A striking exception to this is the response of woodcarvers themselves. They make immediate judgements about masks as masks, as products of degrees of skill, and as representative of the styles of particular carvers. Very few other members of the culture make objective judgements of this kind. Discussions concerning the quality of a piece of workmanship rarely occur except on those occasions when certain leading persons in either Poro or Sande prepare to commission a carver to copy an old mask or to create a new one.

A degree of choice is exercised in the selection of a carver, but the choice is limited by the scarcity of carvers and by the vast difference in cost between the work of an ordinary craftsman and that of the rare master carver. The importance of a particular mask does not, however, depend entirely upon the quality of workmanship. Each of the spirit impersonations has its own name and a distinct "personality" expressed in its dancing, its public mannerisms, and through the legends of its peculiar powers. Thus certain masks which are seen in ritual may be, from the master carver's point of view, very poor workmanship; yet the respect and admiration afforded it by the public and by its ritual followers may be great. On the other hand, the appearance of a magnificently executed mask will invariably elicit expressions of awe and delight from a crowd. The aesthetic values awakened by technical proficiency and creative innovation are an enhancement of the fundamental traditional values associated with these ritual objects, but are not crucial to their effectiveness. The artistic component is, therefore, optional

and the role of the exceptional carver is considerably influenced by the fact that he controls a skill whose rare products are highly desirable but not essential. The work of a less skilled craftsman might be solicited for practical reasons.

In order to understand the special value which is attached to products of exceptional talent, it is necessary to know the conditions under which the woodcarver learns his craft and at what point certain carvers become producers of secret society masks. Formal associations of specialists do not exist among the Gola, Vai, or De. Excepting for the blacksmith and the official *zonya*, few vocations are hereditary. Becoming a specialist, therefore, is individualistic in orientation and involves factors of personal inclination, self-appointment, and opportunity. Most professional woodcarvers with whom I have worked attribute their choice of a vocation to the force of their own incentives in the face of obstacles created by their families. They claim that any special talent is looked upon with jealousy by others and as a potential threat to the family in its efforts to develop loyal and dependable members. Intensive devotion to one activity—particularly where it seems to be accompanied by unusual personality traits—is discouraged by adults. The development of varied skills during the sessions of Sande or Poro training is encouraged, however, for this occurs in the context of a programme directed by adults.

The attitude which woodcarvers attribute to the community with regard to themselves is confirmed by my own observations. Woodcarvers, like professional singers, dancers, and musicians are generally looked upon as irresponsible and untrustworthy people. If they achieve a degree of success, it is said that their independence and self-concern removes them from the control of family or local group, and provides them with alternatives through new attachments and patronage. They are said to yearn for admiration and are always to be found where there are crowds. They squander their resources foolishly and are impoverished in their old age. But most important of all is the danger which everyone knows to surround such work if it becomes the major preoccupation of an individual.

One woodcarver recounted how his mother begged him to give up his work because of its threat to the fertility of the women of the family. Another told how his father had angrily destroyed the tools he had made for himself as a child in imitation of those he had seen in the kit of an adult carver. Others spoke of having run away to a more tolerant relative, or placing themselves under secret apprenticeship to a local or itinerant carver. Such men, whether great or lesser craftsmen, distinguish themselves in retrospect from the other children they knew in youth who may have learned to carve for enjoyment, but who never persevered. They speak of having been driven by an urge to carve that they could not control. This is true even of those who do not admit to an active *neme* relationship. Another common feature of this early experience is a sense of having been different from others in curiosity and ambition. Each claims to have been inordinately ambitious and determined to prove himself superior. This was accompanied by a prying curiosity about things inappropriate to his age, and resulted in rejection or punishment.

THE CREATION OF A DEITY

Among the things which every woodcarver mentions as one of the great wonders of youth were the *Zogbea* spirits of Sande and the masked images of Poro. One Gola carver said that he had surmised as a child of seven or eight that the headdresses of these figures had been carved by living men and that, in one case at least, he had guessed that a particular local carver had been the creator because of a similarity between the designs he had placed on a drum and those on a *Zogbe*. When he mentioned this to other children, his parents heard of it and he was severely whipped. He describes his interest in the masked figures of the secret associations as an obsession, and says that he often dreamed of them or saw himself carving them from blocks of wood. He once swore a number of boys his own age to secrecy and took them to his hidden workplace in the forest. There he showed them the crude Sande *Zogbe* and Poro *Gbetu* that he had carved. He remembers the thrill of experiencing their shocked admiration at his audacity and skill. When this escapade was discovered, his punishment was so severe that he does not speak of it, but merely says that his family wanted to destroy him. They finally sent him away to an older brother in a distant village, a silversmith.

In that village he met an adult carver who made ornate utensils and ornamental objects for trade, but who would not reveal himself as a maker of masks. He took to tracking the man into the bush and soon found where he did his secret work. He spied on him for days as he completed a *Zogbe* mask, an experience he recalls as the greatest and most moving of his life. When it was almost finished, he walked boldly into the clearing. The man sprang up with his cutlass and threatened the boy with death for spying and intruding. But the latter felt such great joy that he had no fear. "I only said to that man, I am here, I can do what you are doing, I want you to show me what you know." The carver eventually took him into training, his first formal instruction.

Shortly after this event he began to have overwhelmingly vivid dreams. Once a woman's voice spoke to him. She offered love and "great ideas." She began to come to him frequently and brought "patterns" which she would draw on the sand before him to guide his work. His first *Zogbe*, sponsored by his teacher and inspired by his *neme*, was so successful that the older carver presented it as his own work to the first group of Sande women who commissioned him for a mask. It was not until much later, however, that his name became known to a few people in the secret associations so that he was approached independently. More than ten years after these experiences (when I had first known him) he was sought after among Gola, De, Vai, and Kpele chiefdoms. He was never able to catch up with the demand for his work. He complained of the exhaustion it brought him and he frequently disappeared for months to do farming or wage labour in order to recover his interest. During these periods he says that his *jína* avoids him, as though she too is resting.

Though differing in detail and intensity, the experience of other master carvers is similar. Some do not claim *neme*, and some are not so driven to direct confrontation with the norms of their society, but the theme of misunderstanding and the lonely pursuit of a beloved craft is consistently expressed. Another theme

which appears in the discourse of adult carvers and their admirers is that of the man who lives daringly, who has surmounted obstacles, and who has intruded into realms which even the elders fear. It is essentially the theme of the precocious child who is ridiculed, defies his elders, masters their knowledge, and then produces something of his own which all must acclaim. The woodcarver may see himself, and is often seen by others, as the omnipotent free agent whose vision is indispensable to the very society which holds him in distrust and contempt. All these factors contribute to the charisma of the master woodcarver, and to the romanticism associated with his role.

The primary source of the woodcarver's unique status among craftsmen and performers is the special connection which they have, as men, with the female secret association. It is in this capacity that they enter into an intimacy with sacred female mysteries that is given to no other men excepting the highest ranking elders of Poro. The elders are considered to be free of the temptations of youth and wise enough to bear the great burden of public trust. The woodcarver, however, is neither an elder nor a *zo*. He is seldom a substantial citizen and in many other respects might be looked down upon by the community. Yet it is this same craftsman who may participate in a highly ritualized and sexualized commerce with the leading women of Sande.

The organization of any local Sande lodge is maintained under the authority of the *Mazo* and her elder *zo* assistants. The initiated women of the community are ranked into three "degrees" in accordance with their age, lineage status, and dutiful service to Sande. The women of the "third degree" are usually of middle age and constitute a body of the leading matrons of the community. It is from this group that the impersonators of the *Zogbe* are chosen. For this role a woman must be a great dancer, show exceptional endurance and forceful personality, and be beyond reproach in performance of Sande tasks. It is also required that she be a member of one of the lineages from which *Mazoa* are recruited, for the rigours of the *Zogbe* impersonation are considered to be an essential and final part of the training for a *Mazo*.

In each Sande grove the number of *Zogbe* groups depends upon the size of the local membership. A *Zogbe* presides over a group of from ten to fifteen followers of second degree status, and is attended by a few assistants of the third degree. The leader of the group, who is also the impersonator of the *Zogbe*, is responsible for the care of the mask and costume of the image. Many of the *Zogbea* of a given local lodge are ancient and have appeared for generations in each Sande session. Upon the death or the upgrading of the leader of a group, a new leader and impersonator must be chosen. This must be someone not only with the necessary status qualifications, but one who has learned the style of behaviour or the "personality" of the *Zogbe* she is to impersonate. Masks and costumes must be renewed frequently, for the life of a mask in active service is seldom as long as twenty years. And should the female membership of the community increase, it may be necessary to "bring out" new *Zogbea*.

Towards the end of the four-year Poro session, the leading women of Sande secretly begin making preparations for the Sande session to follow. The preliminary preparations involve the repairing and renewal of ritual paraphernalia. The

women of each group meet and discuss the problem of commissioning a carver and acquiring the necessary funds. Secret inquiries are made through elder male relatives, and negotiations are cautiously begun. In some instances carvers who have been solicited previously are approached to repair their own work, or to copy a piece. But in the "bringing out" of a new *Zogbe* it is often thought most desirable to find a carver whose work has attracted attention in other chiefdoms and whose fame has spread through the groves of Sande. This is very expensive, for the group is competing with many others for the services of a carver. Only very determined and well-to-do groups of Sande women can afford to make such arrangements. But it is under these circumstances that the greatest excitement is generated and the prestige of a *Zogbe* group is enhanced. It also provides the conditions for the classic relationship between the women and the creator of the sacred image.

Great carvers are commissioned by Sande in one of two ways. If a carver is known by a member of the group, through kinship or other connections, he might be approached directly. Where possible this is the procedure used because it means that the Sande group can deal with the carver independently and it ensures an element of surprise and mystery in the first appearance of the mask. On the other hand, it places the major burden of expense, as well as the control of the arduous encounter with the carver on the women themselves. Therefore, another procedure is more frequently employed whereby the women commission a carver through the good offices of an elder of Poro or the ruler of the chiefdom. Such a man can summon the carver and provide him with the hospitality that may encourage him to accept the commission.

The contact between the women and the carver follows a pattern that obtains to some degree in all relations between skilled specialists and their patrons. But the classic arrangement between woodcarvers and their female patrons is uniquely elaborate and intense. When a carver is approached secretly by the emissary of a Sande group, he is brought "encouragements" in the form of token gifts of money and cooked food. It is said that in the past some carvers were given large sums of money or the equivalent at this point, and presented with a slave. There are also legends of Sande groups studying the amorous habits of a carver and contriving his capitulation to their terms by assigning one of their members to the task of captivating him prior to negotiations. Carvers claim that women make strong medicines in order to control the proceedings. The situation is spoken of as one of "war" in which a man must defend himself against the wiles of women.

In his first dealings with the women the carver impresses them with the importance of his own role. He appears distracted by overwork and reluctant to take a new assignment. He claims to have an enormous thirst for strong drink, to be very hungry, to be in need of cohabitation with a virgin. He keeps them waiting for appointments and may even disappear for a day or two. He attempts to embarrass and subdue them by alluding to the secrets of Sande he has learned in his work. He wittily inquires why it is that they must come to a man such as himself for so important a task, or he berates them for trying to seduce and cheat him. The women, in turn, continue to bring him small gifts and promise to

"satisfy" him if he will do the work. They offer to cohabit with him or to find him the love he wants. All of this is carried out in an atmosphere of intense enjoyment. At the same time the women will appear to be angered by the unruly and disreputable person they have been forced to deal with and, at certain points in the negotiations, may make veiled threats of supernatural sanction.

If the negotiations are concluded favourably, certain terms will have been agreed upon which will guide the relations until the completion of the project. The woodcarver often requires total support during the period of his commission. As the work may take from one to two weeks, during which time he must remain almost continually in the seclusion of the forest workplace, he demands to be fed, entertained, and dealt with in accordance with the personal code which supports his inspiration. Some carvers, particularly those with strong tutelaries, require that the women who visit them in the forest humble themselves by complete nudity. Others may demand that "wives" be brought to them whenever they declare a need for sexual gratification. Still others prefer to work in total privacy, claiming that this is the condition prescribed by their tutelaries. Food and other necessities are brought to a separate place in the forest and left for the carver to take them when he pleases.

The women, for their part, will attempt to direct the work of the carver by insisting upon particular stylistic elements, and lecturing him on the character and powers of the *Zogbe* whose image he is creating. The attempted influence upon the carver may include direction as to the use of certain standard motifs such as deer horns, fish or snake scales, neck wrinkles, hair plaiting, or even the desired facial expression of the deity. A highly individualistic carver will invariably resist such advice, or will accommodate only those suggestions which fit into his subjective plan. Woodcarvers have been known to destroy their unfinished work in a rage because of continued criticism as the work progresses. This is always the cause of scandal, and every effort is made to avoid a break with the carver. Some woodcarvers are more tractable and will accept advice or close supervision with the idea of producing a mask which is exactly what the women have themselves envisaged. But master woodcarvers who are "dreamers" speak of such men as "slaves of the knife" who get their ideas from others and who lower the standards which in former times surrounded the woodcarver with glory.

The struggle between the carver and the Sande group may continue throughout the process of production and even for a long while after. When the mask is completed the carver gives it a name, the name of a woman he has known, or a name given by his tutelary. But the Sande women have already selected a male name for their spiritual "husband," and the carver will insist upon a special fee from them for the right to use another name. He will also instruct the women concerning the care of the mask and inform them of the rules which govern its "life." These rules involve strong prescriptions with regard to the storage of the mask, the maintenance of its surface texture, and certain restrictions that may limit its public appearance or necessitate sacrifices to the carver's tutelary. In this sense, the carver affirms his symbolic ownership of the mask. He tells the women that he has the power to destroy his work at any time if it is treated with disrespect (that is, if the rules are not followed).

This threat of the carver is an effective one, for there are many tales of *Zogbe* masks cracking or bursting into pieces with a loud report before the horrified eyes of the spectators. An occurrence of this kind is considered to be a disaster of such terrible proportions that the sponsoring group of the *Zogbe* may be banished while angry spirits are propitiated. The destruction or "shaming" of a *Zogbe* can be caused by a rival *zo*, or by sorcery. But such an event is frequently attributed to a displeased carver. The source of his displeasure is usually the failure of the commissioning group to complete final payment for his work, or their failure to show him the respect he feels is due him. For this reason, every effort is made to satisfy a carver and to conclude all arrangements with him amicably.

But the peculiar relationship between the carver and the new owners of the mask is never fully terminated. He enjoys special privileges with the group. They refer to one another jokingly as "lovers" and he, theoretically at least, can expect sexual favours from them. The relationship is carried on with the air of a clandestine affair, with the woodcarver in the unique position of a male sharing secret knowledge and illicit intimacies with important women of Sande. Whenever he is present during the public appearance of his mask, the *Zogbe* and its followers must acknowledge him in the crowd by secret signs of deference. The women bring him food, arrange liaisons for him, and praise him by innuendo in their songs.

A productive woodcarver will have helped to create *Zogbea* for Sande lodges in many chiefdoms. During the years of the Sande session he may visit various villages to see his work and to receive the homage due to him from the women. He is among the few men who can move about freely and confidently during this period, for he is protected from many of the sanctions of Sande by his compromising knowledge of its ritual. Woodcarvers speak nostalgically of the pleasure they receive from watching their masks perform as fully appointed *Zogbe*. They mingle with the crowds, listen for comments, and watch for every spontaneous effect of their work. They are critical of the leading woman who impersonates the spirit, particularly if her performance is not equal to the intended characterization, and word will be sent to her through her followers. No other man could think of such direct intrusion into Sande matters excepting the most honoured *zo* of local Poro.

One carver explained to me that the sensation of watching his masks "come to life" was one of intense and mysterious fulfilment.

> I see the thing I have made coming out of the women's bush. It is now a proud man *jina* with plenty of women running after him. It is not possible to see anything more wonderful in this world. His face is shining, he looks this way and that, and all the people wonder about this beautiful and terrible thing. To me, it is like what I see when I am dreaming. I say to myself, this is what my *neme* has brought into my mind. I say, I have made this. How can a man make such a thing? It is a fearful thing I can do. No other man can do it unless he has the right knowledge. No woman can do it. I feel that I have borne children.

This identification of the created object as an offspring is not uncommon among woodcarvers who have a tutelary. They speak of the exhaustion which follows the completion of each mask and how continued production is impossible

without periods of rest and distracting activity. The "dream" which provides the inspiration for a specific work is often referred to as the "gift" of loving *neme* and the completed work as the child of the union.

In the setting of his society, the master woodcarver is an individual whose role is imbued with the kind of romance and grudging admiration reserved for the brilliant and useful deviant in many other societies. The most significant aspect of his role is the freedom it affords him with regard to the traditionally hostile and mutually exclusive camps of male and female sacred institutions. He is the creator of sacred objects and the interpreter of symbolic effects. His product embodies the ambivalent principles of male and female orientations to life, and it is his vision which integrates and expresses them as powerful representations of the sacred. He is, to a considerable extent, the conscious recreator of his own status; for he manipulates the symbolic content of his role through the continual re-enactment of the private drama of spiritual guidance. This private drama represents his individual and subjective mastery of the powers which his society as a whole seeks to control in the cycle of Poro and Sande activities, and in the communal myth of ancestral commerce with sentient nature.

NOTES

1. The highly developed tradition of mask production in relation to Poro and other associations of peoples in eastern Liberia are described in Harley, 1941, and Harley and Schwab, 1947 and Harley, 1950.

REFERENCES

d'Azevedo, W. L., "Some Historical Problems in the Delineation of a Central West Atlantic Region." *Annals of the New York Academy of Sciences*, vol. 96. 1962(1). pp. 512-38.
——, "Common Principles of Variant Kinship Structures among the Gola of Western Liberia." *American Anthropologist*. Vol. 64, 1962(2). pp. 504-20.
——, "The Sources of Gola Artistry," in W. L. d'Azevedo (ed.), *The Traditional Artist in African Societies*, Indiana. 1973.
Dalby. D., "The Mel Languages: A Reclassification of the Southern 'West Atlantic'." *African Languages Studies*, vol. VI, 1965, pp. 1-17.
Harley. C. W., "Notes on Poro in Liberia," *Papers of the Peabody Museum*, vol. 19, no. 2, 1941.
——, "Masks as Agents of Social Control in Northeast Liberia," *Papers of the Peabody Museum*, vol. 32, no. 2, 1950.
——, and C. Schwab, "Tribes of the Liberian Hinterland," *Papers of the Peabody Museum*, vol. 31, 1947.
Welmers. W. E., "The Mande Languages," *Georgetown University Monograph Series*, no. 11, 1958.

Kuba Embroidered Cloth

Monni Adams

The breezes I felt while traveling up the Kasai River in central Africa gave me a historical shiver, as I thought of Bateman's adventurous first ascent of the Kasai in 1889 and Hilton-Simpson's difficulties in 1905 with the woodburning steamer in which he accompanied Emil Torday on the now-famous British Museum expedition to the Kuba kingdom. Although my voyage on the Kasai lasted only an uneventful half-hour while our party and jeep were hauled up the river in a motorized raft to a landing site on the other side, I too was on my way to Kubaland to fulfill a long-held dream of walking in the streets of Mushenge, the fabled royal capital. I was inspired by Torday's admiring descriptions, by Jan Vansina's careful study of Kuba institutions in the 1950s, and most intensely by the beautiful textiles that were produced in this area.

The multi-ethnic Kuba kingdom, probably organized in the early seventeenth century, is set in a fertile area of central Zaire between the Kasai and Sankuru rivers. The various peoples who live within and near this kingdom display an unusual range of artistic expression that includes varieties of poetry, abundant and skillful carvings, and spectacular costumes worn by men and women on special occasions. Kuba textiles used as costume stand out from all others in Zaire in their elaboration and complexity of design. In terms of surface decoration, the most outstanding are rectangular or square pieces of woven palm-leaf fiber enhanced by geometric designs executed in linear embroidery and other stitches, which are cut to form pile surfaces resembling velvet. Only women can turn a simple raffia cloth into a valued plush, often referred to as "Kasai velvets." These decorated panels, some dyed in soft, rich colors, are not only beautiful but they also reflect something significant about African aesthetics.

Reprinted in abridged form from *African Arts*, Vol. 12(1):24-39, 106, 1978 with permission of the author and publisher.

One of the liberating and enriching lessons of modern art is that the artist does not have to be tied to measure, to regularities, to conformity either to the rules of the past or to fixed units. Although art historians often acknowledge the influence of African sculpture on modern artists, little attention is given to the possible influence of African two-dimensional design on Euro-American taste. For the most part, in our textile tradition we expect regular repetition of design units. However, in the past generation, a slow change has been taking place, evident in the introduction of varying designs in one piece of cloth, the juxtaposition of different design units in one garment. The change opens the way to greater appreciation of African design and of African craftspersons who have for so long practiced this approach to composition. Fortunately we have a very large corpus of work from one of the richest textile traditions in Africa, that from the Kasai-Sankuru region, which can be used to demonstrate the aesthetic references of the Kuba in a solid fashion. From studying splendid exemplars in museums, I began to understand what I now consider to be a fundamental feature of African preferences in design: within any entity, the Africans show a taste for interrupting the expected line; they compose through juxtapositions of sharply differing units, through abrupt shifts of form.

In earlier times, this difference from our taste led to a denigration of, a certain condescension toward, African design. The craftspersons' skills—"the clever hands"—were admired, but the odd shapes and irregularities of pattern were greeted with bemused tolerance and were attributed to the whimsicality of "folk" culture, the spontaneity of native inspiration, or the casual, episodic nature of artisans' attention to their work. Today we are better able to appreciate the African approach to numeration, mathematical play, and geometric form and pattern. The work of Claudia Zaslavsky (1973) has called our attention to the measuring and counting systems of Africa. Mathematician Donald Crowe (1971, 1973, 1975) has analyzed, in particular, the two-dimensional designs of Benin, Yoruba and Kuba arts and has shown the extent of the Africans' explorations into the formal possibilities of geometric variation. In their art, the Kuba have developed all the geometric possibilities of repetitive variations of border patterns, and of the seventeen ways that a design can be repetitively varied on a surface, the Kuba have exploited twelve. This exploration does not mean that they confine themselves to repetitive patterning in confronting a surface to be decorated.

The character of Kuba design accords with Robert Thompson's observation that some African music and art forms are enlivened by off-beat phrasing of accents, by breaking the expected continuum of surface, by staggering and suspending the pattern (1974:10-11). In textile design, the Africans of the Kasai-Sankuru region do not project a composition as an integrated repetition of elements. Until recently, Euro-American attitudes on this point were so fixed that we called a textile design a "repeat," and expected to find a unit of identical imagery repeated over the surface. This kind of integration is not typical for African two-dimensional arts.

The example in Figure 1 illustrates this point for Kuba "velvets." Within the hemmed border, we find a tessellated composition in which the design unit varies

Figure 1 Detail showing embroidered stitches and plush work, taken from a garment worn by a masked figure. Institut des Musées Nationaux du Zaire (IMNZ) 73.531.1. Photo: Monni Adams.

and different images are juxtaposed. This freedom is all the more remarkable because the freehand embroidery is applied to a foundation cloth of plain weave, consisting of rigidly repetitive, right-angled crossings of two strands. The underlying modular framework would lead one "naturally" to pursue the rhythmic pleasures of exact repetition of a single motif. The Kuba artist, however, draws on a range of other effects.

Liberties with the image unit can be accepted because there are other links that hold the surface together. African artists do use repetition and contrast, theme and variation in composition, but they disperse these principles through a wide range of sensory elements. The surface of Figure 1 exhibits constant elements: the diagonal ordering of the designs; the rectangular shapes of the individual units, uniformly outlined in light and dark lines; the color variation and the velvety pile texture within and between rectangles. These similarities of direction, shape and texture override the sharp differences in image units and permit innumerable variations in detail. The artist has held other variations to a narrow range: the motifs are made up of only two shapes, triangles and rectangles, and only two colors, black and beige. However, both of these pairs are played off as intensive contrasts. Thus, sensory links are distributed over various elements of the whole and take their effect subtly, while the visual changes in image are striking. Combining several different kinds of images together, they create restless, provocative and continually interesting compositions. In fine examples this distribution of sensory correspondences yields a dynamic balance that led

Torday, who paid attention to art production, to observe of the Kuba: "Their principal trait is sureness of design" (1910:209).

Other compositions illustrate the preference for changing patterns. The panel in Fig. 3 is organized by two sets of interlaced bands. But the interstitial areas contain design units that have marked differences from one side to the other, the combination of designs counteracting the integrating dominance of the interlaces. A detail from a Kuba mask costume (Fig. 1) shows the common use of rectangular outlines, but each of the interior spaces, marked by purple stitching, is of different dimensions.

In cloths that repeat images, one is likely to find contrasts of color or technique and marked variations in detail: changes in thickness, in width and length of line, in degree of angle, in shape-and-color relationships. If a single plush image is repeated, it is likely to be an off-balance form or to be altered by color accents. Embroidered lines usually intrude on the continuity and break up the surface into sections. The mixture of plush and stitches on a panel, the irregular interpenetration of design lines, and the shifting placement of color accents upset another deeply held expectation of Euro-American aesthetics that designs will have a figure-against-ground relationship.

Because of these formulas of variance, it is difficult to neatly label individual designs or to name cloths by their design units. But it is helpful to distinguish large groupings by employing two other visual criteria: one is the arrangement of designs as diagonal (Fig. 1) or parallel to the edges of the cloth (we will find that the diagonal arrangement predominates), and the other is the relationship of design units to each other. Some lie flat, as either isolated units or linked as in a network (Fig. 2). Others appear plaited; the design elements seem to move over and under each other (Fig. 3).

In Torday's time (1907-08), the Bushong, who were the ruling ethnic group in the central Kasai-Sankuru region, were noted for their excellent embroideries and plush cloths. Their garments tended to show less range in color than those of the northern groups he visited. "They excel in making velours but their garments gain their effect more by perfection of stitching than by color," Torday observed (1910:190). These velour garments combine stitched lines with plush effects (Fig. 4). The central panels of the ceremonial skirts, usually all beige or all red in color, show the most regular arrangement of designs, but the border that is added to form a wraparound skirt provides an arresting contrast with the centerfield in both design and color. The border design itself may be interrupted by a sudden shift of pattern and color. Perhaps this type of colored section was first introduced to strengthen joints in the border; however, it occurs frequently where there are no seams. When we see the corpus of Kuba textiles, we know these craftspersons explored the links and discontinuities to a remarkable degree.

These richly ornamented textiles are represented in many museums in the United States and are included in very early collections. The Peabody Museum of Archaeology and Ethnology (PMAE) at Harvard University possesses several pieces of plush (PMAE accession nos. 64-47, 65-3) of Kuba style dating from 1890 to 1893, obtained by a missionary who lived during that time at Kinshasa, and two other pieces collected by one of Henry Morton Stanley's American officers

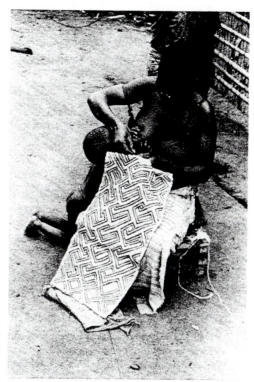

Figure 2
Shoowa woman embroidering a raffia
palm fiber panel with designs that
seem to lie flat, linked to each other.
Photo: Joseph Cornet, 1974.

in the former Congo Free State, probably in the early twentieth century. About fifty other works (PMAE 17-41) date from a pre-World War I collection of Lieutenant G. Mackenzie, who was stationed mainly in the Kasai-Sankuru region for the Congo Free State, and therefore prior to 1910, the terminal date of the Congo Free State. These early cloths show close similarities in design, composition and technique to textiles collected later in the twentieth century by the Musée du Congo Belge, now the Musée Royal de l'Afrique Centrale (MRAC) at Tervuren, and to examples at Zaire's Institut des Musées Nationaux in Kinshasa (IMNZ) which were collected in the Kuba region in the 1970s.

Most of the Kuba textiles that come to foreign markets today consist of single, fringed, square raffia panels, embroidered with an all-plush surface; they lack the alternation with stitched lines. Although enlarged and often simply repeated, the motifs are drawn from the traditional angular design inventory. According to one nursing aide formerly at Mushenge, the Bushong capital, the mission there began even in the thirties to encourage the making of such plush cloths for sale. Shipments out of the Bushong area today are still assisted by the missions, although the occasional traveler may buy up all that is available in accessible villages.

The most spectacular use of Kuba textiles is in the costumes of which Torday made a remarkable photographic record from 1907 to 1908 (1910:102-108). Historian Jan Vansina described these costumes brilliantly, referring to the Bushong king's entry onto the palace plaza with his officials to attend an *itul*

Figure 3 Shoowa embroidered panel showing large design elements that seem to move over and under each other. Peabody Museum of Archaeology and Ethnology 17-41-50/B2647. Photo: Hillel Burger.

festival in the 1950s: "It was a magnificent spectacle; there were more than a hundred of them in full costume. One saw only baldrics and collars, covered with beads and shells, veloured and embroidered cloths, ornaments of metal glittering in the sun, headdresses surmounted with bundles of multi-colored feathers, a meter in height, and waving in the breeze. Each held in his hand his insignia of office. The dignitaries occupied one of the long sides of the plaza, while the king took his place along the smaller side closer to his palace" (1964:124). The last great costumed ritual occurred at the installation of the present *nyimi*, or king. This event in 1969 was captured on film in a reenactment for the noted photographer Eliot Elisofon.[1] Since that installation, the grand aspect of court ceremonial has declined, but recent information and photographs of events and ritual scenes in the region add to the ethnographic record and help answer some basic questions about the making and uses of Kuba cloths.

Even in everyday life, men of the ruling ethnic group, the Bushong, wore a distinctive, gathered skirt of red barkcloth or woven palm fiber. On festival days, traditionally occurring at least once a month, one saw a burst of visual variety in the costumes, and a full panoply of textile arts made its appearance.[2] The most elaborate costume is the white outfit of the king, which he wears at its fullest only at his installation and burial (see cover of Fraser and Cole 1972; Cole 1970:no.38). In this costume he is almost covered with cowries as a sign that he is a descendant of Woot, the mythical founder of Kuba culture who came from the sea (Vansina

Figure 4
Typical Bushong ceremonial skirt.
Two panels in natural color
decorated with cut-pile embroidery
to form the central part, surrounded
by boldly contrasting border.
Institut des Musées Nationaux du Zaire
(IMNZ) 73.608.21. Photo: Monni Adams.

1964:109). The king and other members of the court possess several complete outfits, required for different occasions, consisting of various decorative elements and color combinations; the main textile in these costumes is the skirt.

Skirts for both men and women comprise several pieces of cloth forming a panel two to three meters in average length. Men's skirts are gathered around the hips, the upper end folding over a belt, the lower edge hanging down below the knees. Men's ceremonial skirts made of barkcloth (now largely replaced by industrial cloth), often checkered in red and white squares, display special border ornamentation consisting of small checked pieces, plush bands, fringes and tassels. Examples of these were worn by the Bushong official and the Dekese chief we met near the Lukenie River on the northern margins of the Kuba kingdom. These skirts and further special accoutrements such as caps, feathers, belts, pendants and hand-held objects publicly indicate the special titles and ranks held by individual officers.

Women drape their ornamental skirts (*nshak* or *ncak*) around their bodies, the lower edges reaching below mid-calves. These wraparound skirts in white or red woven raffia fiber are covered with linear designs in black embroidered stitching, which also outlines small appliqued patches of cloth (Fig. 5). In some cloths these appliques are added only to cover holes resulting from pounding the

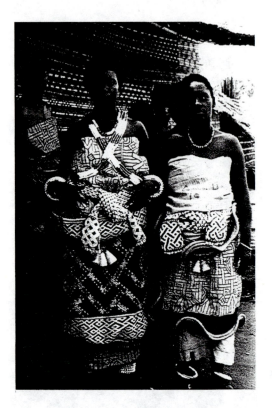

Figure 5
Wives of the current traditional
leader of Kubaland wearing
several kinds of embroidered
and appliqued ceremonial skirts.
Photo: Monni Adams.

fibers to make them supple (see the longer skirt on the woman on the right in Fig. 5, and Sieber 1972:159,166). One skirt (PMAE 17-41-50/B2039) owned by the Peabody Museum shows such sparse decorative elements. More typically, however, the patches are scattered over the surface amid abundant embroidered stitchery (Fig. 5, in the longer skirt on the left). These schematic shapes formed by parallel lines create a visual network of handsome effect. The arrangement of the designs shows the same preference for irregular distribution that I mentioned earlier for the plush-and-stitched designs. Over this voluminous wrap, a woman adds a smaller skirt, consisting of a central panel of embroidered black designs on raffia cloth or of tiny pieces of light-and-dark barkcloth (see Sieber 1972:156). and, as on the men's skirts, a border of plush designs. This kind of skirt possesses an edging bound over a rattan stick, which is peculiarly curled, adding an element of motion to a bulky, sculptural costume.

As highly prized objects of value, these decorated cloths are used as gifts in establishing relations of reciprocity. For example, at a betrothal a youth's female relatives embroider a skirt that he has woven for the bride-to-be, and later the in-laws will benefit from the work performed by the wife. Men's or women's decorated skirts serve as compensation in legal settlements, as in adultery or divorce cases (Vansina 1964:121-122, 147).

The use of decorated garments is integrally linked with public ceremonies. Kuba rituals, including masked appearances, take place in the daytime and

feature dance events, festive food and drink. Formerly these festivals took place frequently, especially at the Bushong capital where a large plaza was available for gatherings, and the population lived off the liberality of the king and his tributes. Dance festivals occurred at the installation and death of an official, at the end of mourning, and any time the king ordered. In recent times, other than the installation and burial of a king, the most elaborate of these rituals has been the *itul*, a festival at which royals and officials enhance their prestige, the former sponsoring theirs in the capital, the latter in the villages. Recent descriptions refer to *itul* sponsored by children of the king (Vansina 1964:122-125; Cornet 1974,1974-75). An *itul* is expensive, and the sponsor has to pay for the costs of preparation, which formerly lasted several months.

After a number of dance events, the festival culminates during the final two days in a dance-drama, in which the display of elaborate costume is a prime marker of achievement and success. *Itul* means "striking viper" and suggests the theme of the event. The story of the dance-drama concerns a dangerous but noble animal that is terrorizing the region—it could be an eagle, crocodile, leopard or a four-footed feline called lightning (a civet cat?). The sponsor, who may be male or female, takes this threatening role. The ravaging animal is symbolically killed by other dancers, and its skin or entrails in the form of a decorated textile is taken as a trophy to the king.

In the several scenes of this dance-drama, we recognize a routine familiar in black Africa: a mimed encounter between humans and a wild animal, a struggle and a final defeat for the animal. In the court context, this confrontation resonates as a ritual of conflict between powerful groups. In the filmed rituals of the court of Benin in Nigeria,[3] for instance, we see a portrayal of a power conflict in a dance-battle between the hereditary nobles and the forces of the palace. In the Kuba court, however, tensions arise between the children of the king and the successors to the throne, who are not the king's children but members of his mother's line, that is, his brothers or his sisters' sons. At the 1953 *itul* scene described by Vansina (1964), that this tension over power is felt and underlies the Bushong dance-drama was made clear by the king. Following his arrival at the plaza, he rose and announced through his herald that this festival was given by his daughter Kyeen, a *mwaanyim* (the class title for the king's children), but that those who held the highest rank in the kingdom were the *matoon*, the successors. This festival then exalts the state of the king's children and that of the successors who also participate. In the mime the king's children fight against the successors and are finally vanquished by them. It also shows, as Vansina points out (1964:124), that all quarrels end before the king, master of all and arbiter between the two powerful groups of the nobility.

This festival and the two *itul* witnessed by Brother Cornet in 1974 at Mushenge were sponsored by women who were king's wives or children. However, not all possible candidates or children of the king, who has many wives, can be sponsors, but only those who win his favor and who are rich. In 1953 the cash layout for the final two days of the *itul* amounted to more than 1,000 Belgian francs (for food for the drummers, chorus and fees to the representative of the successor lineage), not an unmanageable sum in itself for Kuba royals.

Obtaining sufficient costume cloths is the significant cost, for this depends on social relations with the powerful. The sponsor must be able to give ten ceremonial skirts to the representative of the successor lineage; these are in turn partly supplied by the king and by the successors. The sponsor must buy back the cloth representing the wild animal trophy from the successor at the price requested. Each ceremonial skirt is worth about 1,000 francs, but a complication arises here. Skirts are not freely sold. Ceremonial skirts provide, in other words, a standard of value but are not a medium of market exchange. One obtains them only by inheritance, by making one or by receiving one in compensation. A sponsor must rely upon his good relations with his clan section, with the successors, and with the king, who has many textiles in his storehouses. Only a very rich clan section could supply three of the ten, plus enough cloths for outfitting its own members in the white and the red costumes required for the dancers during the last two days, and also dress the sponsor, who must wear a different costume for each dance and jewels of special character (Vansina 1964:125).

In the three reported *itul* rituals, the royal women who appeared as the principal figures wore costumes nearly as elaborate as the king's. On the first day of the final ceremonies that the royal women sponsored at Mushenge in 1974, the principal royal sister wore a red embroidered skirt and cowrie-bedecked waistcloth along with a leopard-tooth necklace and feather headdress. One of the most interesting elements of her outfit is a belt of pendants that is exclusive to royalty. The pendants consist of shells or miniature imitations of various objects formed of redwood material (*tool*), encrusted and sewn with beads and shells. It includes the royal symbol, the interlace, *imbol*, familiar in textile design. Each element symbolically restates the strength and power of the king. The next day, in a costume representing a leopard, she was "killed" by feminine successors using "magic" shots from guns.

Another female sponsor, the second wife of the former king, played the part of a ravaging bird of prey, an eagle, on the final day of an *itul* festival at Mushenge, again in late 1974 (Cornet 1974:153). She is in splendid array with painted red face and elaborate costume including a red plush skirt with a wide embroidered border. Before appearing before the king and public, she shook the supports of her shelter located across the plaza. Then she emerged to make forays against the feminine successors, who danced in a counter-clockwise circle. The sisters of the king evaded her and, armed with weapons, announced to the king that they would kill her. After several encounters they succeeded in bringing down the creature. In Vansina's account of the *itul* in 1953, the king's sister then took one of the cloths that the beast wore, which represented its entrails, showed the trophy to the king and disappeared with it (1964:125).

This brief overview of a public festival shows that plush cloth is not common even in ceremonial costume. Plush-decorated cloth appears in greatest quantity at another public ritual, the funerals of high-ranking persons. Deep-red cloths line the large coffin in which the king's body is laid, and at his feet numerous grave gifts include plush cloths. Part of his funerary decor is a plush cloth with a certain pattern, "the house of the king," which is laid on his head for four days

of the lying-in-state period (Vansina 1964:112-113). According to Dr. John Todd of McGill University, Montreal, who gave a beige plush skirt (of Bushong style, PMAE 18-22-50/B2103) to the Peabody Museum, which had been obtained in 1905 in the neighborhood of the Kasai River, such cloths were not usually worn but were carefully preserved by their owners to serve as a shroud. "The bodies of wealthy men are sometimes wrapped in many yards of cloth, so that the body can only be placed in the grave by the united efforts of many men," he reported. From a functional point of view, the public piling up of highly prestigious cloths is meaningful because the status of a person is affirmed the most in the course of funerary ceremonies.

Kuba practices in the twentieth century show that plush cloth is applied differently to the costumes of men and of women. Torday reported that the skirts entirely of plush panels are worn only by women (1910:174). This association of plush skirts with formal female attire is reinforced by a 1971 photograph from Mushenge, a rare glimpse of the familiar Kuba mask representing a female, *ngaady a mwaash*, in costume. She is out-fitted with a plush-and-stitched skirt (Fig. 6). The underlying garment of the male who wears the mask is in the form of a barkcloth suit with attached coverings for his hands and feet, thus disguising his human form. The suit itself is spectacular, made of an infinity of tiny pieces of barkcloth of contrasting rust, black and beige colors, interspersed with larger, orange-colored sections upon which are painted white and black linear patterns

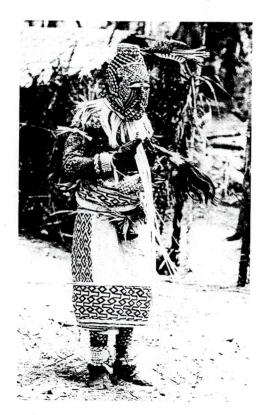

Figure 6
The familiar Kuba *Ngaady a Mwaash* mask worn with a checkered barkcloth suit and plush skirt entirely covering the body. Mushenge, September 1971.

representing the figure's body scarifications. Over this suit, the masked figure wears a woman's wraparound skirt decorated with black embroidered lines, while an outer wraparound skirt displays beige plush and linear embroidery in its central panels, which are joined to a border of strongly contrasting black embroidery in a pattern of chameleon claws. Accoutrements include plant, animal, bird and sea-creature elements.

On other mask costumes, such as the one from which the detail in Figure 1 is taken, plush is used in the form of pieces suspended from the basic costume. These pieces are oblong or trapezoidal in shape and hang from the waist as hip or thigh covers over the body suit. Small pieces of plush appear on old examples of *mokenge* masks, as covering for the base of the projecting trunk (Stritzl 1971, no.60548).

A high-ranking man dons a plush or other decorated cloth over his shoulder as a display piece (Fig. 7). Similarly plush panels are draped over stools that prominent men or women sit on. Single panels were also tucked in front and in back of costumes such as those worn in the *itul* festival. For men, the most consistent use of plush is in the form of a decorative band about 10 to 20 centimeters wide above the tasseled fringes of their ceremonial skirts. On some skirts, the pompons are attached by tiny strips that have been finished in plush (Stritzl 1971, no.79725). In these twentieth-century instances of the use of plush

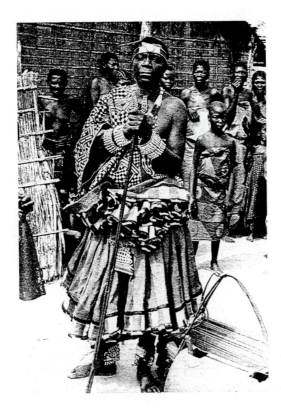

Figure 7
The chief of a Sankuru river village in official dress wearing a plush cloth of Shobwa style over one shoulder.

for men's or male masks' costumes, plush seems to be limited to suspended sections or to trim rather than employed in the formation of garments.

Another association of the plush garment with women is conveyed also by a legend of the origin of plush cloth, called *musese* by the Ngongo, recounted in summary form to Torday by a Ngongo ritual specialist in the northeastern section of the Kuba kingdom: "The king announced his intention of marrying and invited all young pretty girls to come dance before him on a certain day. Naturally all girls were very desirous of being chosen to become the wife of the king and they took great care to dress themselves in all they possessed of the most beautiful things. Now there was a girl named Kashashi, who was not only the most beautiful of all but also the most clever. For several weeks before the dance, she hid herself in her hut and in secret covered her skirt with the most beautiful embroidery. When the great day arrived, Samba Mikepe [the Bangongo form of the founder of the Kuba kingdom] had eyes only for her and she became his wife. It was thus that the *musese* cloth was invented by Kashashi" (Torday 1910:249, my translation). The legend conforms to the reality we know in that women are the only ones who embroider the cloths to form either linear stitching or pile decoration. Although no one has studied the practitioners of this craft, it seems from the frequency travelers encountered work in progress that most women knew and practiced embroidery. Certainly the king's many wives and the households of important men were expected to produce a supply of the handsome costumes and cloths for grave gifts. In general, as Torday noted, men are considered the specialists in the lore of carving, while women are known as the experts on cloth designs (1910:216). Nevertheless the making of plush cloth, especially a finished ceremonial skirt, involves a fascinating back-and-forth alternation of work by men and women.

A descriptive sequence of how the cloths are made and how the plush is achieved documents this rhythm and clarifies technical aspects of the work. A combination of sources makes such a survey feasible: data from my trip (Adams 1976); the excellent and abundant visual documentation on Kuba communities developed by Brother Joseph Cornet, who in the 1970s conducted research visits to the region (Cornet 1971,1974,1974-5); and the study of the literature and museum collections by Angelika Rumpf née Stritzl (1971).

Raffia fiber in plain weave forms the basic material of the cloth. The yarn for this foundation is obtained from the leaves of the palm *Raphia vinifera*. Young boys strip the fibrous leaves and split them by hand or with a raffia-rib comb. Women participate in the preparation of fiber for embroidery, splitting and smoothing fibers with snail shells. The fibers are made more pliant by being rubbed by hand. After treatment they are bound into skeins for the weavers' use. Only men set up and operate the loom. Most men can weave, but some are known as specialists who produce fine cloths. The size of the weaving is determined by the natural length of the palm leaves because it is not usual to join strands by tying or any other artificial means. Most of the cloth panels are made in either of two shapes: a rectangle measuring approximately 30 x 60 centimeters to 50 x 100 centimeters; or a form approaching a square measuring about 50 x 60 centimeters to the largest, about a meter square.

In comparison with looms from other regions of the world, those in southern Zaire are set at an unusual oblique position. The loom is a simple mechanism consisting of a heddle and two horizontal bars between which the lengthwise or warp strands are stretched. The lower bar is fixed firmly; the upper one is suspended from a cross beam supported by two poles. These poles are set in the ground at a 45-degree angle, so that the plane of the warp leans toward the weaver and he sits under the warp (Fig. 8). After he inserts the crosswise (weft) yarns, he beats them in downward and away from his body.

To thread the loom, the weaver binds all the leaf strands for the warp to a fixed horizontal bar at the base of the loom and stretches and attaches them to the upper horizontal bar. He then inserts the weft strands individually, leaving the ends hanging on either side so that fringes are formed. Thus there are no continuous weft strands being turned back into the weave to form a protective selvedge at each side. To keep the woven cloth from fraying, the fringes are later gathered into small bundles and knotted, or they are cut, in which case the edges are carefully hemmed by folding the cut edges inward two times.

Generally the weave of cloth used for embroidery is not different from ordinary cloth, although customs in regard to quality may vary by district or by household. I concur with Stritzl that Torday (1910:188) erred in saying that looser woven basic cloth was used for the velours. The regularity of the foundation weave affects the decoration in terms of straightness of angled lines and size of motifs.

Figure 8 A Shoowa man at his loom. The loose ends of the individual strips of the raffia have been inserted as wefts to form the cloth. The oblique angle of the loom is typical of southern Zaire.

To produce palm cloth that is soft and supple, further special treatment is necessary. The woven panel is dampened in water and kneaded, beaten or rubbed between the hands. To do this the Bushong wrap a new cloth in old pieces and lay it in a trough, where the women pound it with wood piles; it is dried and then beaten again (Torday 1910:186). An early report, probably from the records of the American missionary William Sheppard, mentions pounding the cloth with an ivory implement (see Sieber 1972:159); the Peabody Museum possesses an ivory pestle (PMAE 65-3-50/10709, collected in 1890-93), which was probably used for this purpose. These procedures give some idea of the painstaking attention and the many processes that are given at each stage to produce the decorated cloths that early investigators compared with silk.

After weaving, the next phase of the work—the coloring of the cloth and the embroidery yarn—is done by the women. In general, the woven cloth and the yarns are dyed in advance of the decorative stitching. Color tones vary somewhat within the various ethnic groups that make up the Kuba kingdom. There are few basic hues, although many shades can be produced through variations in processing. Earlier accounts mention four colors: ecru or beige, red, black, and brown. But on the cloths, as Stritzl notes (1971:78), colors appear in a wider range of shades: pale rose to wine red, lilac to purple, bright to dark blue, yellow to orange; depending on age and treatment, the raffia leaf varies from white to light brown. All the dyes are obtained from regional plant sources. According to available evidence, Kuba dyers achieve their color tones by dipping cloth into hot or cooked dyestuffs. Some nuances are the result of special usages. From time to time on ritual garments, it is common to rub red or yellow dyestuff into the surface after the sewn decoration is finished. Other color tones may result from fading in the sun and possibly some effect of chemical change over time.

Red is a significant color for the people of this region. In the form of a wood powder mixed with oil, red is rubbed on the body for festive occasions. Because of this custom, many beige weavings are dyed red on the reverse side, which rubs against the body during wear. Obviously red enhances, yet it is also the color of danger and of mourning. The main source of the red dye is a redwood best known from writings on the western Congo region as *tukula* and called *tool* in Bushong. It is not camwood, which is *Raphia nitida*, a species that grows only in West Africa and does not occur in the Zaire River basin. Very little is known of the procedures for obtaining the other dyes.

After the dyeing, the cloth is ready to be embroidered. Most Kuba embroidery combines on one cloth two types of decoration: stem-stitching (also called over-stitching) and cut-pile or plush stitching. The equipment is simple: a needle and, for cut-pile or plush work, a knife. The earlier bamboo or bone splints or native iron forms have yielded to imported embroidery needles. The embroidery knife is a common type in Kuba communities, for it is the same form as the spatulate iron blade used by men as a razor and by both sexes for scraping the skin as part of grooming the body. The thin blade is in a trapezoidal shape with a smaller drawn-out handle. In our society, a knife form has a padded handle and a cutting edge adjacent to the handle. However, the Kuba knife has a bare metal handle over the blade, and the cutting edge lies at the opposite end, at the

base of the trapezoid, so that the knife is held upright in the hand. In Mushenge, I saw a woman embroidering plush using a bamboo knife.

The embroideress needs an enormous amount of steadiness and patience. Because of the time required, prosperous and royal men who have several wives or concubines gain an advantage in the production of decorated garments. Fine plush pieces are worked on for months and even years. The work is done intermittently, usually in the afternoons, after returning from working in the fields. Even the Queen Mother went out in the morning to work in the fields, and I found her at her embroidery only in the afternoon, just as one sees other women at the capital bending over their stitching outside their houses. The embroideress sits on a stool or a mat in a shady spot outside her house, unrolls the basic cloth from the protective covering that is sewn on at one end and takes out the colored yarns and equipment stored there. Laying the part of the cloth to be worked on in her lap, she sews at a 90-degree angle to her body, the attached cloth helping to steady the panel being embroidered. She does not turn the cloth while working on it but changes the direction of the stitching, if necessary, when forming the linear designs. She views the designs from one end which, when the cloth is made into a skirt, will be turned 90 degrees.

The procedure for achieving the plush effect is simple but requires dexterity. In her right hand, the seamstress holds the needle between thumb and first finger, and with the three remaining fingers she grips a little knife in her palm, the up-right handle of the knife extending through the circle formed by her thumb and first finger. To form a plush stitch she introduces a fiber strand or bundle under the weave, leaving a two-to-three-millimeter tuft at one end. After drawing the strand through, she cuts it with the knife edge at the thumbnail of her left hand, thus forming another tuft, level with the first. The remarkable point is that she makes no knot to secure the plush strand. Obviously the weave must be tight enough to hold this short bundle firmly in place. The seamstress does not puncture the fiber of the weave but guides the needle under the yarn at a crossing of the weave. Because the pile strand is drawn under only one yarn at a crossing, it is barely visible on the reverse side. In choosing the yarn under which to insert the pile strand, the needlewoman, according to our preliminary research, selects the direction in which there are a greater number of yarns per square centimeter; that is, the tufts are inserted parallel to the direction in which the weaving yarns lie closest, which secures a tighter gripping of the pile tuft. Thus the needlewoman chooses for the best mechanical advantage. Whether this is always the warp or weft is still under study.

The significant action in creating the Kuba pile effect is the kind that is likely to be missed in descriptions of the stitch alone. Every so often the seamstress brushes the knife edge back and forth across the cut ends (Fig. 9). This splits the ends, resulting in the characteristic fuzzy dot of the pile. Three additional factors contribute to the appearance of the pile: the variable width and thickness of the strands used in weaving the foundation cloth, the thickness of the pile bundle, and the intervals between the bundles. The manipulation of these three factors produces a variety of plush effects of which two types are notable. By comparing

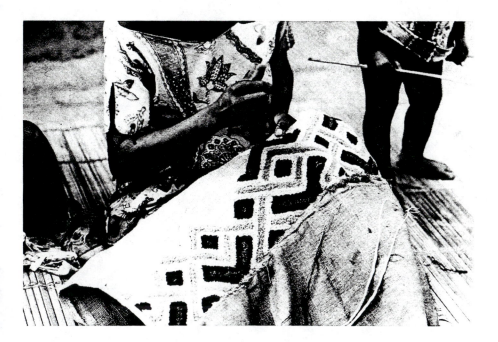

Figure 9 A Bushong woman at work on an all-plush panel typical of contemporary work. She is brushing the raffia pile with the edge of a knife, which she also uses to cut the pile stitches. Mushenge, 1971.

the reverse side of an example of each of these two types, the details of stitching and the resulting contrast of the two types can be seen.

In the most common formula the weave is firm, but the warp and weft are of variable thickness; the pile yarn is a thick bundle, and within the design area the pile bundle is introduced under every other weft (or warp) in both directions. In this way the two pile ends resulting from one stitch remain slightly apart and form two dots of plush. This procedure is repeated to fill the desired shape of the design. In the other type, both strands of the firmly woven cloth are of equal size (they are moderately thick), the pile strands are fine, and within the design area the strand is drawn under *every* weft (or warp) *in both directions*. When the seamstress brushes these ends, the result is an overall plush surface in which the individual bundles or stitches cannot be discerned (Fig. 1).

In the design areas of the densely packed pile, the embroideress can introduce variations. If she leaves two or more rows blank between rows of plush stitching, the pile appears in distinctly grooved rows, or if she leaves blank small squares of the basic cloth, as is typical among the Bushong, a latticed effect is achieved (Fig. 4). Because the seamstress introduces her stitches into the crossings of the weave, which are at right angles, she can produce straight lines either parallel or diagonal to the edges, and although she is free to zigzag and to form short jagged lines, she does not do this. The woman pursues lines in one direction

long enough to form distinct shapes drawn from a traditional inventory and uses contrasting color and choice of stitch to produce designs of a remarkable clarity even in the most complicated networks. The plush can be used either to form designs of linear character or to fill in color masses.

In producing a ceremonial skirt, the final effort is contributed by men, that is, the tailor who sews a thick, reinforcing hem and stitching along the edges. Usually one short end of the skirt is left unbordered, as that is the end that lies underneath in the wraparound mode of wearing skirts.

The advantage of being on the spot while decorative work is going on is that one can find out how the artist proceeds. For the first time, it is possible to provide an illustration of work in progress, which answers definitely how the women, in this case, Shobwa women, form compositions (Fig. 10). The seamstress works her way across the panel from right to left, usually advancing with lines forming angular shapes, the interiors of which are then filled with stem-stitches and plush in either sequence. As she proceeds, she also fills in plush between the lines of the large shapes. In the compositions in which linear stitching is absent, the plush is worked in sections irregularly across the panel. These illustrations show that, as in embroidery work in many other parts of the world, the Kuba women use neither sample patterns nor sketches on the cloth; they are working from models in their minds.[4]

Figure 10 Embroidered panels with linear and plush effects in process. Shobwa, Gelilebo village.

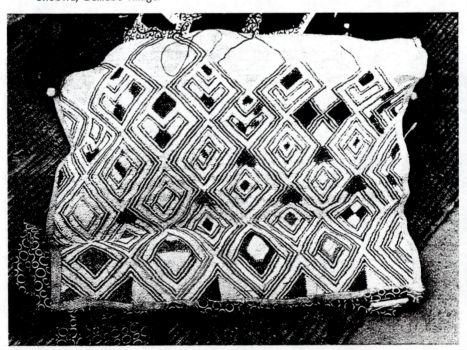

NOTES

The author and the editors would like to thank Brother Joseph Cornet for his photographs which appear in this article.

1. "The Congo," 2-reel, 16mm film by Eliot Eliosofon, available from Edupac, Inc. See also color slides, Eliosofon Archives, Museum of African Art, Washington, D.C.
2. The extant literature on the Kuba, including this article, does not cover all the textile arts. For instance, Torday mentions stamped designs on barkcloth for men's costume (1910:179, no. 242). Other references appear in Sieber 1972.
3. "Benin Royal Rituals," 16mm color film by Francis Speed and R.E. Bradbury, University of Ibadan (22 min.).
4. A final major issue concerns the style characteristics in embroidery among the various ethnic groups within the Kuba kingdom. From twentieth-century data and experience, we can see certain broad regional features, but two factors hinder our ability to assign confidently the various substyles to certain districts: One is the existence of extensive internal trade in textiles (Vansina 1962, 1964:19, 23), and the other is the likelihood that the officials of the Bushong capital may have awarded regional chiefs certain costume elements as part of their official insignia of status.

BIBLIOGRAPHY

Adams, M.J. 1976. Kuba Research Visit, July-August, Journal 1.

Bateman, C.S. 1889. *The First Ascent of the Kasai*. New York: Dodd, Mead.

Cole, H. 1970. *African Arts of Transformation*. Santa Barbara Art Galleries, University of California.

Cornet, Joseph. 1971. *Mission chez les Kuba*, August-September, Books 1-2.

Cornet, Joseph. 1974. *Mission aux Bushong et Shoowa*, November-December, Book 6.

Cornet, Joseph. 1974-75. *Mission aux Bushong et Shoowa*, December 1974-January 1975, Book 7.

Crowe, D.W. 1971. "The Geometry of African Art 1, Bakuba Art," *Journal of Geometry* 1, 12:169-183.

Crowe, D.W. 1973. "Geometric Symmetries in African Art," *Africa Counts*, by C. Zaslavsky.

Crowe, D.W. 1975. "The Geometry of African Art: A Catalog of Benin Patterns," *Historia Mathematica* 2:253-271.

Fraser, D. and H. Cole (eds.). 1972. *African Art and Leadership*. Madison: University of Wisconsin Press.

Hilton-Simpson, M.W. 1911. *Land and Peoples of the Kasai*. London: Constable.

Institut des Musées Nationaux, République du Zaire, 1976. Catalog. Kinshasa.

Loir, H. 1935. "Le tissage du raphia au Congo Belge," *Annales du Musée du Congo Belge*, ser. III, 3, 1.

Peabody Museum of Archaeology and Ethnology, Harvard University, 1978. Accession records and catalog.

Shaloff, S. 1967-8. "William Henry Sheppard: Congo Pioneer," *African Forum* 3/4:51-62

Sheppard, W.H. 1916. *Presbyterian Pioneers in Congo*. Richmond, Virginia: Presbyterian Committee of Publications.

Sieber, Roy. 1972. *African Textiles and Decorative Arts*. New York: Museum of Modern Art.

Stanley, H.M. 1885. *The Congo*, 2 vols. New York: Harpers.

Stritzl, A. 1971. Die Gestickten Raphiaplüsche: eine ergologisch-technologische Untersuchung einer historischen Stoffart im zentralen Kongo. Ph.D. dissertation, University of Vienna (Embroidered Raffia-Plush. . .in the Central Congo, Zaire, translation mss., Cambridge, Mass.).

Thompson, R.F. 1974. *African Art in Motion*. Los Angeles: University of California Press.

Torday, E. and Joyce, T. 1910. "Les Bushongo," *Annales du Musée du Congo Belge*, ser. IV, 3.

Vansina, J. 1962. "Trade and Markets among the Kuba," *Markets in Africa*, edited by P. Bohannan and G. Dalton. Evanston: Northwestern University.

Vansina, J. 1964. *Le Royaume Kuba*. Brussels: Annales Sciences Humaines, ser. 80, 49.

Vansina, J. 1969. "Du royaume Kuba au territoire des Kuba," *Etudes congolaises* (Kinshasa-Kalena) 12:3-54.

Zaslavsky, C. 1973. *Africa Counts; Numbers and Patterns in African Culture*. Boston: Pringley, Weber and Schmidt.

10

Humans and Animals
in Benin Art

Paula Girshick Ben-Amos

I

Introduction: The Ideal Relationship

The art of the Edo Kingdom of Benin, in present-day Bendel State, Nigeria, entered Western museum collections soon after thousands of pieces were brought out by a British military expedition in 1897. The corpus of Benin art consists of a wide variety of objects in ivory, wood, iron, terracotta, leather, and of course, brass. These famous brasses (usually termed "bronzes") have been analyzed on stylistic grounds by William Fagg (1963) and Philip Dark (1973), and have been assigned to several historical periods, dating from the fourteenth century to the present.

Animal representations are found on all major types of Benin sculpture—from royal ancestral altar pieces to village mud shrines. The frequency of their representation and the variety of contexts in which they are found are indicative of their significance in Benin art and thought.

Discussing animals in general, James Fernandez (1974: 120-1) has suggested that they constitute a "primordial metaphor" through which men come to define their own humanity. In his words: "those we domesticate have domesticated us and those we have not domesticated are still useful in measuring the achievement or excesses of our domestication" (1972:41). In the case of Benin, as we shall see, the concept of the nature and defining characteristics of animals functions to establish the outer limits of humanity, that is, the nonhuman or uncivilized as well as the more-than-human or supernatural.

Reprinted in abridged form from *Man*, Vol. 11(2):243-252, 1971 with permission of the author and publisher.

Implicit in the contrast between animality and humanity is a notion of underlying order in the universe. In Benin cosmology, all beings are assigned to specific spheres or domains, some of which are geographical (such as the dry land and great waters), others are existential (the spirit world and the world of daily life) or temporal (day and night). Within each of these domains relationships are hierarchical and orderly. The social structure parallels the human division into noble and commoner classes, and specific roles are recognized such as king, warrior, magician, and even spy. Order within each realm is maintained by each member's acceptance of his station in life, and by his following the laws of his intrinsic nature. In the Benin adage, "Birds do not fly the sky at large but everyone goes its way" (*Ahianmwen itin ukhunmwun vbee domwan d'uro ere olele*).

The ontological distinction between humans and animals is· expressed symbolically in art, myth, and ritual in the contrast between their respective spheres of activity—the home (the social world of the village) versus the bush (the wild forest areas). A myth related to me by Imaguomwanrhuo Idemudia, a priestess in a healing cult, explains the nature and significance of this distinction (1973:p.c.):

> Both bush and home animals were created by Osanobua, the High God. The difference between them was caused by a rift between King of the Bush and King of the Home. King of the Home was then Ogiso (ruler of the mythical first dynasty of Benin kings) and King of the Bush was Leopard. When God created them, King of the Bush had more animals than King of the Home, and those of King of the Bush were more wild than domestic animals. Ogiso was at that time claiming supremacy, whereas Leopard had more followers. So Leopard said to him, "If you claim supremacy, let us test our powers and see which one God has gifted with more." King of the Home left and reported to Osanobua the attitude of King of the Bush towards him. He was advised by God not to entertain any fear. But King of the Home reported to God that the trouble would result in a fight between them, and that he had few children, whereas King of the Bush had plentiful ones. If fighting breaks out, he will not be able to withstand King of the Bush. If the antelope alone is sent from the bush to wage war against his subjects, they cannot withstand it. How much more if all the wild beasts of the bush are sent! God replied, "Do not entertain any fear. I am the creator of all animals. I created the animals of the bush so that they can be killed and consumed by man and the spirit world." Osanobua asked King of the Home, "What is the date of your fight?" King of the Home replied, "The next seven days to come." On the seventh day, God made a ritual pot and put palm fronds in it. Then God advised King of the Home, "As soon as the fighting begins, get your diviner/healer to carry this pot and to sprinkle its water with the palm fronds on King of the Bush's soldiers." As soon as the fighting started and it was sprinkled, all the beasts in the bush started transforming into human beings. Those transformed into humans joined King of the Home's troops and the remaining ones ran into the bush along with Leopard. This is why we have an adage that whenever someone behaves abnormally, we ask him, "Why are you behaving like a bush animal?" It is from that period that the word "beast" (*aranmwen-oha*) applied to humans started. Then after the war was over, King of the Home went to God to report and to thank him for the power given him. Then God took charms and cursed bush animals that henceforth they would never come and wage war with domestic ones. God gave authority to man that whenever he finds bush animals he can kill them.

Humans > Home animals > Bush animals

This myth reflects the basic principles underlying the ideal relationship between humans and animals and alludes to the consequences of their violation. Boundaries are drawn up and their maintenance divinely sanctioned. As Imaguomwanrhuo Idemudia makes clear in her exegesis, the distinction between the realms of men and animals is a symbolic expression of the dichotomy between the wild and the civilized:

> Any shameless person is a bush animal. He does not have the blood of ordinary people but that of a transformed beast. Some families, right from the ancestors, look different from other people, are not progressing, do not behave well. (In the Benin adage) we describe them as "people who gobble up kola nuts peel and all."

The kola nut is the symbol *par excellence* of civilization, of supernaturally sanctioned sociability. Householders generally welcome guests by offering them kola nuts. After an invocation, the nut is broken into segments and distributed according to relative seniority. Paralleling this domestic ritual is the Salutations ceremony (*Otue*) which opens *Igue*, the major yearly ritual of Benin divine kingship.

> Enthroned before his father's altar, the Oba [king] receives his chiefs as, rank by rank, from the lowest to the highest, they come to salute him. Each group kneels in homage . . . Then, starting from the senior chiefs, the Oba sends them kola nuts and wine, in descending order of seniority. . . . At *Otue* the Oba is the host and the kingdom his household (Bradbury 1959: 187-8).

The Salutations ceremony, as Bradbury points out, functions to demonstrate publicly the relative rank of office holders. But it is also a pledge of support. By accepting the kola nut, the recipient is accepting his position within the hierarchy and demonstrating his recognition of legitimate authority.

Kola nuts are usually offered to guests on a wooden or china plate, or somewhat more prosaically, with the bare hands. Chiefs and wealthy men, however, may purchase carved wooden containers in order to underscore their wealth and provide an aesthetic dimension to the rite. These boxes (*orievbee*) are mainly rectangular with geometric or figurative designs, although a few are circular or in the form of an animal or fish. Since kola nut boxes are status markers, a number of animals appear on them which, as we shall see later, are symbols of rank: the leopard, elephant, snake, and crocodile. However, other frequently represented animals—the cow, antelope, fish (particularly mudfish), and pangolin—do not fulfil this function, and their depiction on these boxes requires explanation.[1]

The carved box (Fig. 1a) represents either a cow or an antelope; my informants disagreed strongly as to its identification. (Since most of Benin art was removed in 1897 by the British expedition, and objects such as these may never have been seen or created by contemporary chiefs and artists, identification of specific species is often difficult.) In this particular context, however, the cow and the antelope are equally effective artistic symbols through their exemplifica-

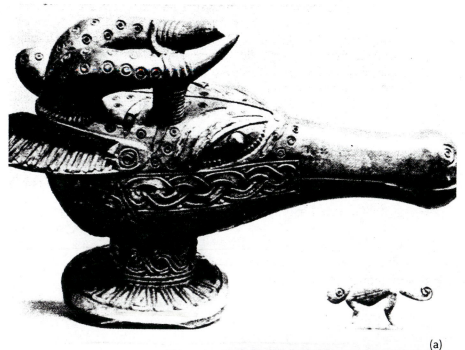

(a)

Figure 1
(a) Ivory kola nut box representing a cow or antelope. Museum fur Völkerkunde, Berlin. (b) Contemporary carved wooden rooster for use on paternal ancestral shrine. Artist: Richard Amu. Photographer: Philip Dark.

(b)

tion of traits of physical attractiveness and social docility. Both are considered beautiful animals, the cow for its rich, fat body and the antelope for its smooth gait and curving horns. These qualities, plus their gentle natures and desirability as food, make them favourite sacrificial offerings.

The mudfish is the freshest, most robust and most delicious of all fish and is considered very attractive and desirable. It represents prosperity, peace, well-being and fertility through its association with the water, the realm of the sea god, Olokun.[2] It is one of the most popular sacrifices in Benin.

The pangolin is considered very "shy" or "shameful" because it rolls itself up into a ball when attacked. While viewed as an extremely ugly animal *en toto*, its skin is thought to be beautiful and, before the importation of European red flannel, it was used in chiefly robes. Even today the red ceremonial outfit of chiefs is called "pangolin skin" (*ikpakp' ekhui*).

These animals depicted on kola nut boxes—the mudfish, antelope or cow, and the pangolin—all share certain characteristics: accessibility, docility, and vulnerability. All domestic creatures (by definition) and certain wild ones, such as the antelope, are easily caught by man, and more especially, they do not attack or fight back. Moreover, they all can be killed without restriction and consumed—they are freely for man's use. The fact that they are represented in the form of a container expresses their complete and utter utility to humans.

These characteristics are shared with other animals and birds appearing in art as metonymic references to sacrifice: the goat, ram, chicken, and (again) cow. Free standing carved or cast fowl and ram's heads are placed on ancestral altars as decoration and commemoration of the deceased (Fig. 1b), while goats, cows, and rams, both as a whole and in the form of skulls, are depicted in relief on altars of the hand[3] and brass plaques. In both cases the reference is to the wealth involved in making substantial sacrifices. While the religious meaning of sacrifice obviously differs from the previously discussed rituals, the social behaviour clearly parallels the kola nut ceremonial: the meat of the slaughtered animals is carefully distributed among the participants according to social status and is then consumed by all present in a feast of solidarity.

Towards all these animals man is hostile, aggressive, and devouring. In so doing, he is expressing his domination. In the ideal order of things—and this is the second major assertion in the myth—man dominates animals as his god-given right. This domination is expressed in his license to take their lives with impunity. The right to kill is *the* defining characteristic of leadership. As Bradbury (1967: 33) points out, "One of the most important meanings of human sacrifice, for which Benin becomes notorious, lay in its capacity to demonstrate the sole right of the Oba to take human life." Although no ordinary man may take another's life, all men may kill domestic and game animals. Thus, through their docility, accessibility, and submissiveness, the mudfish, chicken, antelope, and cow represent the ideal order, the submission to the dominance of humans.

But there exists a set of animals which reverse this relationship, which hunt humans and consume their flesh. These are called by the Edo *aranmwen dan* or *kho*, dangerous or aggressive animals. By their capacity to kill they make humans accessible and vulnerable. This reversal of the dominance order takes place in

two contexts: aggression within the framework of order and control is a metaphor for leadership, while aggression which violates order is an embodiment of extraordinary power.

II

Danger and Authority

Certain animals, birds, and reptiles considered dangerous by the Edo are symbols of legitimate authority and are used in contexts supportive of political power; these are the leopard, elephant, python, crocodile, and vulturine fish eagle. Their representations appear on a variety of objects, cast in brass, sewn on leather, and carved in wood and ivory, which function in the commemoration of royal achievements and the aesthetic enhancement of status.

The most important of these, the leopard, is designated the King of the Bush, as mentioned earlier, and thus stands in artistic and mythological contexts as the counterpart of the Oba of Benin, the King of the Home. Although considered beautiful, the leopard's major quality in the Edo view is its vicious and predatory nature, as reflected in its praise name, *ekpelobo* "quick in catching." Often depicted on the prowl, with its tail curved over its back, or pouncing upon a passive victim, the leopard is the essence of aggression in graceful motion (Fig. 2a, page 158). According to a myth related by Aikaronehiomwan Isibo, a diviner/healer, the leopard was chosen for kingship over the animals by the High God not only because of its fierce power and colourful regalia, that is, its beautiful skin, but also for its good nature and capacity to convene and direct an orderly, peaceful meeting of animals. Thus, the predatory nature and ferocity of the leopard are balanced by qualities of restraint and moderation in leadership.

Because of its size and power the elephant is considered a lord (*ogie*) among the animals—but specifically not a king (*oba*). In fact, many folktales deal with the rivalry between the leopard and the elephant for seniority, and in their historical traditions, Edo associate powerful rebel chiefs with the elephant. When an important man dies in Benin it is said that "an elephant has fallen out of society".

Representations of the elephant appear on such chiefly accessories as leather fans, hip masks, and shrines of the hand. The tusk of the elephant was especially prized for use in jewelry and as an object of decoration in its own right. As Chief Ineh of the brasscasters' guild explained, "Its teeth are expensive and so elephant's name is very high."

The python and the crocodile are both associated with the realm of Olokun, lord of the great waters. The python in particular is considered the "playmate" and messenger of Olokun, sent to warn neglectful devotees to change their ways. The python is considered the king of the snakes and is admired for its great stature, beautiful coloration, and crushing power. Prior to the destruction of Benin City by the British army expedition in 1897, a large brass casting of a python decorated the frontal turret of the palace,[4] emphasizing the correspondence between King of the Dry Land (the Oba) and King of the Sea (Olokun). The crocodile shares the power but not the beauty of the python. For its ferocity and

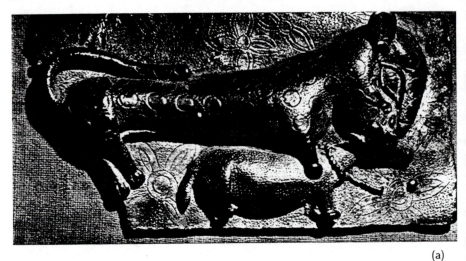

(a)

Figure 2 (a) 17th Century brass plaque of leopard pouncing on cow. British Museum. (b) Terracotta plaque from present palace in Benin City representing Oba Akenzua II sacrificing a leopard and an elephant. Artist: Ovia Idah. Photographer: Dan Ben-Amos.

(b)

tenaciousness, it is considered to be the policeman of the water, sent by Olokun to punish evildoers by overturning their canoes. Representations on brass plaques indicate that warriors once wore images of crocodile heads, probably as amulets for protection.[5]

The vulturine fish eagle is the king of the day birds. Like the leopard and crocodile, it has a vicious and predatory nature. Its beautiful white feather is worn by chiefs as a symbol of respected old age and proper chieftaincy and it is represented—in fact, the only artistic depiction of the fish eagle—on the wooden commemorative heads (*uhunmwun-elao*) placed on chiefly ancestral shrines.[6]

The leopard, elephant, python, crocodile, and vulturine fish eagle can function as metaphors of leadership because of their taxonomic positions—they are all rulers or lords over their respective species—and because they stand in the same relationship to human society as the Oba, that is, they can take human life.

In their hostility towards humans these animals reverse the ideal relationship. Their aggression, however, is neither random nor uncontrolled, but is directed, as is that of the King himself, by forces of the supernatural world (*erinmwin*). The Edo believe that when leopards or crocodiles attack men they are doing so at the behest of a deity who is utilising them as an instrument of vengeance.

The ritual relationship towards these animals is quite different from that towards the passive, accessible ones. Leopards, elephants, and vulturine fish eagles cannot be killed freely or without ritual expiation. For instance, any hunter who accidentally kills a leopard must report to the king, swearing seven times that he has killed the leopard of the bush, not the leopard of the home. In olden days, special guilds used to exist to hunt elephants, leopards, and fish eagles, and in the latter two cases, to bring them back alive and maintain them in captivity.

None of these five creatures can be utilised for sacrifice except under highly restricted conditions. For example, the crocodile is rarely sacrificed because, as one informant succinctly claimed, "Before you've even thought of sacrificing it, you've had it!" The leopard and the elephant may only be sacrificed by the King (Fig. 2b). At the yearly *Igue* ceremony, reaffirming his divinity, the King sacrifices a leopard to his own head, the locus of mystical power. His possession of live and tamed leopards, with whom he used to parade in the streets, and ultimately, his taking of the life of the leopard to strengthen his own powers, symbolises for the Edo the ultimate domination of King of the Home over King of the Bush.

III

Aggression and Abnormal Power

In the second category there are certain animals which are dangerous because their hostility to man is derived from a breakdown of boundaries between realms and a violation of the ideal order—these are transformed animals, wild animals of the bush and night, associated with witchcraft and power beyond the normal. The capacity to transform into a wild night creature represents the pinnacle of supernatural power obtainable by humans. This relationship between humans

and animals is qualitatively different from those previously discussed, for the dissolution of boundaries creates a new ontological status of paradoxical duality. In transforming, the human becomes *both* man *and* animal: the identity between them is no longer metaphoric but substantial.[7]

Two categories of humans achieve this abnormal power: the witch (*azen*) and the diviner/healer (*obo*). The Edo believe that witches operate through transformation. Since, like all other realms, the witches' society is hierarchically organised, with a ruler (*Obason*, "king of the night"), a council of elders (*eniwaren ason*, "elders of the night"), and commoners (*azen*, "witches"), the particular animal or bird in to which they transform depends on their status and specific duties. For instance, the lord of the witches has the right to become a grey heron, king of the night birds, while commoners can transform into owls, which are only messengers. At night, witches send out their life force (*orhion*) in the guise of one of these aggressive birds or animals and they transform the life force of their intended victim into a passive animal, a goat or antelope, which they then devour. "In the marketplace of the witches, humans are the goats." As Beidelman points out:

> A witch's behavior is inverted physically, socially and morally. He works at night . . . and he travels . . . without the impediments experienced by ordinary people . . . He treats all humans like non-humans, killing and eating people as though they were animals (1963:67).

The *obo* differs from the witch primarily in that he is not morally inverted. Yet, to accomplish his goals, he too must cross the boundaries between village and bush, day and night, human and animal. There are many different types and ranks of *ebo* (plural of *obo*) specialising variously in divination, curing, administering ordeals, or fighting witches. The specialists in divination and curing deal with the inverted world of the witches indirectly, through knowledge of the signs of their impact and of the medicines and devices to ward them off. But the one who combats witches must take on the attributes of their realm. Dressed in black, he goes out at night to the crossroads, the meeting place of this world and the spirit world (*agbon vb'erinmwin*), where he negotiates with witches in order to ransom the captured life force of their victims.

Certain *ebo* have reached full ritual status (*ebo n'osegberhan*); they have abnormal powers and special medicines which enable them to fly through the air, disappear when in danger, and especially to transform into animals. According to Aikaronehiomwan Isibo, himself an *obo* (1973: p.c.):

> There is an adage in Benin that an *obo* who is not able to transform himself into a cow or leopard is not a real *obo*. Once an *obo* has reached the age to be able to do this, he is beyond sexual relations. He has had all his children and won't eat food cooked by a woman again.

By going beyond normal human relations, and beyond normal human capacities, into the realms of the bush and the night, the *obo* now stands in relation to human society in the same position as the witch, although he represents the positive side of the coin. He shares the same powers, but utilises them for good.

One locus of the *obo's* power is his medicine staff *(osun ematon)*, a wrought iron rod (Fig. 3) surmounted by a bird and decorated with figures of other birds, animals, reptiles, and a variety of objects of ritual and daily usage (ceremonial swords, hoes, etc.) The use of iron links the *obo* to the warrior, hunter, and craftsman, all of whom have Ogun as patron deity. Ogun is the mystical force inherent in metal and associated with blood, flames, vengeful anger, and warfare. While craftsmen attempt through periodic sacrifice to keep the iron of their tools "cool," that is, to tame its force for civilising purposes, the *ebo* exploit its power to go beyond civilization and control. It is their means of transformation.

The imagery of the staff provides a further link between the *obo* and the warrior, the destructive force of Ogun and the transformational capacities of the god of medicine, Osun (the power inherent in leaves and herbs). In addition to the ceremonial weaponry usually represented, there also appears the image of the mythical bird *ahianwen-oro*, a reference to the victorious battle of Oba Esigie over the Attah of Idah in the early sixteenth century. (A casting of this bird is carried by chiefs at the yearly ceremony commemorating this victory). The staff itself is seen as representing flames shooting upward. Its praise name in Edo is *osun nigiogio, osun* meaning the power inherent in medicines and *giogiogio* meaning burning up with heat. Thus, Aikaronehiomwan Isibo claims, "When a diviner/healer goes to battle he cannot be caught because he will turn into an *osun nigiogio* and spark fire and nobody can come near." In the olden days, an

Figure 3
Medicine staff surmounted
by *ahianwen* oro bird.
Brooklyn Museum #71.22.7.

obo actually used to accompany soldiers to the war to insure success against their enemies. The idiom to describe a powerful *obo*—and indeed any magically powerful individual—is to claim that he cannot be caught in battle. When faced with an invincible foe, he will transform into an animal or disappear. The battlefield is the ultimate testing ground of a man's control over his own life. If the highest degree of political power is the right to kill, the pinnacle of magical strength is to be invulnerable, to be in complete control of your own destiny—truly a power beyond the normal.

The animals and birds represented on the medicine staff are mainly the aggressive ones of transformation. Each appears on the staff in accordance with its role in the night world. At the top of most *osun ematon* is the dominating figure of a bird, either astride an animal or surrounded by a secondary group of birds. Several types of birds may be depicted, but the most important is the grey heron (*akala*), the king of the night birds.[8] As the supreme night creature, it is, in the words of Osarenren Omoregie (1973: p.c.):

> the means of mobility for *Obason*, the king of the night. A wizard must reach a first class rank of Lord of the Witches before he can transform into a grey heron and then he can attend meetings at far distances. If the chief wizard wants to hold a meeting in London this night, transformation into a grey heron will dignify him and he will be respected.

The grey heron is viewed as a vicious, predatory creature with a long sharp beak and a huge head. It is used by powerful men not only as a means of mobility, but to strike terror and cause disease. Other night birds are represented in subordinate positions on the staff, such as the owl, the spy of the night people, or the senegal coucal, their timekeeper. All night birds are warriors with sharp piercing beaks.

Along the stem of the iron staff are frequently found images of the chameleon. It is one of the main animals associated with the diviner/healer because it symbolises his greatest power: transformation. Von Sydow (1938: 59) quotes the Oba as saying: "The chameleon figure on the Osun rod symbolizes how the world is changed by the magic power of the medicine man just as the chameleon can change the color of its skin." In the night world, the chameleon is a spy. As Izevbiohen Idemudia, an *obo*, explained (1973: p.c.):

> The chameleon is the camera of the night people; that is why it changes colour all the time. The skin is like camera film. If an *obo* transforms into a chameleon whatever it sees at night it pictures and reports back to the grey heron, Lord of the Witches.

The chameleon is considered a symbol of wisdom in a double sense, that is, the wisdom acquired in old age (indeed, the gait of the chameleon is compared with that of an old man), but also the cleverness associated with the ability to change to meet all situations. Unscrupulous and tricky individuals are nicknamed "chameleon."

Along the sides of the iron staff, often shooting upwards like flames themselves, are representations of snakes. The snakes *aka*, *ovbivbie*, and *iviekpo*[9] are the most dangerous because they are the warriors of the night people sent by Osun, the god of medicine, to kill offenders.

Human passivity towards these animals is clearly established in ritual relationship towards them. All hostile animals are taboo (*awua*), forbidden for consumption. It is similarly forbidden to kill any of them, and only the most powerful *obo* dares claim to use one for sacrifice.

All the hostile animals and birds of the night share one characteristic: they violate Edo canons of aesthetics. Some are disproportionate: the grey heron and the snake *aka* are believed to have huge, clumsy heads in relation to their bodies, a trait considered particularly ugly in Benin. Others are anomalies in Mary Douglas's terms (1957; 1966), that is, they combine characteristics cutting across taxonomic categories, such as lizards, bats, and frogs. The snake *ovbivbie*, for instance, is believed to have the head of a cock and to crow as it spits. Both the submissive and the kingly animals that appear in Benin art, such as the cow or the leopard, are considered beautiful (*mose*). They are visual statements about proper order. In contrast, witches are inversions of the proper order—they are monsters. And, in their ugliness, the animals into which they change are visual statements about moral aberration.[10]

NOTES

1. For illustrations of kola nut boxes with representations of a cow/antelope see Forman and Dark (1960: plate 13) and Pitt Rivers (1900: XLIV-336). For the pangolin see Dark (1962: XX-47) and Coon and Plass (1957:36), and for the mudfish see von Luschan (1919: pl. 117) and Pitt Rivers (1900: XLVII-372-3).
2. Olokun is the most widely worshipped deity in the Benin pantheon and is considered the bringer of health, wealth, and fertility. See Ben-Amos (1973) for a discussion of the artistic symbolism of the Olokun cult.
3. The altar of the hand is dedicated to the power of individual achievement in the search for material success. For information and illustrations see Bradbury (1961).
4. Van Nyendael, who visited Benin in 1701, describes a copper snake on the turret of the palace (1705: 534). A representation of what the palace probably looked like before it was destroyed in 1897 can be seen in von Luschan (1919: pl.90).
5. A plaque depicting warriors with crocodile head ornaments is illustrated in Dark (1962: I-250). von Luschan (1919: pl. 46) has examples of a number of plaques with crocodile images.
6. For an illustration of a wooden commemorative head see Dark (1962: XXIX-129).
7. The terminology of "metaphoric" versus "substantial" identity is based on Finnegan and Horton (1974: 43). Firth (1966) has argued that men-animal equations are a type of metaphor, but here I agree with Buxton (1968) that it is a question of "real identity" not "a way of representing ideas." The creation of metaphor is impossible without the presupposition of boundaries between categories.
8. The symbolism of the gathering of the birds in Yoruba art is discussed by Thompson (1970) and much of the imagery is paralleled in Benin. A medicine staff with a representation of the grey heron, *akala*, can be seen in von Luschan (1919: pl. 109).
9. According to Melzian, *aka* is a grass-snake (1937: 5) and *ovbivbie* is a black mamba (1937:153), although it might also be a cobra. He has no attribution for *iviekpo*.
10. Rebecca Agheyisi (1973: personal communication) has indicated that the Edo word for ugly, *khorhion*, is a compound of *kho*, hostile, and *orhion*, life force—a particularly appropriate combination of the aesthetic and the moral.

REFERENCES

Beidelman, T. O. 1963. Witchcraft in Ukaguru. In *Witchcraft and sorcery in East Africa* (eds) J. Middleton & E. H. Winter. New York: Frederick A. Praeger.

Ben-Amos, P. 1973. Symbolism in Olokun mud art. *Afr. Arts* 6,4,28-31,95.

Bradbury, R. E. 1959. Divine kingship in Benin. *Nigeria Mag.* 62, 186-207.

1961. Ezomo's *ikegobo* and the Benin cult of the hand. *Man* 61, 129-38.

1967. The kingdom of Benin. In *West African kingdoms in the nineteenth century* (eds) D. Forde & P. M. Kaberry. London: Oxford Univ. Press.

Buxton, J. 1968. Animal identity and human peril; some Mandari images. *Man* (N.S.) 3, 35-49.

Coon, C. S. & M. Plass 1957. African Negro sculpture. *Univ. Mus. Bull.* 21, 4, 36.

Dark, P. J. C. 1962. *The art of Benin*. Chicago: Chicago Natural History Museum.

1973. *An introduction to Benin art and technology*. London: Oxford Univ. Press.

Douglas, M. 1957. Animals in Lele religious thought. *Africa* 27, 46-58.

1966. *Purity and danger*. London: Routledge & Kegan Paul.

Egharevba, J. U. 1960. *A short history of Benin*. Ibadan: Univ. Press.

Fagg, W. 1963. *Nigerian images*. London: Lund Humphries.

Fernandez, J. 1972. Persuasions and performances: of the beast in every body . . . and the metaphors of everyman. *Daedalus*, Winter, 39-60.

1974. The mission of metaphor in expressive culture. *Curr. Anthrop.* 15, 119-33.

Finnegan, R. & R. Horton (eds) 1973. *Modes of thought*. London: Faber & Faber.

Firth, R. 1966. Twins, birds and vegetables: problems of identification in primitive religious thought. *Man* (N.S.) I, 1-14.

Forman, W., B. Forman & P. Dark 1960. *Benin art*. London: Batchworth.

Leach, E. R. 1964. Anthropological aspects of language: animal categories and verbal abuse. In *New directions in the study of language* (ed.) E. H. Lenneberg, Cambridge, Mass.: M.I.T. Press.

Luschan, F. von 1919. *Die Altertumer von Benin*. Berlin: Museum für Völkerkunde.

Melzian, H. 1937. *A concise dictionary of the Bini language of Southern Nigeria*. London: Kegan Paul, Trench, Trubner.

Nyendael, D. van 1705. A description of Rio Formosa, or the River of Benin. In *A new and accurate description of the coast of Guinea* (ed.) W. Bosman. London: J. Knapton.

Pitt Rivers, A. H. L. F. 1900. *Antique works of art from Benin*. London: Harrison.

Sydow, E. von 1938. Ancient and modern art in Benin City. *Africa* II, 55-62.

Thompson, R. F. 1970. The sign of the divine king. *Afr. Arts* 3, 3, 8-17, 74-80.

1971. *Black gods and kings* (Occ. Pap. Mus. Lab. ethnic Arts Technol. 2). Los Angeles: Univ. of California Press.

11

Kinshape
The Design of the
Hawaiian Feather Cloak

Tom Cummins

At the time of Cook's visit (1778) the islands were divided into four kingdoms, ruled by rival kings who were frequently at war with each other. Within a dozen years, Kamehameha I, through his own genius and his ability to win the help of foreigners and their weapons, had conquered his rivals. At the time of Kamehameha's death in 1819 the islands were united under one rule and were at peace.

Then came the overthrow of the Kapu (1820). The Hawaiians had no religion when the first missionaries arrived in 1820, and the power of their ruler was sadly shaken.[1]

Fifty years from the coming of the European the making of feather cloaks had ceased. . . .[2]

In 1792 Kamehameha the great, the eventual ruler of all the Hawaiian islands, gave to the English explorer Vancouver a feather cloak called an *'ahu 'ula*. He enjoined the captain to deliver the cloak to King George III, saying that "it was the most valuable in the islands of Hawaii, and for that reason he had sent it to so good a monarch, and so good a friend, as he considered the King of England."[3]

The historical reasons for this particular gift notwithstanding, its content underscores the esteem that the feather cloak had in Hawaii, and it raises several questions concerning the nature of the *'ahu 'ula* in that society. I want, here, to restrict these questions to issues concerning the shapes and colors chosen to create the designs of the *'ahu 'ula*. The reasons for this insistence will become clear in the description of the pieces. It is important, now, to note that the previous writing on this subject has either dismissed these issues altogether or

Reprinted in abridged form from *Art History*, Vol. 7(1):1-20, 1984 with permission of the author and publisher.

given general aesthetic appraisals. This is because the designs are composed of abstract shapes of solid colors (Fig. 1). To a contemporary viewer they are devoid of meaning because they strike a chord with Modernist sensibilities for abstract shapes as the essence of pure universal aesthetic expression. But abstraction has meaning proper only to its time and place. Abstract art is no more devoid of particular content than is figural art. The difference is that figural images by their intent to depict known forms are more immediately understandable and lend themselves to readings that normally end in the identification of what is replicated and, sometimes, why. Abstract forms by their refusal to replicate, by their negation of the familiar, demand the identification of the cultural, ideological if you will, force that gives them their significance. This means that a study of such forms that in any way questions what they are requires an analysis of their culture.

Such an analysis means the study of a culture's shared but unreflected view of its social relations. The mode of analysis depends upon the economic and ideological structure of the society under question, but in each case it must focus on the means by which material human relations are transformed to suppose a cultural ideal. For Hawaii, the dominant structure of the economy and politics must be reckoned within the sphere of kin relations. This will allow for the determination of the material value and political importance of the cloaks. As we shall see, the size and the color find their meaning at this level of analysis. The design of the cloak, however, does not. To get at this central question, the cloak must be investigated in its structural role in Hawaiian thought. In discovering its associations and manifestations in Hawaiian mythology, we can find the ideologi-

Figure 1 'Ahu 'ula (Kearney cloak). Bishop Museum, Honolulu.

cal place in which the abstract designs take their meaning. But to understand how these forms operate in the real world of men and women, they must be brought back to the economic and political realm where real events occur. This path is found in kinship because it unites the two spheres by functioning at the ideological level of mythology and the material level of economic relations.

Today there are approximately 160 *'ahu 'ulas* in museums and private collections throughout the world. They range in size from shoulder capes to full length cloaks, and although no two are exactly alike, William Brigham, author of the first and still most authoritative monograph on these cloaks, notes that no great originality is shown in their form or design.[4] What he means to say is that the *'ahu 'ula* invariably has a crescent shape formed by the woven coconut fiber lining to which the feathers are attached. This crescent shape is further repeated in the color design of the feather work. Peter Buck in his study of Hawaiian material culture notes that the crescent appears noticeably in well over half of all extant cloaks.[5] His estimate is conservative since a closer examination reveals that the crescent is the structural design element in almost all cloaks. Generally, the design is created by a few geometric shapes of colored feathers set against a ground of feathers of a different color. These geometric units are created by a solid block of color or by the colored outline of the shape. Usually only red, black, and yellow feathers were used in the manufacture of these cloaks. One of the most frequent designs of the *'ahu 'ula* shows a large crescent with its center coordinated with the central vertical axis of the cape (Fig. 2). The crescent arcs upward toward the side borders of the cape but does not meet them. Two smaller

Figure 2 'Ahu 'ula (Kaumuali'I cloak). Bishop Museum, Honolulu.

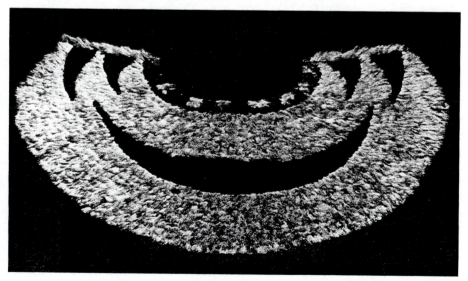

half-crescent units extend from either side border and flank the ends of the central crescent. When the cape is worn, the two side borders meet and create two full crescent elements, while the center of the large crescent falls at the middle of the wearer's back.

This basic motif has several variations. The large crescent frequently peaks at the middle, pointing upwards so as to emphasize the central vertical axis. The side half crescents are replaced by triangles (Fig. 3). On larger capes or cloaks these elements are multiplied and varied. The central solid crescent design is sometimes replaced by smaller circular or diamond elements which none the less stretch across the cloak horizontally to define the arc of the essential crescent (Fig. 4).

These few examples demonstrate the pervasiveness of the crescent. This fact, however, has not led to any studies that treat the design as significant to the function of the cloak. The question of the *'ahu 'ula's* design has been addressed only once in the literature by Peter Buck[6] who simply suggests that the design is dependent upon the shape of the cloak. He supposes that the upper and lower borders of the cloak's woven fiber lining were originally straight like those of the

Figure 3 'Ahu 'ula (Peterson cloak). Bishop Museum, Honolulu.

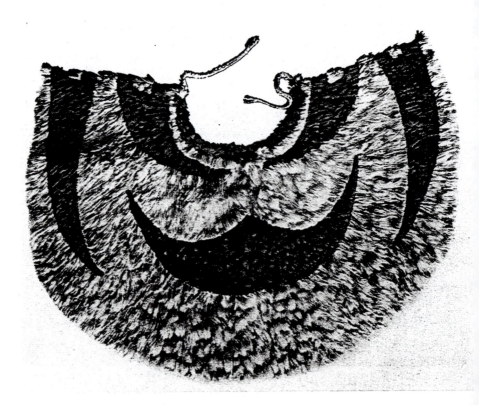

Figure 4 'Ahu 'ula (Peterson cloak). Bishop Museum, Honolulu.

New Zealand Maori cloaks, but that eventually in Hawaii these borders were curved. The crescent design of the colored feathers merely followed the structural change of the lining. This intuitive explanation of the early change may or may not be correct, but it does not pertain to the *'ahu 'ula* as we know it. The examples available for study represent the feather cloak at a highly developed stage and used by a society which had changed dramatically from its early beginnings. Furthermore, Buck does not question why the form of the cloak was ever altered, nor does he ask why, once the Hawaiians decided upon the change of the lining, they accented it by repeating it in the colored design. Other patterns were available by arranging the feathers differently. We have examples of Hawaiian feather work in which the geometric designs do not follow the form of the lining; yet, this freedom is not shown in the *'ahu 'ula*. The specific design of each cloak is unique, but it is unique only within a highly restricted vocabulary. Only three basic colors were used, and only one principal geometric pattern was considered. The overall design and shape show a coordinated and determined emphasis on the crescent. This careful articulation cannot simply be the result of an early arbitrary change in the borders of the lining. Rather, these artistic restrictions or choices must be seen as being made within the framework of the Hawaiian social structure.

The use of the *'ahu 'ula* was restricted to the men of only one class of people, the *ali'i*. They were the royal class of a social system unique in Polynesia, and the word *'ahu 'ula* refers to that class. It means "red cloak"[7] and red was the royal color of Hawaii in the same way that purple was the royal color of the Byzantine state. Only, the Hawaiian system was much more restrictive than Byzantine royalty. Theoretically, there was no admittance to the *ali'i* other than by birth, nor could one lose the prerogatives of royalty no matter what the course of political events.

Below the *ali'i* was the peasant class, the *maka 'ainana*, and below it was the *kuawa*, a group of people with no rights or land—essentially a slave class. The relationship of all three to one another was based on birth and mediated by a system of government that embodied both the secular and religious elements of the society.

Within the *ali'i* there were ranks and degrees of nobility. At the pinnacle of power was the *ka moi*, a supreme and absolute chief of an entire island. The position was held only by a male and was contingent on two factors: rank by genealogy and the personal ability to establish rule. This ability rested on the number of his followers and the sacred aspect of the *ka moi* which enabled him to declare what was *kapu* (taboo). Because the *kapu* served as both an external and internal force for the order of the social and religious life of the entire community, it gave him extraordinary power.[8]

The *ka moi* usually came from a body of chiefs generally called the *aha-ali'i* or *papa ali'i*. Theoretically, it was composed of three ranks of chiefs based on kinship. The highest rank belonged to the child of a brother-sister marriage called *pi'o*. The second rank was held by the offspring of a first cousin marriage called *hoi'i*, and the third belonged to the child of a union between a half-brother and sister, called *naha*. The children in all three cases were called *niaupi'o*. Socially, these were the highest and most sacred members of the Hawaiian society. The child of a brother-sister marriage was divine. His presence was so sacred that theoretically he could only travel at night because everyone had to prostrate themselves in his presence. The two other ranks had similar but less severe taboos. However, as in the case of all preferential marriages, these unions were the ideal rather than the fact. The *aha-ali'i* or body of chiefs was staffed by many chiefs who were not the children of such marriages but who were accorded the same general title given to the offspring of the three most preferred marriages. More often than not, the *ka moi* himself did not come from these forms of marriage. In fact, the one real requisite for entrance into the *aha-ali'i* and for the recognition as a chief at all was a pure genealogy which could trace a person's ancestry through a royal line that ultimately reached back to the gods themselves.[9] To insure this, at the time of the birth of a chief, a name chant was composed glorifying and tracing the family history. A member of the *ali'i* visiting another island or chiefdom had to recite his name chant to the *aha-ali'i* of that area before he could receive the prerogatives of a chief.[10] These matters of kinship and genealogy were what ultimately invested the *ali'i* with their sacred power or *mana*, of which the offspring of a brother-sister marriage was the ultimate expression, and were what set them apart ideologically from the peasant and slave classes.[11]

As the supreme ruler of an island chiefdom, the *ka moi* had the power to dispossess peasants and lesser chiefs of their land, and to receive a yearly tribute. Non-payment of tribute was one cause for being thrown off the land. A second reason resulted from the advent of a new *ka moi*, who had the right to redivide the land among his followers. The sacred nature of the *kamoi* extended to an active role in the religious part of Hawaiian society. As head *kuana* or priest, he consecrated the temples, oversaw religious rites and presided over the celebration of the most important festival, the *makahiki*.[12]

The *ka-moi* was assisted by an adviser called *kalai-moku*, meaning "island carver." He essentially acted as a counselor of state and guided a young or new *ka-moi* in his decisions. His title derived from the fact that it was through him that the lands were divided. The largest districts, called *ahuapua'a*, were given over to high chiefs for their sustenance and control. In addition to the *kalai-moku*, there was the position of *konohiki*. These were men in charge either of separate pieces of land or of work projects. They essentially insured the cultivation of the land, co-ordination and execution of labour projects, and the collection of tribute.

From the above, it can be seen that within the *ali'i* there was a dual structure of sacred and administrative authority. The latter was rooted in the former, but the administrative posts did not necessarily, and most often did not, belong to the most sacred members. Rather, these positions were filled by ambitious chiefs who could gather support either by wit or force or both. To the peasants however, the rank of the *ali'i* was regarded with an awe that was accented by the taboo which attended the person of every chief.[13]

The *maka 'ainana* were the common and most numerous class of people. For that reason, they were also called *hu*, which means "to swell or multiply." Unlike the *ali'i* and *kauwa* or slaves, this class was amorphous in its genealogy. Both *kauwa* and the *ali'i* were born to their state with their ancestral origins clearly defined in the creation myths.[14] But in the case of the *maka 'ainana*, except for common descent from *wakea* and *papa*—the primordial pair—there is no mention in the creation myths or any subsequent myth that specifically recounts their origin. As such, they simply existed between the two clearly articulated polar opposites, master/slave, and had no history and therefore no power of their own. It is understandable then that the *maka 'ainana* dreaded both classes, and reasonable that they called them both *akua* "god," or "godlike," and themselves *kanaka*, "men."

Malo says of the *maka 'ainana* that "the life of the people was one of patient endurance yielding to the chiefs to purchase their favour."[15] This patient endurance meant yielding produce, goods, and/or labour including military service to the *ali'i*. Apart from the necessary occupations of farming and fishing, some of the *maka 'ainana* also practiced professions such as canoe-makers or housebuilders. Within this category of works was one of the sources of feathers for the *ali'i*, the professional bird catcher—*po'e hahai manu*.[16] However, because there was a standing order for the collection of feathers and because a great portion of the annual tribute was paid in feathers, most families regardless of their profession also trapped birds.[17]

The annual tribute of feathers as well as food, *tapa* cloth, *pa-u* (a woman's garment), *malo* (a man's loin cloth), and other things occurred during the four-month-long *makahiki*, the paramount religious festival of Hawaii. First the food, *tapa* cloth, *pa-u*, etc. were collected by the *konohiki* for the *ka moi*. These goods then were displayed before the gods for a day and then were distributed by the *ka moi* to members of his courts and to the chiefs. Their shares were proportionate to their political and sacred rank. No part of the bounty was returned to the people, but there was a warehouse of sorts in which some of the tribute was kept and which could be drawn upon in times of drought.[18] Whether

feathers were collected and distributed at this juncture of the festival is not recorded.

Slightly later in the *makahiki* season, an image called *akua loa* was made. It was carried around the island, stopping at the border of each *ahuapua'a* where an altar had been built. Here offerings of O-o, Mamo, and Iwi feathers; swine; *tapa*; and bundles of pounded taro were presented to the idol. This collection was also co-ordinated by the *konohiki*.[19] It is not said who ultimately received these goods except for the taro which was used to feed the bearers of the idol, but Malo does say that the *makahiki* idol was the god of the *ali'i*. He also avoids mention of feathers in the first collection of goods presented to the *ka moi*, but he specifically names the three most important feathers used by the *ali'i* in their cloaks as being collected in the second. It is reasonable to assume that these feathers went to the *ka moi* who then distributed them to his chiefs.

This structure of collection and redistribution of goods follows the dual nature of the *ali'i* itself. The first collection was required for the sustenance of the *ka moi's* administration while the second dealt with sacred aspect of the *ali'i*. It is in association with the second aspect of the *ali'i* that the three types of feathers used to make the *'ahu 'ula* were collected.

These feathers and the feather cloaks were the most valued possessions in ancient Hawaii. Their material value resulted from the vast expenditure of labour required for their collection. Each bird had to be ensnared, plucked of the desired feathers, and released. Because the tail feathers of the Mamo bird were the most highly prized for the yellow in a cloak, the capture of many more of these birds was required to furnish the same amount as red or black feathers. As yellow does not appear in Hawaiian myths as synonymous with royalty, nor does the Mamo bird appear in any tale that would give it such symbolic importance, its value therefore stood in direct relation to the labour involved rather than to any mythological account. That the labour involved gave value to the feathers was explicitly understood by the Hawaiians. This value was artificially inflated because in Hawaii several other birds of yellow plumage were available so that the use of either the O-o or Mamo yellow feathers meant a controlled scarcity of this type. And because the system depended upon a central collection and subsequent distribution by the *ka moi*, there was further control of the feathers. Finally, Malo notes that the *'ahu 'ula* was an object of booty in every war,[20] but even this source was tightly regulated by the *ka moi*. In the legend of Kamapuaa from Kauai, the *ka moi's* brother-in-law takes the *'ahu 'ulas* from the slain enemy chiefs without being seen. The *ka moi* finally notices that the cloaks are missing and becomes furious because the *'ahu 'ula* "were always his perquisites from the booty take."[21]

This management of feather resources meant that the size and color of the cloaks were not arbitrary. Of course, the *'ahu 'ula* was the prerogative of all chiefs, but this prerogative based on the sacred aspect of all chiefs did not mean that all chiefs had access to cloaks of any size or color, or even a cloak at all. Rather, it meant that a member of the *ali'i* had the right to accumulate the necessary feathers to have a cloak made. The ability to do so rested upon one's political position within the *ali'i*. The position at court meant greater access to feathers, especially yellow ones. Chiefs at the lower spectrum of the political scale did not

have enough power to gain the material to have a cloak made, or if they could, their cloaks were smaller and made with less valuable feathers.

These cloaks and capes were worn either on formal ceremonial occasions or in battle. During these important occasions, one's approximate political position in the *ali'i* was visually expressed. Both the size and color of the cloak demonstrated to all classes the political power of an individual chief. By the protection it afforded during battle, it was a very real object that guarded a man's life according to his value in the social hierarchy. A fanciful version of the death of Captain Cook, painted by George Carter c. 1783, illustrates this hieratic scale (Fig. 5). Three men face Cook in the right foreground. Each one wears a cloak. The figure which plunges a dagger into Cook's back wears a full-length yellow cloak. A second figure is placed closer to the viewer and bends forward to thrust a spear into Cook's abdomen. He is less elegantly clothed, minus the first figure's helmet and necklace, and wears a smaller red cloak. The third figure kneels in the foreground and looks up at Cook. He wears a shoulder cape composed of white and long green feathers (the least valuable of all feathers used). The slain Hawaiian sprawled at the feet of Cook is without any cloak at all.

Figure 5 *The Death of Captain Cook* by George Carter. Oil on fabric, c. 1783. Bishop Museum, Honolulu.

The early European explorers understood the size and color of the cloaks as indicating the proper order of Hawaiian chiefs just as it is rendered through scale and position by Carter in order to indicate this social order for his western audience through the visual keys that they understood. From these early descriptions and later writings by the Hawaiians themselves, we can explain the material value of these cloaks and the symbolic value they had as signifiers of rank. But while a materialist analysis reveals the political significance of the cloak's size and the type of feather used, it does not explain the term *'ahu 'ula* itself. Nor does it explain the ubiquitous crescent shape and/or design which was used equally on the smallest cape as on the largest cloak, or why the feathers were collected during the second tribute levy. To get at these issues, we must work at them from a different angle. We must seek the levels at which the cloak was transfigured from a material property to a symbolic unit by identifying the cultural codes that gave it meaning.

As has been said, the *ali'i* represented not only a politically ranked group of overlords but also a sacred class of people who, if they were not gods incarnate, were at the very least their relatives. In this aspect, the *ali'i* were thought to be accompanied by various signs and attributes, both real and mythical, of which the *'ahu 'ula* was a combination of both. We have already seen that the signification of the real occurs at the material level of the cloak's size and color, but we have also found no trace of its mythical signification at that level. In fact, the striking contradiction between the term for the cloak (*'ahu 'ula*—red cloak) and the fact that the most desired color was yellow demands recognition that there are several levels of signification at work.

At one level the term *'ahu 'ula* referred to red, the royal color. This association derived from the pan-Polynesian tradition of red as a royal signifier. Moreover, it seems very likely that historically Hawaiian cloaks were totally red before the time when there was sufficient surplus labour to use some of it in gathering the much scarcer yellow feathers. None the less, when the preference for yellow feathers over red ones occurred, the generic term for the cloak was not changed.[22] The concept of red still held greater cultural signification than the merely materially important yellow. In this context it is important to note that red was also associated with the rainbow, another royal sign. The rainbow marked either the coming of a chief or the unknown presence of one. The relation between red, rainbow, and feather cloak is not arbitrarily drawn. Their close connection is demonstrated by linguistic evidence from the closely related Polynesian languages of Maori and Tahitian.

In Maori, the language of New Zealand, the word for feather cloak, *kahukura*, also signifies both the name of the god in the rainbow and simply the rainbow.[23] In Tahitian the word for feather cape, *tohura*, also means "peace of the rainbow." These two words are related as is *kulelulu* in Hawaiian which belongs to the same phylum and means "bending" or "arching of the rainbow."[24] Unlike the Maori and Tahitian terms however, *kulelulu* does not also signify a feather cloak. However, *kulelulu* is linguistically related to *'ahu 'ula*, but this ancient relation is mitigated by the rare use of the word *kulelulu* in Hawaii. When

referring to the rainbow that heralds a Hawaiian chief's presence, the words *pi'o-o-ke-anuene*, "arch of a rainbow," or simply *pi'o* are used instead.[25]

It would seem, then, that at some point in Hawaiian history the connection between rainbow and feather cloak as expressed by the linguistic relation between the words *'ahu 'ula* and *kulelulu* became obscured by the shift to the use of the terms *pi'o-o-ke-anuene* or *pi'o* to signify the rainbow.

Regardless of the fact that *'ahu 'ula* and *pi'o* are linguistically unrelated, Hawaiian nomenclature and chants sometimes recall the ancient connection between the cloak and the rainbow. For example, one chant sung before going into battle is phrased as follows:

Komo ku i Kono 'ahu 'ula
(Ku is putting on his feather cloak)
Ka wela o kan na i Ka lani
(the rainbow ((stands)) in the heaven).[26]

A further suggestion that the *'ahu 'ula* was at least unconsciously conceived of as a *rainbow* lies in the *kahili*. The *kahili* was a large feather standard used to denote the royal presence and is presumed to have derived from a feather fly whisk.[27] Its antiquity, however, is suspect, and its use became conspicuous only during the period of the nineteenth-century Hawaiian monarchy,[28] that is, after the dissolution of the *ahu ali'i*, the breaking of the *kapus*, and the cessation of the widespread usage of the *'ahu 'ula*. The word *kahili* means either "a feather standard symbol of the *ali'i*" or "a segment of a rainbow standing like a shaft."[29]

Here the feather symbol of royalty and the sign of a rainbow were fused in a time of social and cultural upheaval and confusion, as if to preserve the association that was merely implied by the *'ahu 'ula*. The *'ahu 'ula* and the *kahili* have shared properties that make this connection more secure. Both were the exclusive property of the *ali'i*, both were made of feathers, and both touched the back of the *ali'i* (the *'ahu 'ula* covered the back; the *kahili* was originally used to brush it).[30] This last point is the most significant when it is realized that the back of the *ali'i* was taboo.[31]

It seems certain then that the *'ahu 'ula* was at least tacitly conceived of as a rainbow and that its arched shape was linked to, or even inspired, the shape and design of the cloak. Yet, this metaphor does not fully explain why the *ali'i* restricted the cloak's design almost exclusively to the crescent nor does it explain the disjunction between two meanings of the Hawaiian words for cloak and rainbow. Both the Tahitians and the Maori used the same word for feather cloak and rainbow; yet, neither culture used the arching form of the rainbow in the design of their cloaks. For these questions to be answered, the distinct significance of the rainbow in Hawaiian society must be determined. And, because the rainbow is a mythical attribute that can identify the presence of a chief, we must turn to the actual legends and myths in which it occurs.

The legend of Umi is one of the most often told legends of Hawaii,[32] and it is also the key myth in the group under analysis. It is not the intention here to discuss all the variations and transformations the set entails, but rather to show how it derives its social meaning from the social structures of Hawaiian culture.

Thus, the legend of Umi, in a condensed form, can stand as the theme against which a few select variations can be set.

The Legend of Umi

It is said that Umi was a part chief because his mother, Akahiakulana, was not a chiefess, although his father, Liloa, was a very high chief, whose genealogy could be traced to the very beginning of all things. So it is that Umi was high on his father's side, but very humble on his mother's side. But in tracing out the origin of Akahiakulana, his mother, it is found that she must have been of very high blood, for her name appears in the genealogical tree of the Kings.

Liloa, the father of Umi, King of Hawaii had as his first wife Piena who bore Umi's older half-brother Hakau.

After having dedicated a temple at Kokohalile, Liloa goes to bathe in a stream where he sees Akahiakulana. Seeing how beautiful she is Liloa seduces her. After living with her a short while, Liloa sees that she is pregnant and asks her "Who is your father?" Akahiakulana answers, "Kuleanakupiko." Liloa then says, "you are a cousin of mine?" She replies "Maybe so." Liloa then leaves but before doing so he tells Akahiakulana that if she has a son to name him Umi and send him to him. He leaves behind his malo, niho-palaoa, and war club for Umi so that he can recognize him.

Umi grows up in his mother's household, thinking her husband is his father. Finally after mistreatment of Umi by the husband, Akahiakulana says, "Stop. You can not treat Umi in this fashion for he is not your son but that of Liloa."

She then sends Umi off to join his real father giving him the things Liloa had left behind and having two friends to go with him. Umi finds the court, climbs over the wall, and sits down on his father's lap. Just as the guards start to seize him, Umi produces the malo and Liloa recognizes him as his son. All goes well except with Hakau, Umi's older step-brother, who is absolutely furious at his father's recognition of Umi.

At Liloa's death, Hakau is willed all the lands of Hawaii, but Umi is left the temples and the gods to care for. Umi therefore lives under Hakau as dependent but in a high position. While thus living, Hakau shows great hatred for Umi in many ways. If Umi took Hakau's surf board, Hakau would become angry and say to Umi, "You must not use my surfboard because your mother is not a chiefess; the same with my loin cloth." Finally after much abuse, Umi leaves court with his two followers. They go off and live secretly with a common family, taking wives.

During the aku season, people begin seeing the frequent appearance of a rainbow on the cliff. Kaoluloku, a high priest who lives in this area also sees the rainbow and wonders at its appearance. Being of a class well versed in ancient lore, he realizes this is the sign of a true chief and knowing of Umi's disappearance, follows the rainbow. He takes Umi and his two followers with him and helps Umi to raise an army. With the army, Umi is able to overthrow his half-brother who is hated by all and becomes the King of Hawaii.[33]

Reduced to the barest outline, the story concerns the gaining of rank, the fall from that rank, and the subsequent regaining of that rank. A slight variation of this theme is found in the legend of Kila.

The Legend of Kila

Kila the new King of Hawaii, is despised by his brothers who plot against him. They suggest that they all go to another island in order to bury the bones of